Glorious Gulf of Mexico

NUMBER TWENTY-EIGHT
Gulf Coast Books
Sponsored by Texas A&M University–
Corpus Christi
John W. Tunnell Jr., General Editor

*A list of titles in this series is
available at the end of the book.*

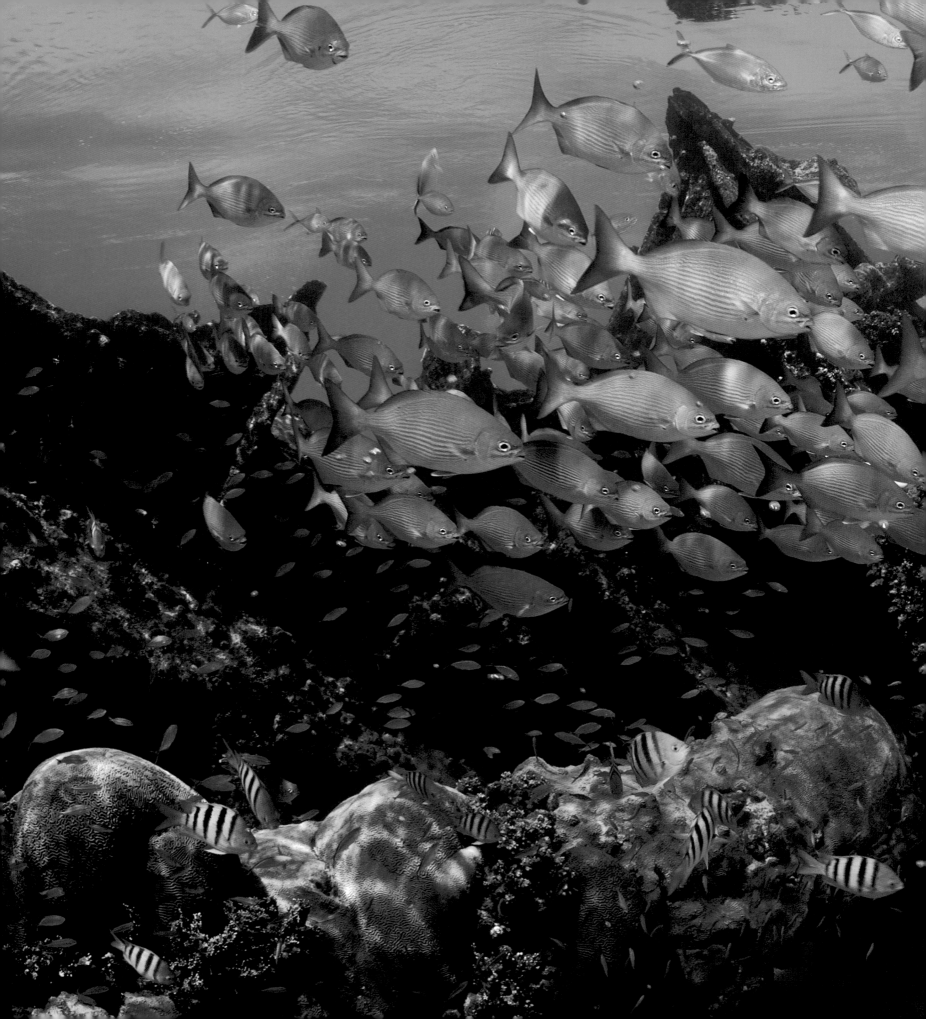

Glorious Gulf of Mexico

Life Below the Blue

JESSE CANCELMO

TEXAS A&M UNIVERSITY PRESS · COLLEGE STATION

This paper meets the requirements
of ANSI/NISO Z39.48–1992
(Permanence of Paper).
Binding materials have been
chosen for durability.
Manufactured in China
by Everbest Printing Co.
through FCI Print Group

Library of Congress
Cataloging-in-Publication Data

Cancelmo, Jesse, author.
 Glorious Gulf of Mexico : life below the blue /
Jesse Cancelmo.—First edition.
 pages cm—(Gulf Coast books ; number
twenty-eight)
 Includes bibliographical references and index.
 ISBN 978-1-62349-374-5 (flexbound (with
flaps) : alk. paper)—ISBN 978-1-62349-375-2
(ebook) 1. Mexico, Gulf of—Description and
travel. 2. Marine ecology—Mexico, Gulf of.
3. Marine resources—Mexico, Gulf of. 4. Mex-
ico, Gulf of—Pictorial works. 5. Marine pho-
tography—Mexico, Gulf of. I. Title. II. Series:
Gulf Coast books ; no. 28.
 QH92.3.C36 2016
 577.709163'64—dc23
 2015032594

*Front Cover: Every year from January to mid-
March, Atlantic sailfish feed on sardine bait-
balls north of Isla Mujeres, where the Carib-
bean meets the Gulf of Mexico.*

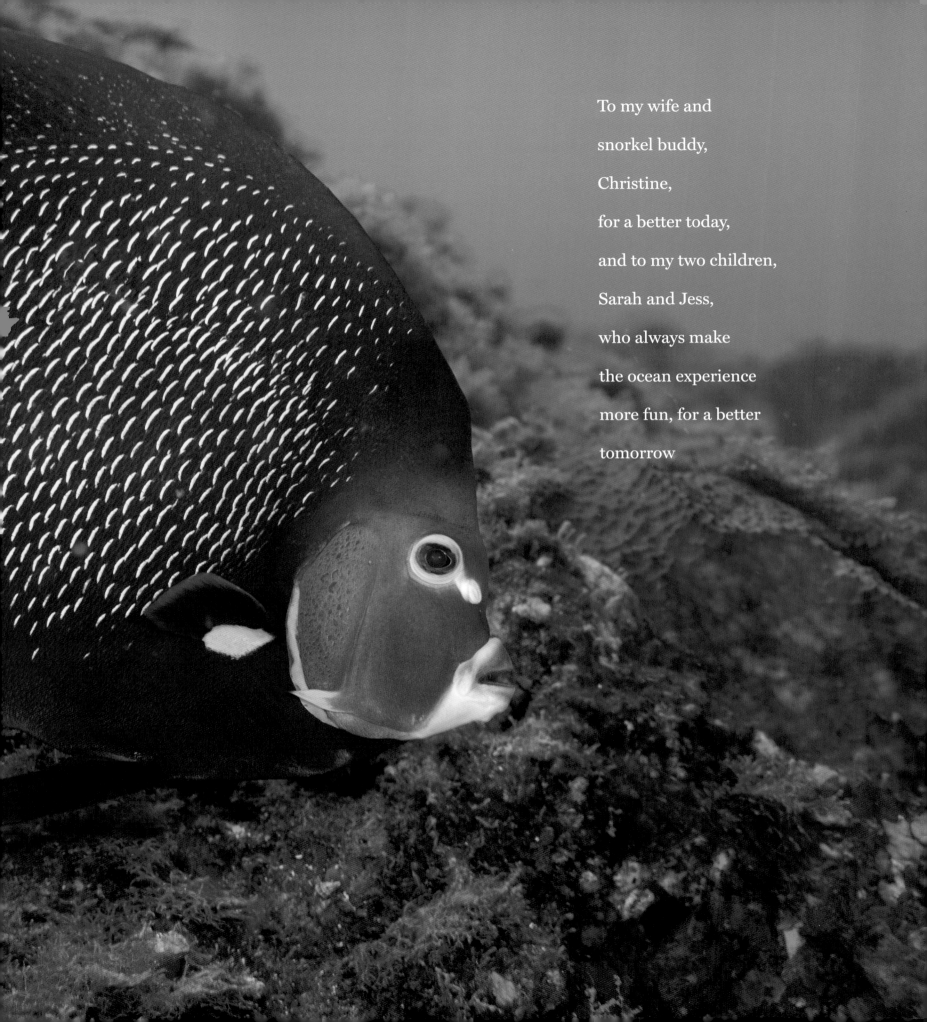

To my wife and
snorkel buddy,
Christine,
for a better today,
and to my two children,
Sarah and Jess,
who always make
the ocean experience
more fun, for a better
tomorrow

Contents

Maps

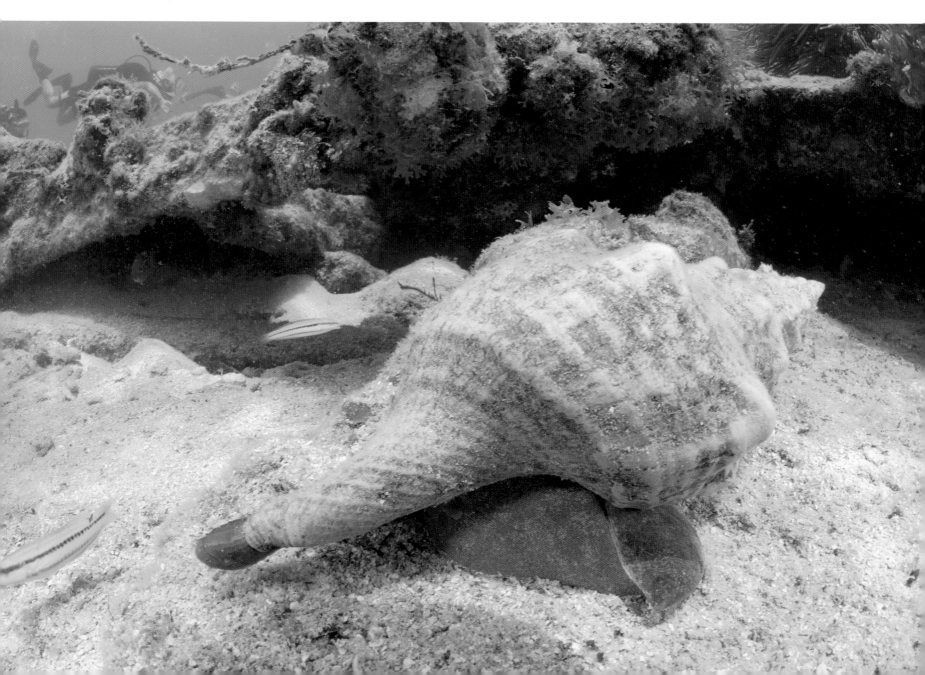

Foreword

Glorious, Gulf of Mexico? Most people who have not closely experienced the Gulf of Mexico, and probably all who have not seen it, would never think to use those words in the same sentence. Yet, individuals who have spent time in some of the more pristine, natural Gulf coast areas, or out in the open blue waters offshore, will tell you that there are some spectacular and beautiful places to be experienced. Very few individuals have had the opportunity to immerse themselves into the deep blue and amazingly colorful places out of the mainstream locations of the Gulf, but those who have will tell you of the beauty of those special places. Rarer still are those who have had the opportunity to see these special places in all three countries surrounding the Gulf of Mexico.

To some, the Gulf of Mexico is an enigma. How can it have so much industrial activity like shipping, oil and gas exploration and production, heavy industrial refineries, dead zones, red tides, and commercial fishing, yet it continues to be one of the most ecologically and economically productive bodies of water on earth? How can it be so resilient to these threats and continue to bounce back? Are we approaching a tipping point of abusing the Gulf? At selected nearshore or coastal locations, where humans have completely altered the landscape, there are definitely signs of stress or failure of natural ecosystems. We can and must do better, and we need to apply today's conservation knowledge and restoration opportunities to help bring some of those coastal areas back to their former glory.

Offshore in the Gulf of Mexico, environmental conditions are not perfect, but they are generally in better condition than inshore or coastal areas. Generally, the offshore ecosystems are in better condition than coastal ones because they are primarily farther away and out of the influence of coastal impacts, but protection and stewardship have also played a role. Cooperation and coordination between industry, government, non-governmental organizations, and academia have shown that partnerships can make conservation strides together. As an example, one night when I was on one of our research monitoring cruises from Texas A&M University-Corpus Christi to the Flower Garden Banks National Marine Sanctuary in the northwestern Gulf, I counted the lights of fifteen oil and gas platforms in the distance outside the surrounding sanctuary boundary. Yet these two coral reefs are some of the healthiest reef ecosystems with the highest coral cover of any in the Western Hemisphere.

In Mexico, the coral reefs of southern Veracruz are in bad environmental condition, but those of northern Veracruz are in pretty good shape. To the north and west of the Yucatan Peninsula on the Campeche Bank, the reefs are mostly in good condition because of their distance from land and humans and because there are no rivers carrying land-based environmental problems offshore. The populations of colonial nesting seabirds on these islands are extensive and amazing also, again because of their remoteness.

In Cuba, it is like a time warp of fifty years ago. Not just with the old cars that everyone is familiar with, but also on many of the coral reefs, where they look like the beautiful and diverse Gulf and Caribbean reefs from the 1960s.

Jesse Cancelmo has selected the Flower Garden Banks, and other natural treasures encircling the Gulf of Mexico, to demonstrate the beauty and glory of its diverse habitats and species. Revealing this outstanding beauty and glory to a larger audience should make us all want to work together to protect and conserve these international treasures.

—John W. Tunnell Jr., General Editor

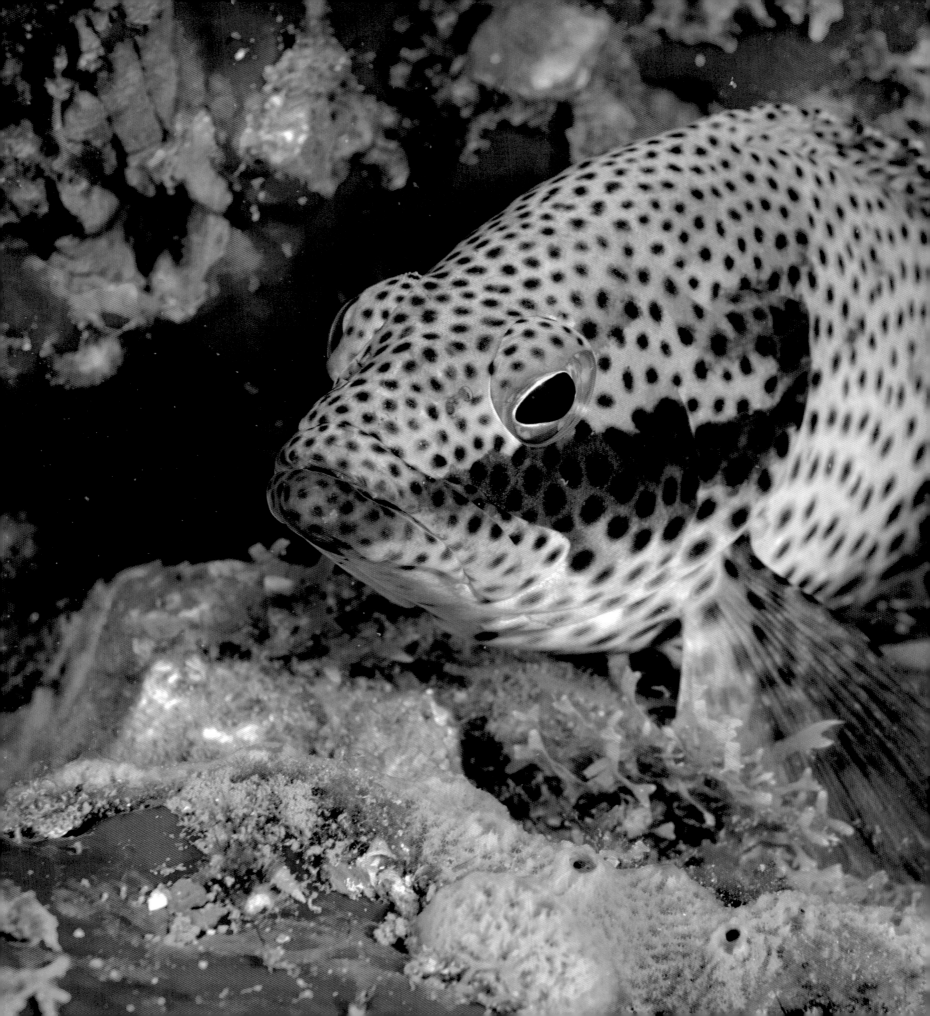

Acknowledgments

All five maps developed for this book are courtesy of Marissa F. Nuttall. Her fine work and enhancements are highly appreciated. Also, see Map Data Sources at the end of the book.

For supporting my efforts to photograph the Veracruz and Tuxpan coral reefs, I thank Fran Espresate, Alberto Bolanos, and Xareni Favela. I am also deeply grateful to the Harte Institute for supporting my travel to Alacran Reef.

In my earlier book, *Texas Coral Reefs*, I was remiss in not acknowledging a very important person. I owe a debt of gratitude to Dr. Thomas Bright, who was instrumental in introducing me to the science and wonders of the northern reefs of the Gulf of Mexico, which are again showcased in chapter 5 of this book.

Introduction

America's Sea

Americans flaunt their East Coast and West Coast, but then there's what some call the "Forgotten Coast." Like a redheaded stepchild, the Gulf Coast—our southernmost stretch of coastline—is more often than not both under-appreciated and misunderstood. Yet, the Gulf of Mexico is an expansive, circular, six-hundred-thousand-square-mile international sea: an incredibly vibrant ecosystem that connects five US states, six Mexican states, and the northern coast of the island nation of Cuba. This imposing deepwater basin has a broad, shallow rim—the continental shelf—along much of the five thousand miles of shoreline. In areas off Louisiana and Texas, the shelf stretches one hundred miles or more offshore and culminates in the dazzling coral reefs known as the Flower Garden Banks. Most people are surprised to learn that, while the average depth of the Gulf is fifty-three hundred feet, the Sigsbee Deep, two hundred miles southeast of Brownsville, Texas, plunges to fourteen thousand feet. The astonishing biodiversity of the Gulf includes more than fifteen thousand species of life, from the coastal estuaries to the deepest depths.

Tropical coral reefs thrive off Florida, Texas, Louisiana, Mexico, and Cuba, and in the northern Gulf the mass coral-spawning event that occurs every August at the Flower Garden Banks is so spectacular it draws observers from around the world. Contrary to dismissive descriptions one often hears about the Gulf environment—"a near-endless stretch of flat featureless sediment" or an area "overrun by oil rigs"—it includes a treasure trove of habitats. The northern Gulf of Mexico alone possesses canyons, ridges, folds, salt domes, pinnacles, and hundreds of hard-bottom banks. Hard-bank areas off Louisi-ana, Texas, Mississippi, and Alabama are home to impressive encrustations of algae, sponges, and mollusks, which in turn form habitats for fish communi-ties and hordes of other sea life. The deepwater corals of the Gulf hold great interest for researchers, as do the brine seeps. These seeps are bizarre hyper-saline underwater lakes, seven and a half times saltier than seawater, that host

microorganisms important to scientists studying metabolic adaptations. The abundant marshes of the Gulf serve as vital nurseries for fishes and as havens for countless birds. The Gulf is also beneath a central migratory flyway for an estimated five million waterfowl that pass through or spend the winter in the northern Gulf coast marshes, which, incidentally, comprise more than half the wetlands in the lower forty-eight states.

Between the rich shoreline habitats and prolific oceanic communities of the Gulf there are more than fifteen thousand living species, including an iconic cast of marine life: sperm whales, manta rays, whale sharks, spotted dolphins, and more. The truly remarkable biological features are often manifest in unusual events of nature. In June 2010, for example, a videographer documented an aggregation of a hundred whale sharks off the Louisiana coast near Ewing Bank. People are generally amazed to learn of the exceptionally large sperm whale population (fifteen hundred) in the Gulf, as well as the presence in lesser numbers of as many as twenty-seven other species of dolphins and whales, such as minke, blue, pilot, and orca whales, to name a few. Another impressive metric—an estimated forty-five thousand bottlenose dolphins make Gulf waters their home.

The enormity of seafood productivity in the Gulf is largely unknown to the public. The Gulf annually yields more finfish, shrimp, and shellfish for US consumption than New England, Chesapeake Bay, and the rest of the Atlantic Seaboard combined. An annual harvest of 1.3 billion pounds makes the Gulf one of the most productive fisheries in the world, supplying a third of the seafood eaten in the United States, not to mention Mexican and Cuban consumption.

Historically, the Gulf of Mexico played a critical role in the colonization of Cuba, Mexico, and the United States. The numerous harbors and river outlets invited early settlements and commerce. Veracruz, in Mexico, and Havana, Cuba, were both settled in the same year, 1519. A settlement at present-day Pensacola, Florida, was established some forty years later, the earliest European settlement in the United States. The Gulf has also played a crucial role in the maritime heritage of all three nations, and for the United States, the history of the Gulf Coast region is every bit as impressive if not more so than that of our other two coasts.

Not to be overlooked is the crucial contribution of the Gulf of Mexico to the energy economy. Extensive offshore gas and oil production and near-shore land facilities are critical to the energy demands of both the United States and Mexico. The health of the Gulf is as essential to our national economy as it is for Mexico and Cuba. This amazing body of water, prodigiously productive in so many ways, is truly "America's Sea."

• • •

My incentive for writing *Glorious Gulf of Mexico* sprang from the Deepwater Horizon oil spill in 2010 and the unprecedented surge of media reports and public responses that followed. I was stunned by widespread public ignorance of the richness and importance of the Gulf of Mexico—a state of affairs this book proposes to help correct. To properly cover the entire scope of the beauty, bounty, and history of the Gulf would require several volumes, so I have chosen to sharpen my focus to a celebration of the fascinating and sensational marine life I've encountered throughout the Gulf of Mexico—from the north and the tiny yet magical reefs off the Texas and Louisiana coasts to the south and the tropical wonderlands just west of Havana, from the east and the splendor of the Dry Tortugas coral reefs to the west and the enchanted underwater scenery off Veracruz. More than merely celebrating oceanic beauty, however, my intent is to inspire readers to better understand and appreciate the natural marine habitats in the Gulf in order to strengthen support to protect and sustain them. As I traveled, went diving, and photographed reefs in each of the three Gulf countries in the course of my research, I recognized that this book might also serve to better demonstrate how much sense it makes for each of the three countries interconnected by this magnificent body of water to work together to preserve and protect it for future generations.

The Mexican stretch of the Gulf of Mexico contains an expansive bounty of colorful coral reefs and other wonderful marine habitats. This cornucopia of ocean wonders extends from Tuxpan, an eight-hour drive south from the Texas-Mexico border, all the way to Isla Holbox, more than five hundred miles to the east, on the northeastern corner of the Yucatán Peninsula. Three major coral reef systems exist in the area. The reefs near Tuxpan and Veracruz are close to shore and vulnerable to coastal impacts. By contrast, the reefs off Campeche have miles of ocean buffer that provide isolation and protection. Coral reefs in the Mexican Gulf attract divers from Mexico City, Puebla, and other major cities of Mexico but for the most part remain off the radar for international divers. Isla Holbox is known not for coral reefs but for the phenomenal whale shark and ray encounters that make it an exceptional destination for tourists from around the world.

Tuxpan Reef System

The Tuxpan Reef System (also called the Northern Veracruz Reefs) has seven separate coral reefs in two groupings some thirty-five miles apart. The three to the north are called the Lobos Reefs and the four to the south, the Tuxpan Reefs. The Lobos group includes Blanquilla, Medio, and Isla de Lobos. The Tuxpan group reefs are named Tanguijo, Enmedio, Tuxpan, and, the most recently recognized, Pantepec. Although fishing and collecting corals or shellfish have been banned at all reefs in this system since June 2009, enforcement has been spotty at best.

Isla de Lobos (Island of the Wolves) is a tiny island (five hundred by six hundred yards). It's only eight miles from Cabo Rojo and sixteen miles from

The Mexican Gulf Waters from Tuxpan to Isla Holbox

the nearest town, Tamiahua, about thirty minutes north of Tuxpan. The surrounding reefs are protected from coral collecting and certain types of fishing, and a permit is required to land on the island, camp overnight, or dive. The only residents of the island are the park ranger and the friendly park workers. Visitors enjoy fresh, home-style cooking prepared by the park staff. Much of Isla de Lobos is in a near natural state, and the brilliant white lighthouse surrounded by towering palm trees, bushy casuarinas, and sugar-white beaches make for ultradramatic tropical island scenery.

Coastal pressures, including overfishing, have clearly affected the Lobos and Tuxpan Reefs. In many areas the corals are stressed, and too many coral heads are covered with blue-green and red algae. Yet, whenever I finned my way through the reefs near Isla de Lobos I was always able to find a coral formation with a level of health and beauty deserving photographic capture. Giant mounds topped with symmetrical brain corals and boulder star corals, their undersides encrusted with yellow and blood-red sponges, made impressive photographic presentations. I was also pleased to see soft sea whips, staghorn corals, and elegant elkhorn corals, none of which have prominence in the northwestern Gulf. Chromis juveniles and other tiny tropical fishes flitted around the tops of the coral heads, and an occasional queen angelfish or scrawled filefish dazzled the eye as it nonchalantly swam by. Also present were some of the tinier reef dwellers, which never cease to dazzle and amaze: redlip blennies, lettuce sea slugs, and neon gobies resting on star coral heads. Entranced by all these little creatures on the reef, I almost missed seeing a hawksbill turtle cross in front of me at arm's length as it flippered its way through the water column. After that near miss, I then encountered a pair of iridescent green black jacks that darted across the cap of the reef while a trio of French angelfish slowly danced their way up and down and around the reef in an elegant, seemingly choreographed fashion.

Perhaps the most unusual experience for me at the Northern Veracruz Reefs occurred eighteen miles south of Tamiahua, a quiet fishing town north of Tuxpan. Alberto Bolanos, owner of the local dive operation, served as my guide and host. Our adventure began when we departed by boat from Tamiahua and cruised through a waterway connecting the majestic local lagoon to the Gulf of Mexico. I stood up the entire ride to get a better view of the miles of thriving, dark-green mangroves and wonderful marshes lining the waterway. I couldn't help but wonder how many future Gulf residents were just beginning their lives within these shoreline habitats.

We soon reached our destination—the Plataforma Tiburón (Shark Platform). The Plataforma Tiburón

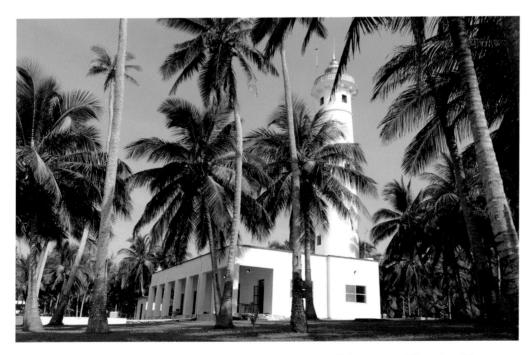

The ageless and unforgettable lighthouse at Isla de Lobos, off the coast of Tamiahua, Veracruz.

is a retired oil production platform that now serves as an artificial reef extraordinaire. Secured to the bottom in 185 feet of water, the horizontal members of the structure are heavily loaded with an array of massive sponges. They include boulder-sized black ball and loggerhead sponges—the latter variety also known as cake sponges. The squatty loggerheads are a dull black in color and have bumpy surfaces, flat tops, and numerous pores and openings. Many I saw were fringed with stinging, snow-white hydroids. The overall fusion of cnidarians on this steel structure included sponges of the barrel variety, as well as orange elephant ear and yellow tube, which had thick, rough walls. Multitudes of brown chromis, crimson creolefish, and juvenile wrasses hovered above the spongy mass. Reef residents within the structure made up an impressive list of tropical fishes, among them queen angelfish, honeycomb cowfish, and flashy barracudas. Silvery spadefish, shimmering lookdowns, and mighty horse-eye jacks swished and swirled in and out of the steel framework in impressive, often massive schools.

Next on my itinerary was the set of Tuxpan Reefs to the south. About ten miles northeast of the mouth of Río Tuxpan, I found myself swimming through a maze of coral heads at the Enmedio Reef. Many of the corals have been affected by their proximity to the coast, yet I was delighted to see several healthy, multihued coral heads.

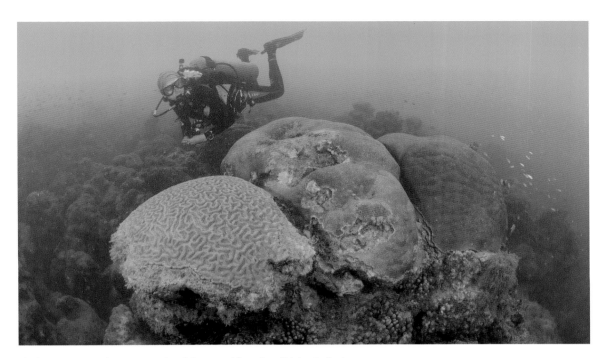

A diver swims along some healthy coral heads off Isla de Lobos.

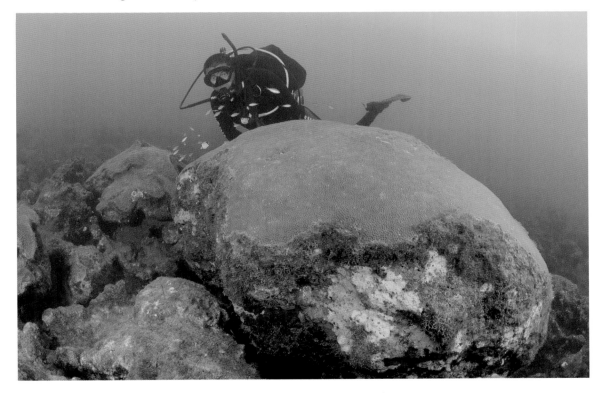

Diver Alberto Bolanos watches juvenile tropical fishes frolic over a huge star coral mound off Isla de Lobos.

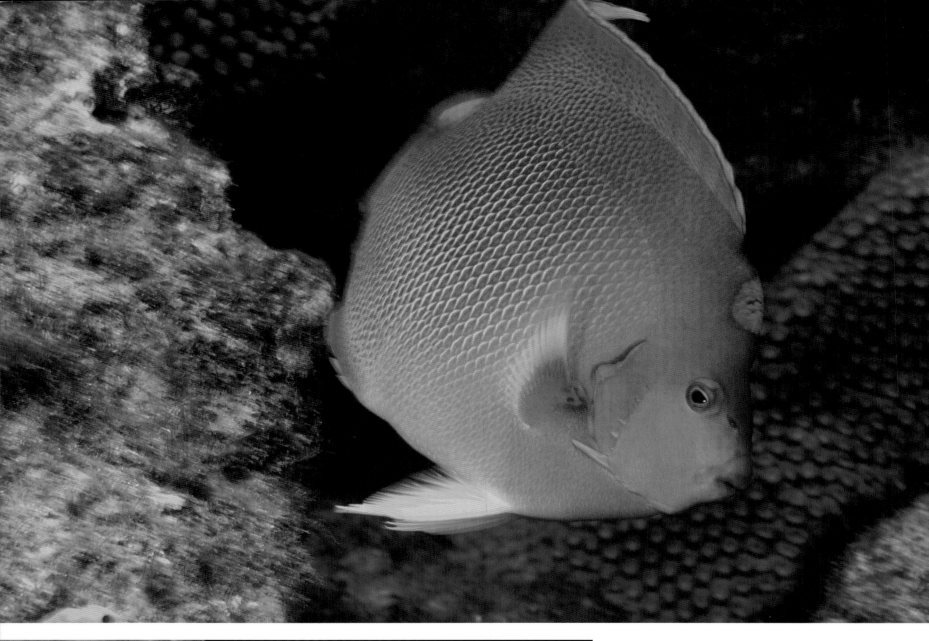

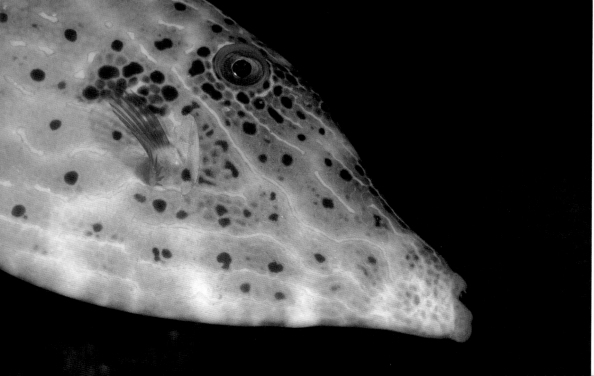

A charming queen angelfish flashes its color as it flits around a reef off Isla de Lobos.

The scrawled filefish has a peculiar mouth and "collagen" lips.

A lettuce sea slug slides across
a reef off Isla de Lobos.

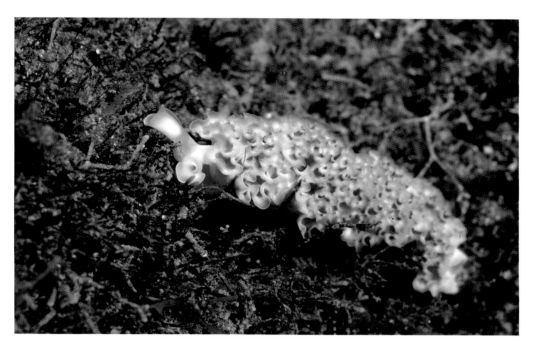

A black jack charges across the reef
like a shadowy bullet.

A trio of French angelfish
move slowly and gracefully
across the reef.

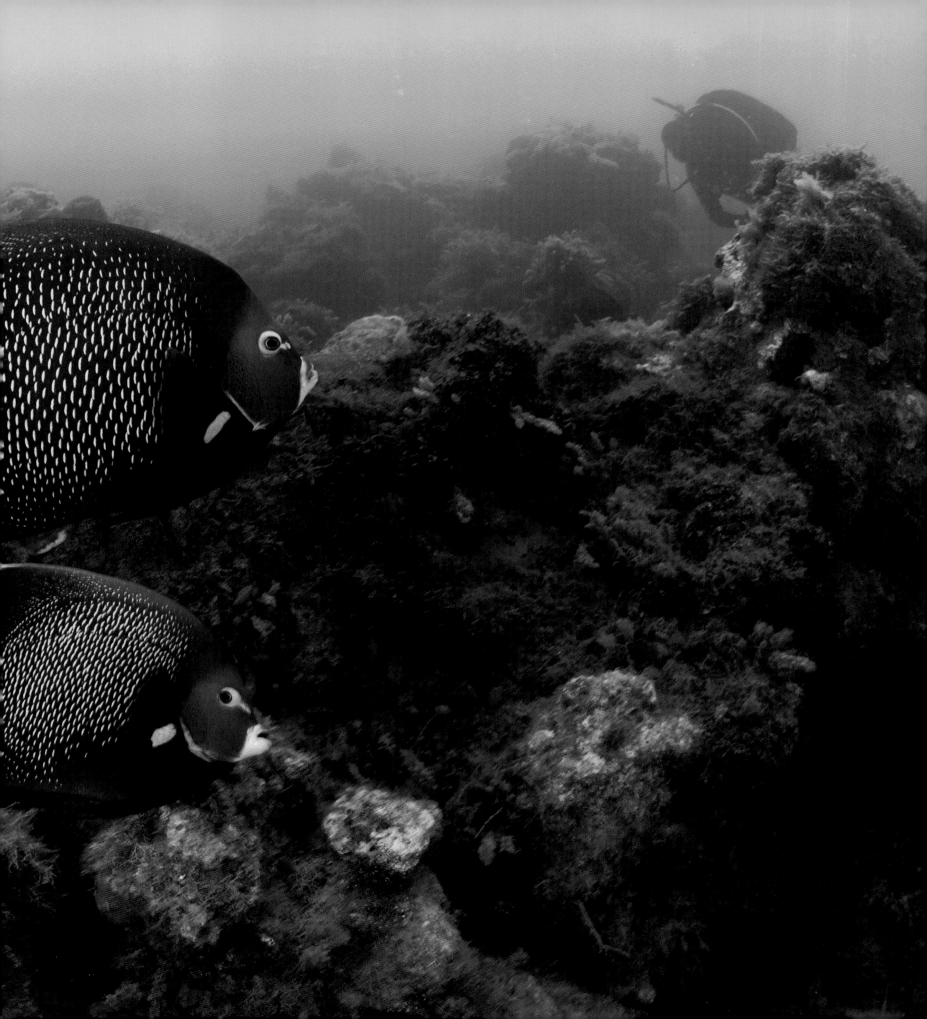

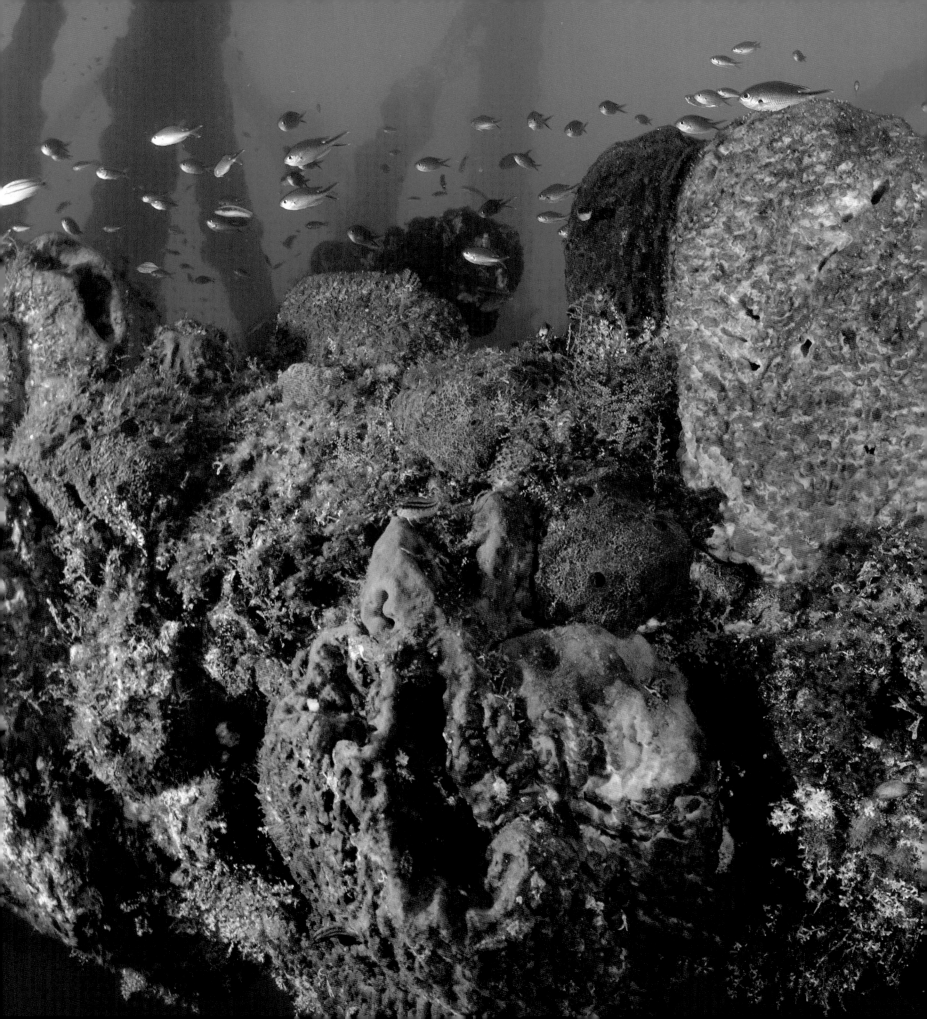

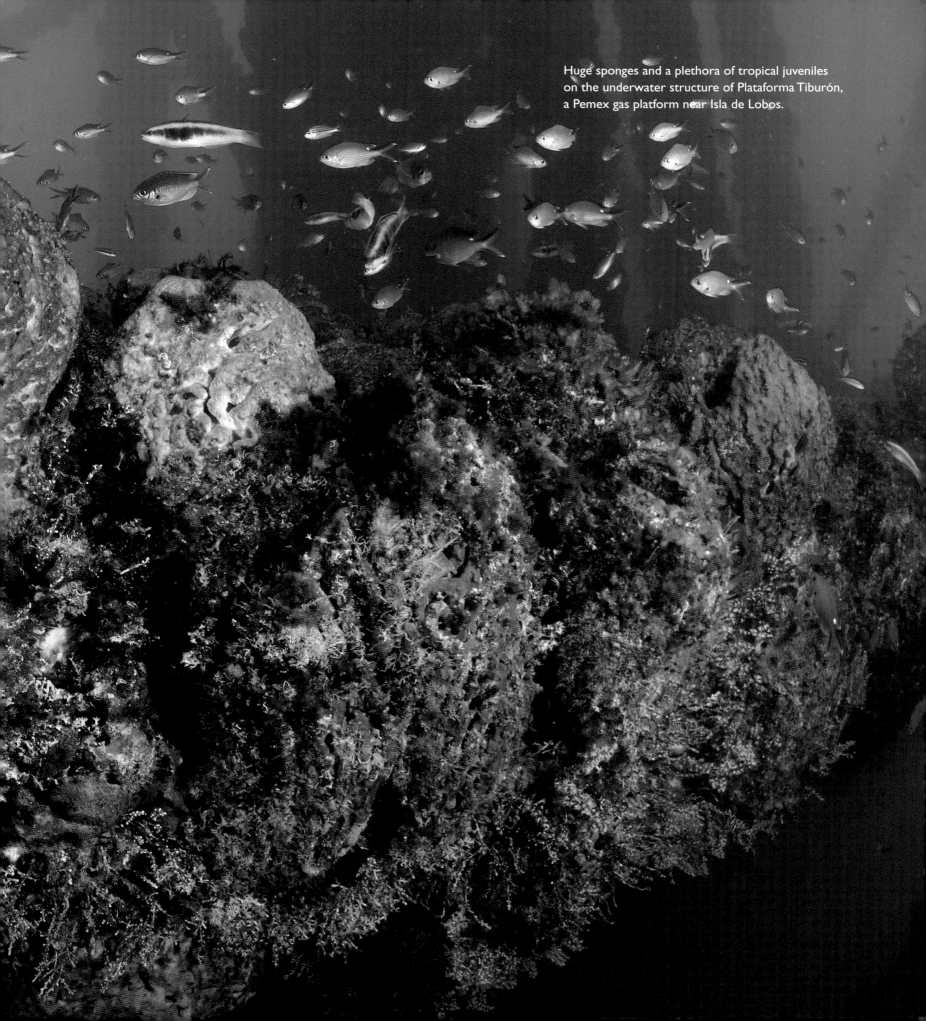

Huge sponges and a plethora of tropical juveniles on the underwater structure of Plataforma Tiburón, a Pemex gas platform near Isla de Lobos.

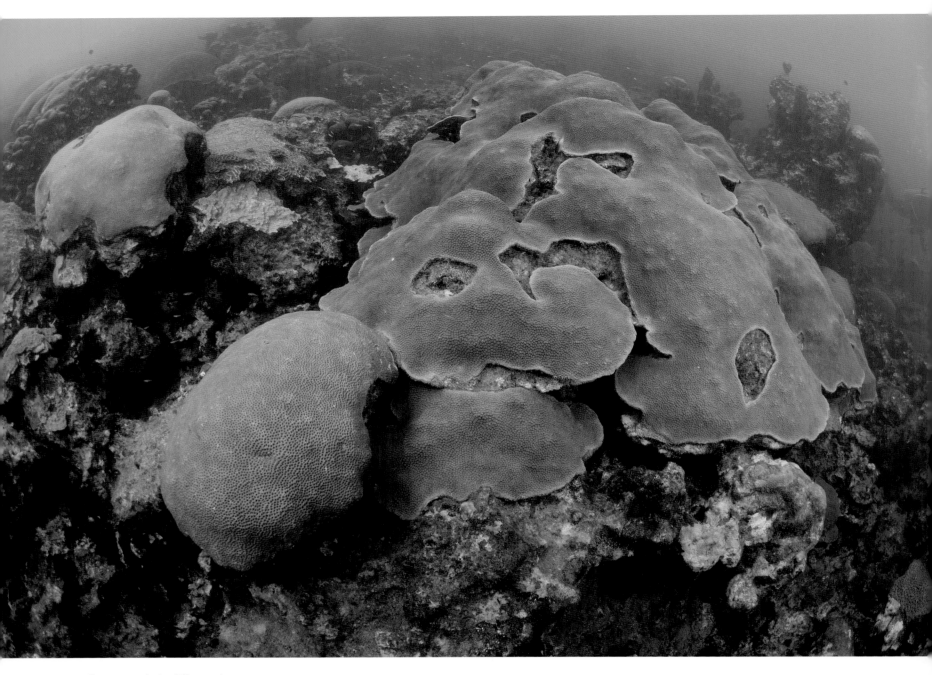

Stony corals in different hues and shapes drape the reef off Tuxpan, Veracruz.

One that got my attention early in the dive was like a natural sculpture, one created by two competing corals. A large mound of starlet coral complemented a major mat of boulder star coral that lay draped over the reeftop.

Alberto continued to accommodate me as he graciously posed to provide scale for a gorgeous formation of *Montastraea annularis*, or boulder star coral.

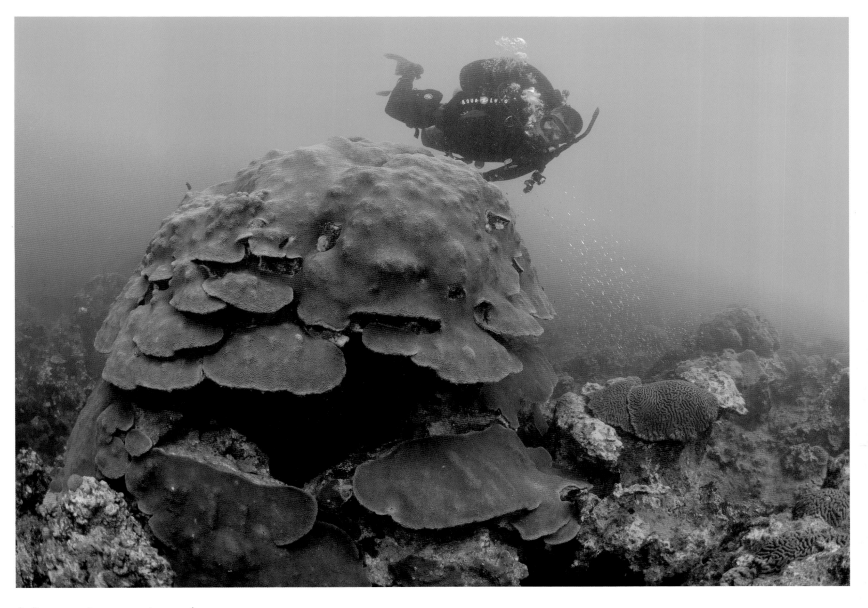

A diver examines a massive coral formation off Tuxpan, Veracruz.

Veracruz Reefs

The city of Veracruz is home to the oldest, largest, and most historic port in Mexico. Founded by Hernán Cortés in 1519, Veracruz is one of the oldest Spanish settlements in the Americas and was the first in Mexico.

Today the port is critical to shipping, commerce, and the overall economy in Mexico. Culturally, Veracruz has a mix of Spanish, Caribbean, Cuban, African, and pre-Columbian influences. The Olmecs, Huastecs, and Totonacs populated this region years before Cortés arrived, and the city and surrounding area are rich in

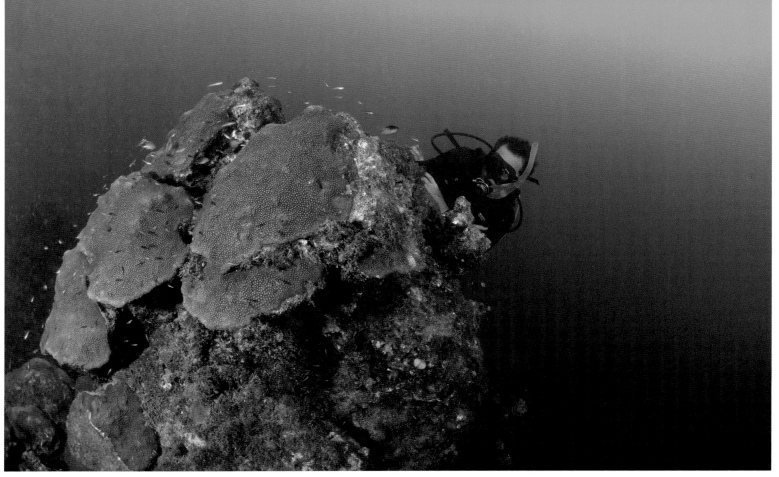

Fran Espresate observes a busy damselfish at
Anegada de Afuera.

Anja Corona Bähre approaches a massive
brain coral formation at Anegada de Afuera.

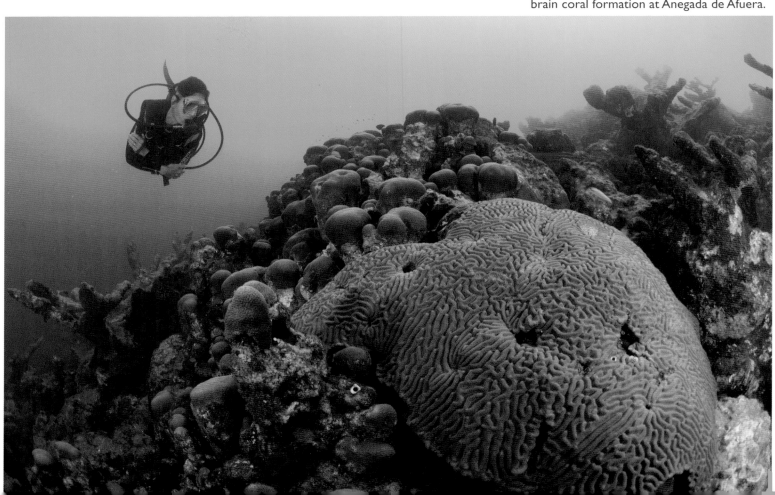

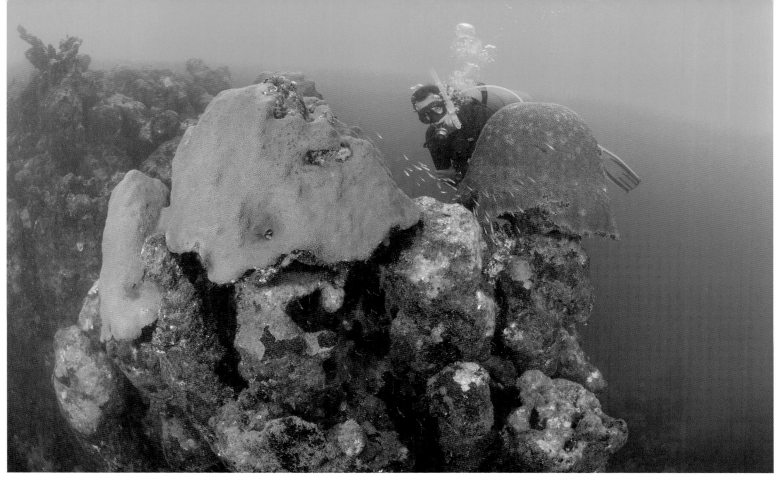

Fran Espresate is enchanted by a school of purple wrasse on the coral reef at Anegada de Afuera.

The Spanish hogfish, a member of the wrasse family, has a distinctive, lavender-colored upper body.

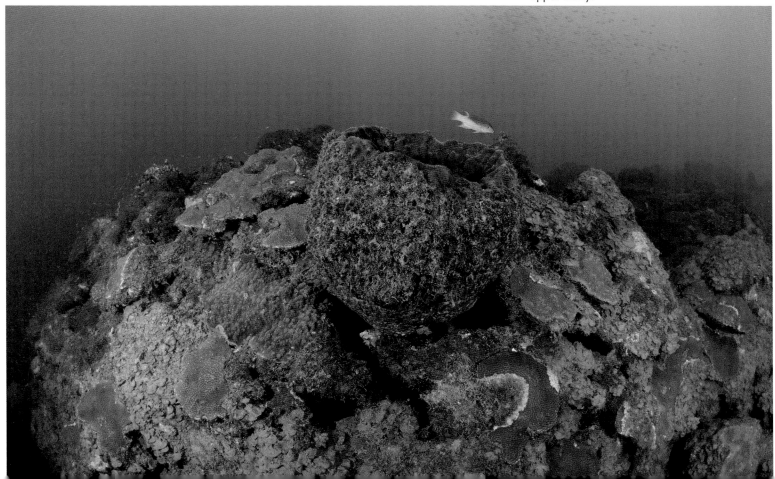

pre-Hispanic archaeology and ruins. Two of the more famous ancient sites are Quiahuiztlan and Cempoala. Both were originally inhabited by the Totonacs. Veracruz is heralded not only for the history and culture it offers but also the unique and tasty cuisine, such as the Veracruz-style seafood dishes characterized by herbs and spices such as marjoram, bay laurel, saffron, and cilantro. Peanuts also add to the uniqueness of Veracruz food preparations and are regularly added to meat, fish, and vegetable dishes. Also deserving mention is the fascinating music of Veracruz. The traditional music known as Son Jarocho has African and Caribbean influences and is popular throughout Mexico. Ritchie Valens's famous song "La Bamba" had its roots in the Son Jarocho style. Veracruz is the second-largest coffee producer in Mexico and a mecca for caffeine lovers who find the espresso-like coffee known as *lechero* to be heavenly. Coffeehouses in Veracruz are popular meeting places for the locals, and the custom is to click your cup with a spoon to request a refill. What Veracruz isn't so well known for is the two hundred square miles of colorful coral reefs in the adjacent Gulf waters.

There are seventeen major reefs off the coast of Veracruz. Eleven are located off Antón Lizaro, fourteen miles south of Veracruz, and the rest of the reefs are minutes by boat from the busy industrial port of Veracruz.

The reef system possesses a mix of low islands surrounded by coral reefs and platform reefs that rise from depths of up to 120 feet. Veracruz reefs have been affected by human activities since the sixteenth century. Natural stresses include winter cold fronts and turbidity from the runoff of the muddy Río Jamapa, which especially affects the inshore coral reefs. Unfortunately, coastal development and unchecked fishing harvests have taken their toll. The good news is that Veracruz reefs have been protected since August 24, 1992, when Pres. Carlos Salinas de Gortari declared the reef area a national marine park. No corals or mollusks can be taken there, and many types of fishing are restricted. Stabilization and recovery have been occurring at a glacial pace at best, but some positive signs are emerging.

As I swam through a maze of magnificent coral reefs at Anegada de Afuera, I was thrilled to find a small, very young but sturdy stand of golden healthy-looking elkhorn coral. This species, *Acropora palmata*, is severely threatened throughout the Caribbean, so finding a young, resilient stand so close to Veracruz added to my encouragement. The Afuera Reef is thirteen miles from Veracruz and much less affected by the river outflows than the inner reefs. Tropical-clear waters wash through the reefs, and the structure of this outer reef has gorgeous mounds of brain coral, knobby star corals, and boulder star corals in striking colors and shapes that range from inverted

cones to convex, galeated forms. Perhaps one of the most impressive presentations of stony coral life I encountered at Afuera was an arrangement of symmetrical brain, boulder star, and numerous cactus corals. The colorful formation was dotted by numerous bright-yellow boring sponges. Not far away I noticed several purple creole wrasse and damselfish swimming above a great star coral formation festooned with colorful branching sponges.

Fran Espresate, owner of Mundo Submarino in Veracruz, was my experienced guide to the Veracruz reefs. He quickly motioned me to another healthy great star coral (*Montastraea cavernosa*) formation guarded by bicolor damsels, brown chromis, and juvenile wrasses. Anja, Fran's wife and an equally talented diver, posed for perspective behind a massive set of symmetrical brain coral, *Diplora strigosa*, complemented by several morphs of boulder star coral. Next, Fran waved me over to an exquisite formation where a school of juvenile wrasses hovered between a virescent stand of symmetrical brain coral and a lavender boulder star coral. A mosaic of purple, red, and orange encrusting corals and sponges adorned the coral head's surface. Turning away to yet another resplendent coral head, I captured a Spanish hogfish lit up with both vibrant color and an air of suspicion as it cruised above a brilliant magenta barrel sponge the size of a fifty-gallon drum.

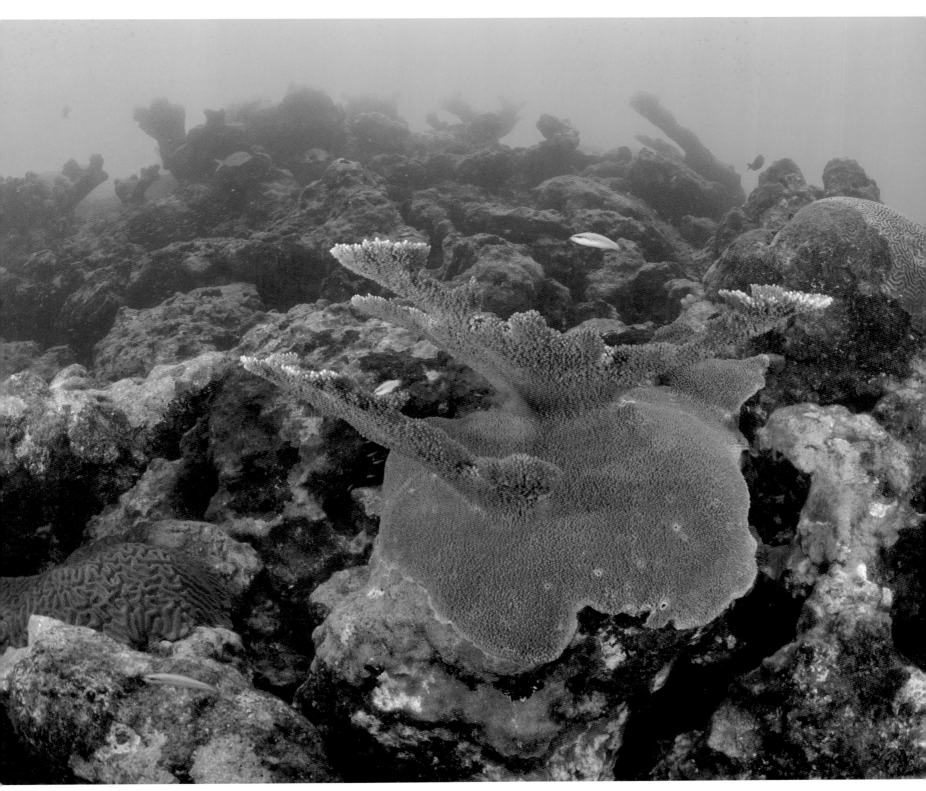

Elkhorn coral shows signs of making a comeback at the Anegada de Adentro reef.

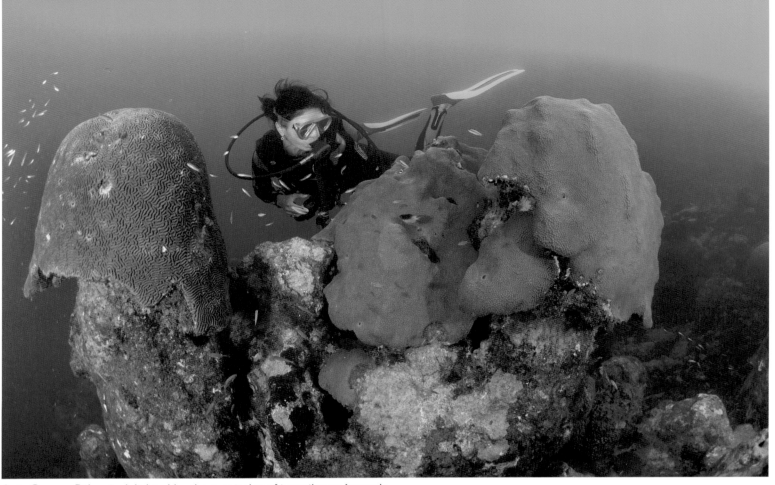

Anja Corona Bähre is delighted by the tropical reef juveniles at Anegada de Afuera.

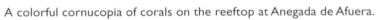
A colorful cornucopia of corals on the reeftop at Anegada de Afuera.

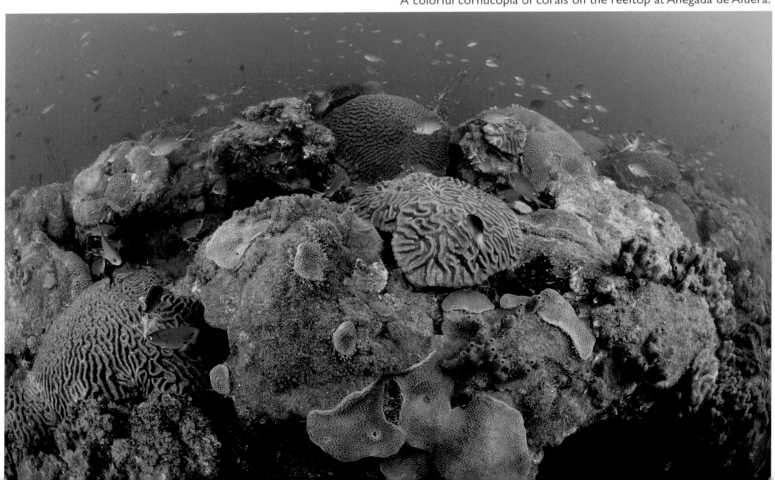

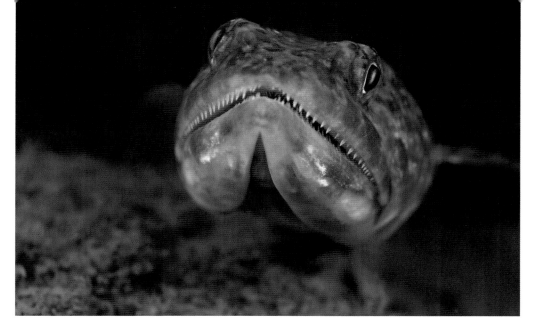

The following day I found myself swimming through a meadow of brown sea whips at an inner reef less than five miles from Veracruz. The visibility is reduced near the coastline, so I changed lenses and moved in closer to capture images of a sand diver lizardfish in an arched stance showing off its razor-sharp chompers, as well as a portrait of a mottled, spotted scorpionfish. Scorpionfish are champs at camouflage yet are seen everywhere on Isla Verde Reef, five miles off Veracruz in the Veracruz reef system. Very large, sinister-looking green moray eels were poking their heads out of the many cracks and crevices in the reef. For novice divers, morays always make for good drama, but in actuality they are mostly nonaggressive and even shy. A couple of miles farther away, at Anegada de Adentro, I photographed a tiny masked goby barely two inches long atop a brain coral head, and I later spotted one of its more skittish near look-alikes, a rosy blenny. With my eyes focused on the tiny members of the reef community, I spotted a seaweed blenny that seemed

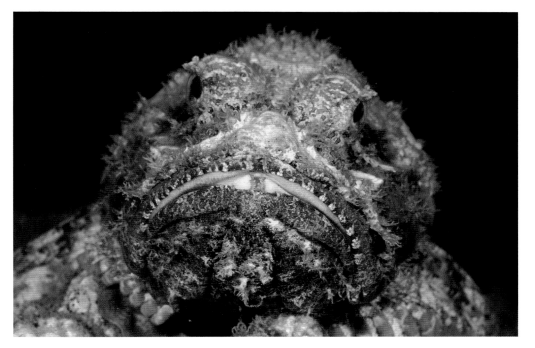

(Top) A lizardfish at Anegada de Adentro showing the set of teeth that identify it as a carnivore.

(Middle) Face to face with a spotted scorpionfish at Anegada de Adentro.

(Bottom) Green moray eels have poor eyesight but compensate with an acute sense of smell.

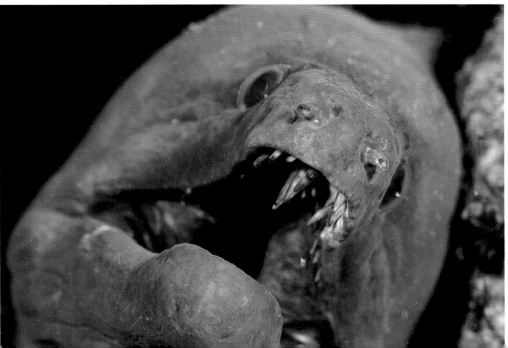

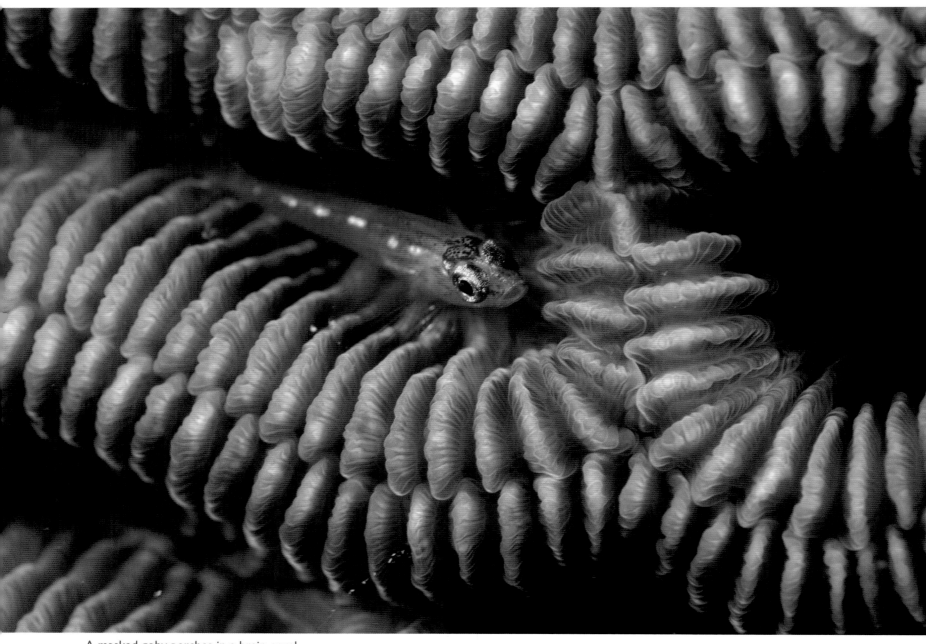

A masked goby perches in a brain coral
recess at Anegada de Adentro.

➤➤A rosy blenny resting on the reef at
Anegada de Adentro.

➤A seaweed blenny perched on coral at
Anegada de Adentro.

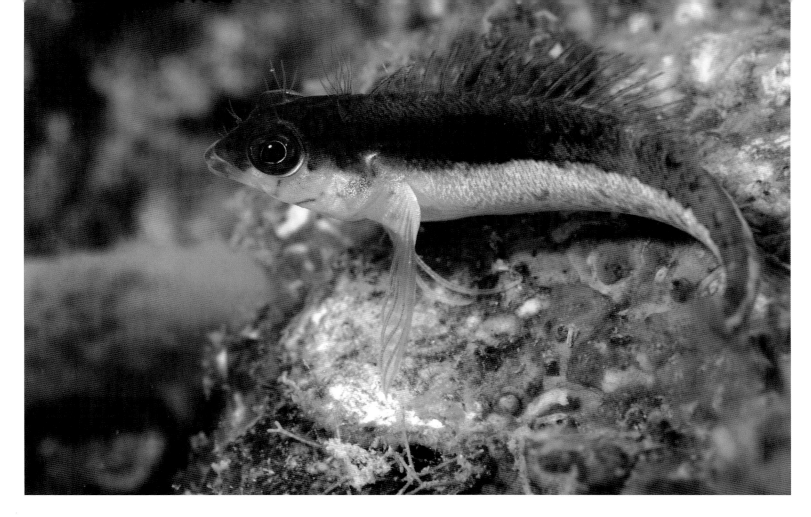
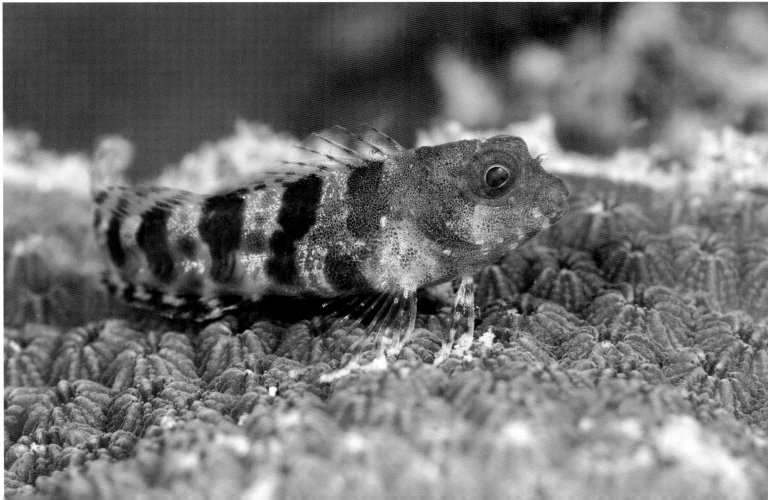

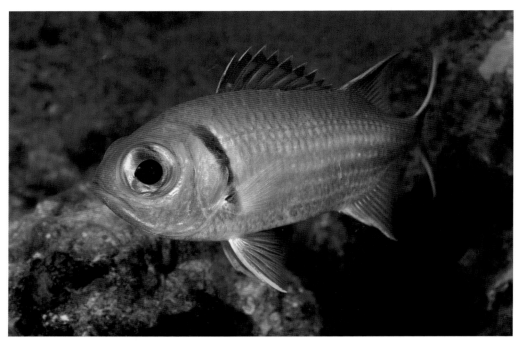

A blackbar soldierfish, having come out from hiding, makes a dash across the reef at Anegada de Adentro.

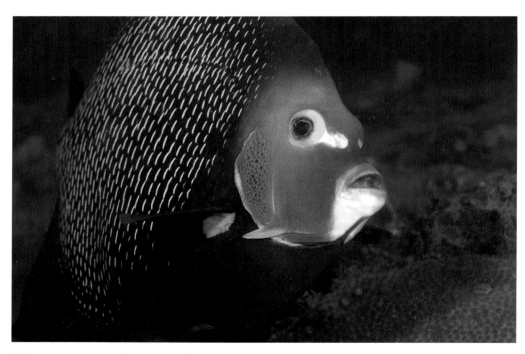

Often seen in pairs, French angelfish are a common sight at Anegada de Adentro.

unusually confident on top of a star coral head. Close by I noticed one of the more reticent residents of the reef, a big-eyed blackbar soldierfish. These guys are somewhat curious and sometimes seem confused as they swim upside down outside openings in the reef. A curious and delightful French angelfish swooshed by my camera then turned and stopped as though posing to have its picture taken, so I did just that.

The Campeche Bank

The Campeche Bank is an extension of the limestone plateau off the Yucatán Peninsula in the southeastern Gulf of Mexico. It hosts a succession of five coral reef complexes. They are, from north to south: Arrecife Alacranes (also known as Alacrán Reef, or Scorpion Reef), Cayo Arenas, Cayo Nuevo, Triángulos, and Cayo Arcas. The bank extends for 650 kilometers (about 400 miles) along the northern and western Yucatán coastline, and, aside from Cayo Nuevo, all of the reef groups have at least one island that supports vegetation. Cayo Nuevo has only a barren sand cay. The four main islands that do have substantial vegetation have lighthouse keepers on rotations, so there are no permanent inhabitants on the Campeche Bank islands nor are there any resorts for divers or visitors. A scant number of scuba divers or snorkelers have ever seen the reefs at Campeche Bank. At the time of

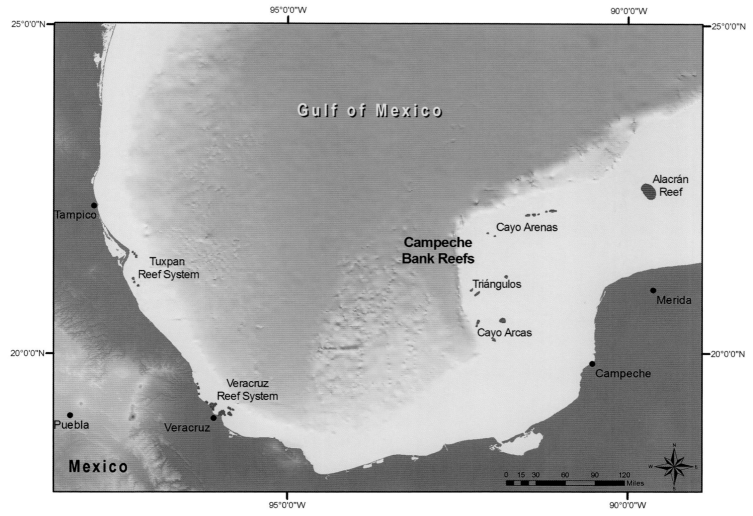

Map 1. Major coral reefs in Mexican Gulf waters

this writing, there are no commercial dive operators offering trips to the Campeche Bank, but divers can visit the islands and dive the reefs by private boat. Visitors to Alacrán Reef need a national park permit.

Alacrán Reef

My first impressions of Alacrán Reef began with listening to blaring salsa music while bouncing and slicing through four-foot seas on an open, twenty-seven-foot center-console boat for three and a half hours. Continuous sea spray along with saltwater splashes every five seconds or so kept us all on our toes as the two 150-hp outboard engines propelled seven of us from the port of Progreso to Isla Pérez, the main island of the Alacrán complex. Upon our arrival eighty-two nautical miles later, we were greeted by three hundred thousand sooty terns, tens of thousands of brown noddies, and multitudes of magnificent frigatebirds. We soon met the lighthouse keeper and several Mexican navy personnel outside of their modest station on the island, a short walk from our wooden cabins on the beach. Isla Pérez has few creature comforts, yet its simplistic, near-natural state in form, scent, and sound makes it unusually therapeutic for the body and soul.

Discovered by Gonzalo Guerrero y Jerónimo de Aguilar in 1511, Alacrán Reef is not only the largest coral reef complex on Campeche Bank but also the largest in the entire Gulf of Mexico. This platform reef, a biodiversity wonderland, is oval in shape (eight by fifteen miles) and atoll-like, having a lagoon filled with a succession of patch reefs. The five islands in the

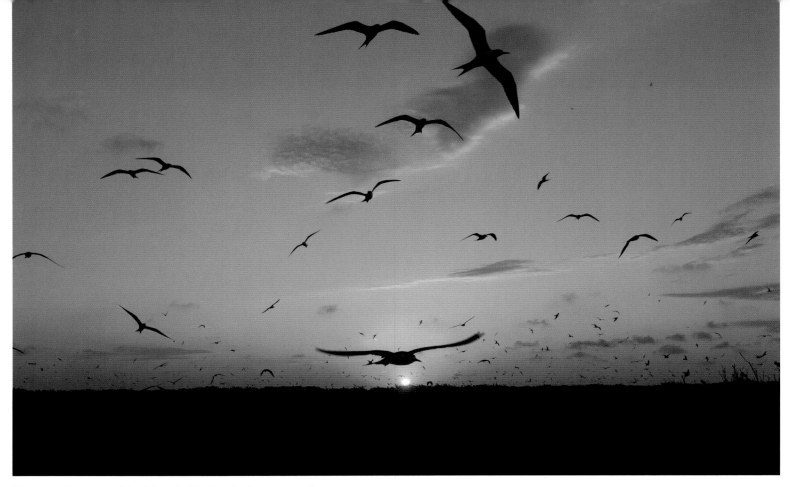
The morning sky at Isla Pérez is filled with thousands of sooty terns.

Isla Pérez has that "lost in paradise" look and feel.

complex are Isla Pérez; Isla Chica to the east; Isla Pajaros, also to the east; Isla Desertora (also known as Isla Muertos), to the northwest; and Isla Desterrada, to the far northwest. Masked boobies populate Isla Pajaros and Isla Desertora, and it is noteworthy that the latter island also has several red-footed booby nests. The "ring of reefs" of Alacrán is so colossal it can be seen from the International Space Station. Fortunately, the Alacrán Reefs have been protected by the Parque Nacional Arrecife Alacranes since 1994.

➤A panorama of Isla Desertora, which is populated only by birds.

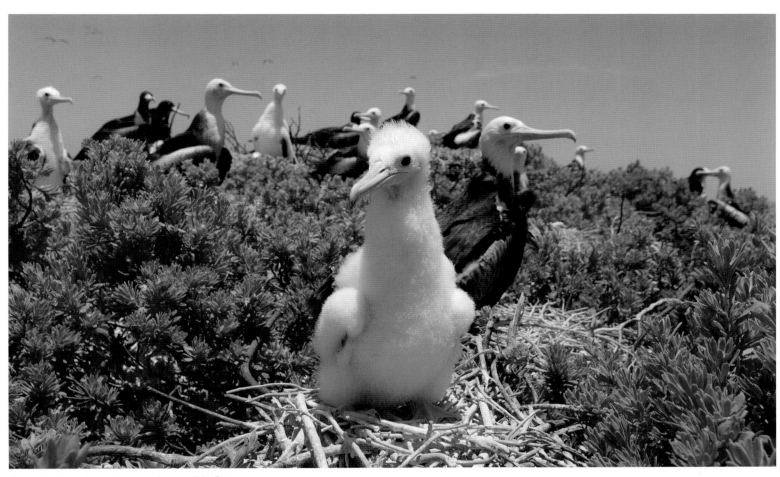

A masked booby chick nesting on Isla Pajaros.

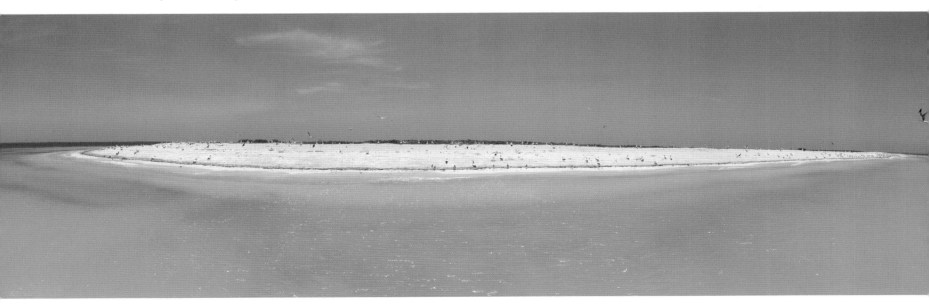

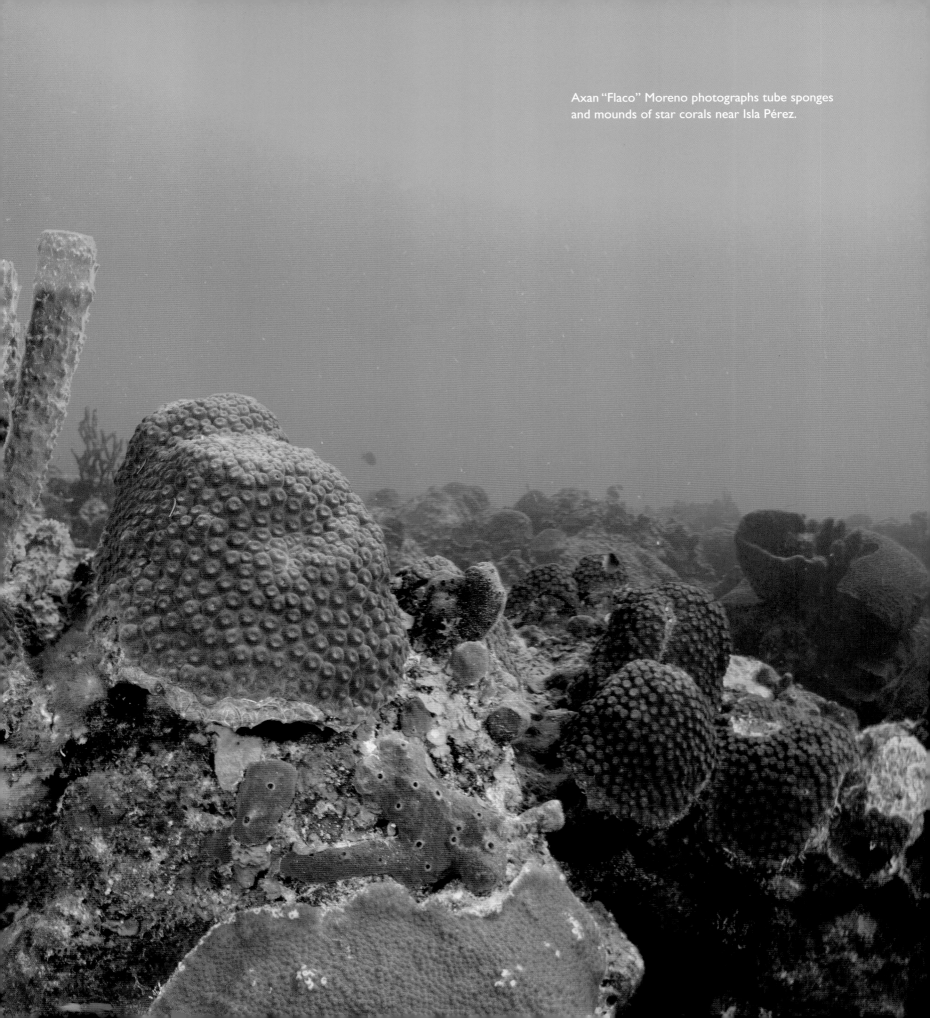

Axan "Flaco" Moreno photographs tube sponges and mounds of star corals near Isla Pérez.

The Alacrán Coral Reefs

The reefs of the Alacrán complex have mountainous formations of star and brain corals, and, unlike the northern Gulf and more like the Caribbean, the reefs are replete with soft corals, sea fans, sea rods, and sea whips. There are forty-two coral species in all. Included are impressive formations of Graham's sheet coral, *Agaricia grahamae*. The shallow reef between Islas Pajaros and Pérez is incredibly thick, with an enormous profusion of soft gorgonians and purple fans. An area inside the platform barrier on the eastern, windward side has a field of elkhorn corals that runs intermittently for a stretch of ten miles. Green turtles roam freely in the grassy lagoon areas, and numerous juvenile lemon sharks and stingrays swim along the island shorelines in only a few inches of water. The Alacrán coral reefs are far enough offshore to suffer no or at least negligible impact from coastal development, but many of the corals were affected by the same white band disease that caused havoc throughout the Caribbean, most significantly in the late 1970s and early 1980s. More than 150 species of Caribbean tropical fishes inhabit Alacrán Reefs, and standouts like Nassau grouper and sought-after hogfish swim through the reefs protected by its sanctuary status.

Numerous ships met their fate on "Scorpion Reef." The wreck of the *Caribbean*, a massive rusted steel skeleton in less than fifteen feet of water, is now an unintended sanctuary of its own for sergeant majors and blue tang.

Holbox

Holbox (pronounced HOLE-bosh) is a tiny fishing village on a small sand barrier island of the same name. Only a mile wide and seven miles long, Isla Holbox is located near the northeastern tip of the Yucatán Peninsula, just west of Cabo Catoche. The closest airport choices are Cancún and Mérida. Cancún is two to three and a half hours by taxi or bus from Holbox; add another hour for Mérida. Accessed by a short ferry ride from the mainland town of Chiquila, this colorful and laid-back destination is a pleasant reflection of the Mexico of the past. Holbox is in fact the antithesis of Cancún. It's a favorite with tourists from Europe, South America, and the United States who are looking

Nature forms artistic displays underwater, such as this Graham's sheet coral.

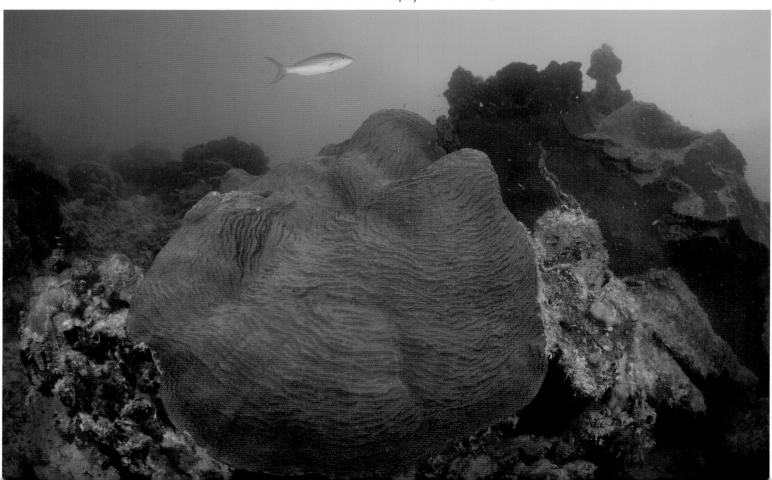

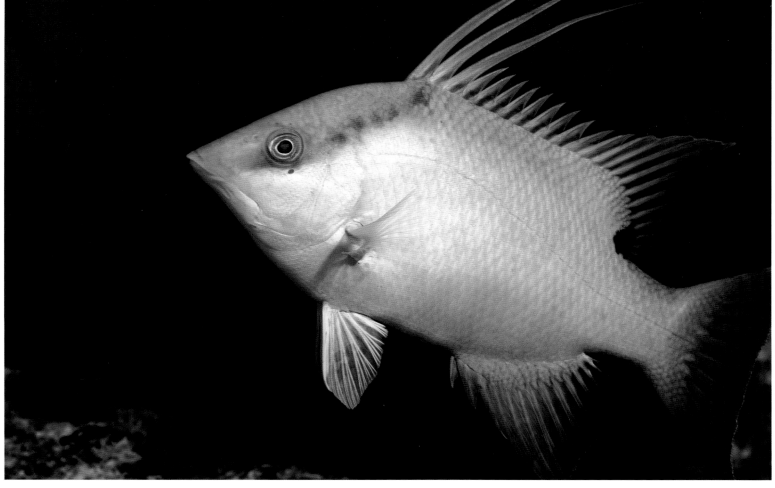

A hogfish swaggers across Alacrán Reef, which is fully protected by sanctuary status.

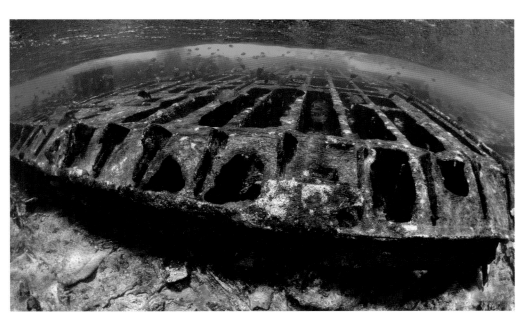

The wreck of the Caribbean forms a protected area for hordes of sergeant majors and other tropical fishes.

for something more genuine, without glitter, and off the beaten path. A short walk from the town square will take you to the small number of hotels and cabanas along the beach. And with cars being scarce on the island, you can enjoy a self-guided tour of the mangroves and stunning coves or a trip down the beach to check out the resident colony of pink flamingos via the local vehicles of choice—bicycle or golf cart.

The most impressive magic at Holbox lies beneath the surface of its emerald, nutrient-rich waters. Every year from June through September dozens upon dozens of whale

sharks, *Rhincodon typus*, congregate east-southeast of Cabo Catoche, near the confluence of the Gulf of Mexico and the Caribbean Sea. There are very few places in the world where whale shark experiences are practically guaranteed, and Holbox is one of them. The *tiburones ballena* congregate to feed on the bounty of the protein-rich waters, which includes spawn from the little tunny (a small species of tuna). There is no mistaking these gentle, slow-moving filter feeders. Their massive bodies, mostly gray with white undersides and up to forty feet in length, are distinctly marked with a checkerboard pattern of pale yellow spots and stripes. Their spot patterns, as unique as fingerprints, are used as identifiers by researchers. Two tiny dark eyes are located toward the front of the shark's wide, flat head. Whale sharks filter feed by ramming their way through the water or by remaining stationary and gulping the plankton-filled seawater. Little is known about the aggregations or the migration of

The sea grass and mangrove areas around Isla Holbox and other Mexican nearshore islands serve as important nurseries for the ocean.

these, the largest fish in the ocean, but it is known they are ovoviviparous (giving birth to live young, about two feet long) and have a lifespan of about seventy years. Swimming with one of these behemoths is an unforgettable experience. My wife and I spent the better part of five days in the water mesmerized by one whale shark after

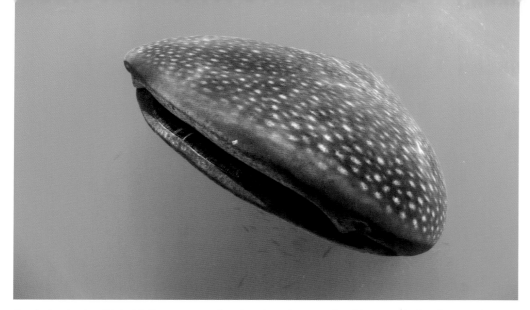

A whale shark off Isla Holbox approaches head on, its mouth wide open in feeding mode.

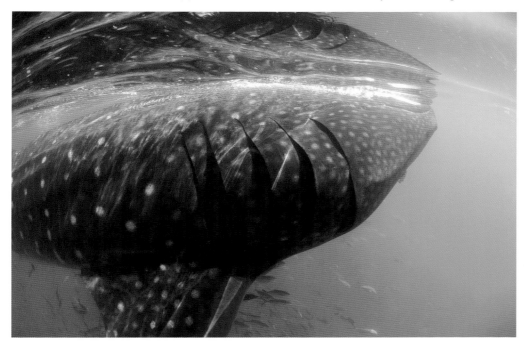

The whale shark has massive gill slits along its sides.

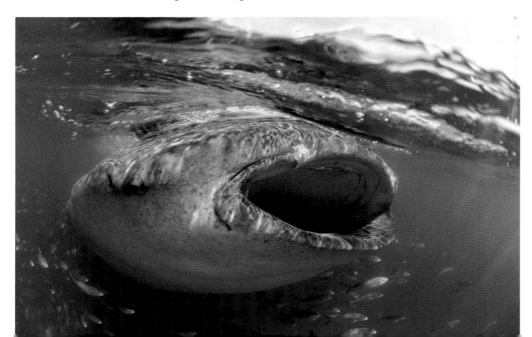

another. As if that wasn't enough, along the way we also encountered a massive school of golden cownose rays.

During the winter months of January to March, another ocean spectacle occurs near the same general area east of Cabo Catoche and north of Isla Mujeres. Atlantic sailfish, *Istiophorus albicans*, congregate in scores to feed on sardine baitballs in the sweet spot where the Gulf of Mexico meets the Caribbean Sea. I didn't think twice one early March morning as I grabbed my camera and jumped in the water with an excited group of spear-wielding game fish. To observe these agile, incredibly speedy animals repeatedly slap and immobilize their quick-moving prey was awe inspiring, and I found equally interesting the intersection of food webs. Like beads of mercury moving in liquid synchronization, the sardines herd together tightly, maintaining fluidity and motion. But their movements don't delay the sailfish from getting down to serious business—a rapid slap, stun, bite, and gulp action that leaves in the warm shallows plenty of sardine bits as tasty snacks for the hovering frigatebirds. The sailfish are precise, and their stalking appears almost effortless. As the predators close in, the sardines react by closing their silvery ranks to create an

Whale sharks congregate annually off Isla Holbox from June through August.

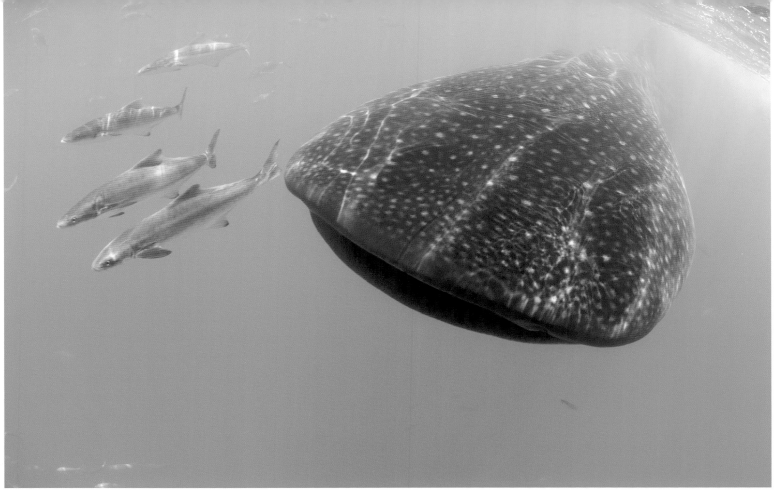

This approaching whale shark appears to be piloted by a school of cobia.

Christine Cancelmo swims behind a gigantic whale shark off Isla Holbox.

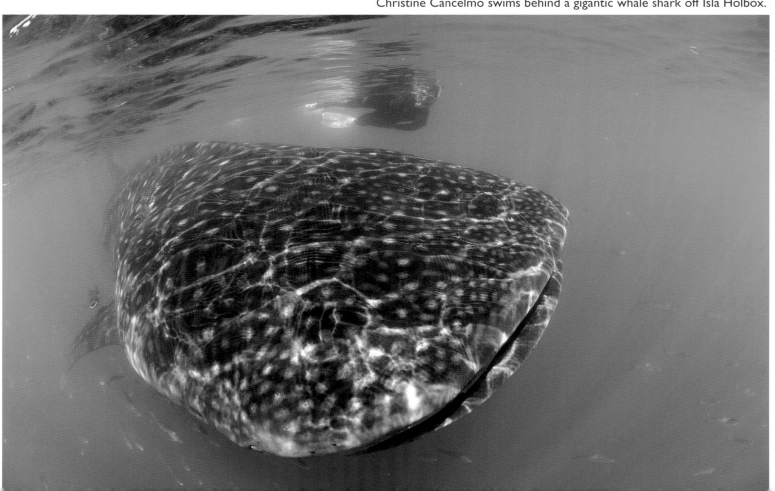

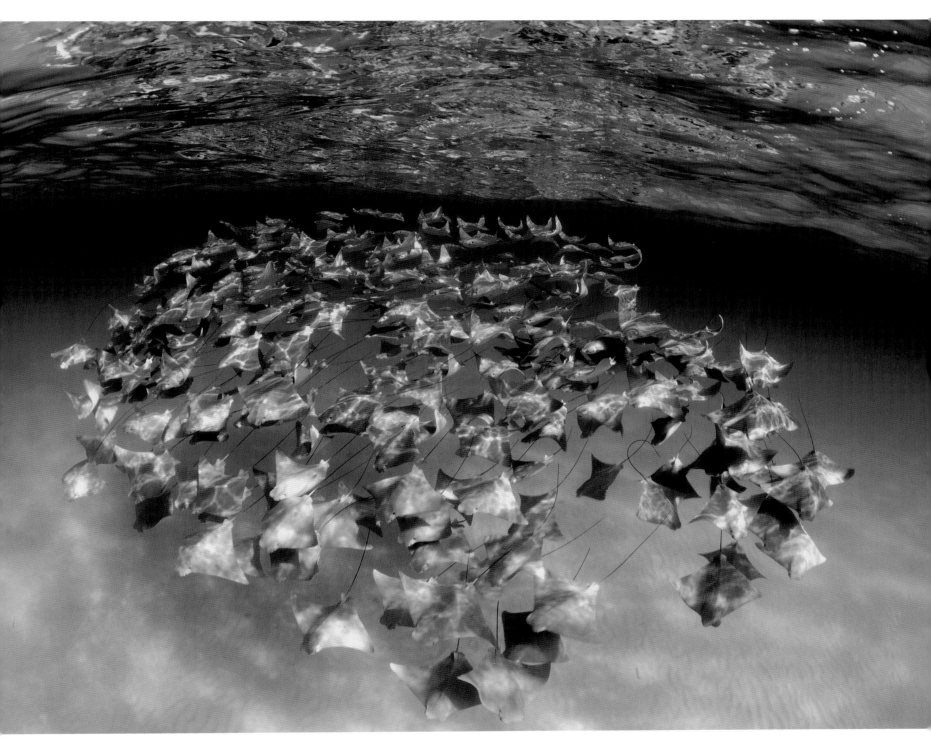

A school of golden cownose rays off Isla Holbox.

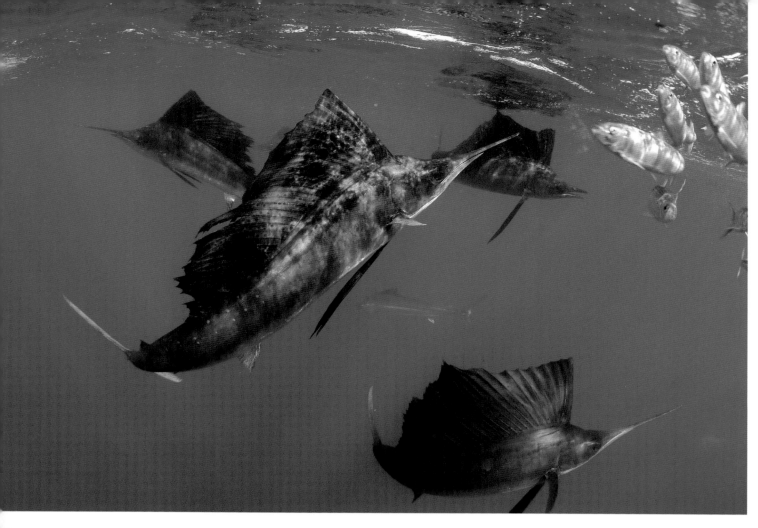

Atlantic sailfish are able to swim at speeds up to 68 miles per hour (110 kilometers per hour), making them the fastest fish in the ocean.

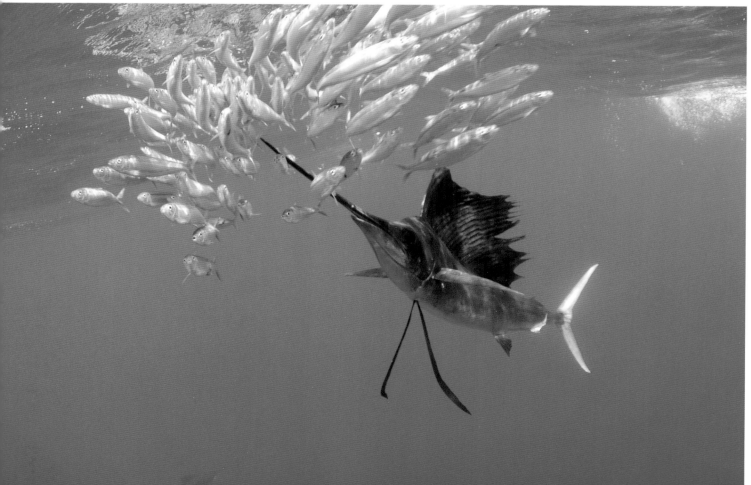

Sailfish with a sardine baitball fifteen miles north-northeast of Isla Mujeres.

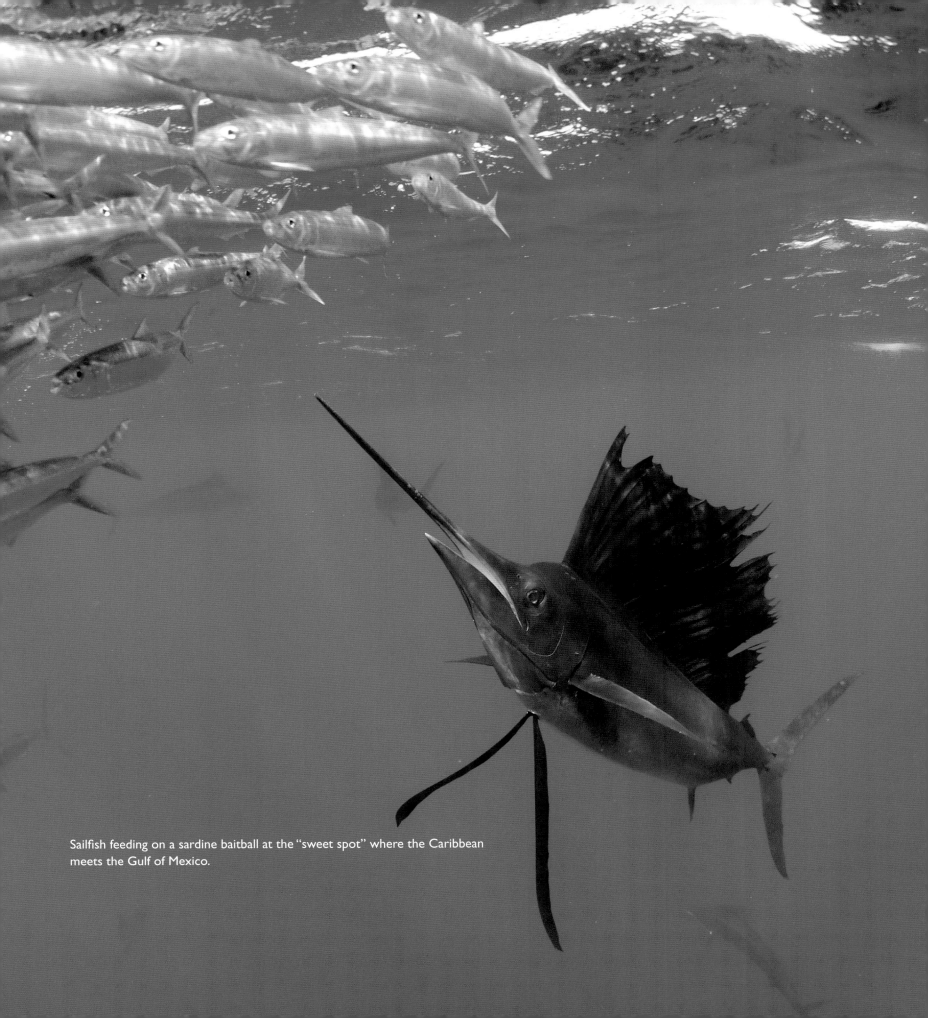

Sailfish feeding on a sardine baitball at the "sweet spot" where the Caribbean meets the Gulf of Mexico.

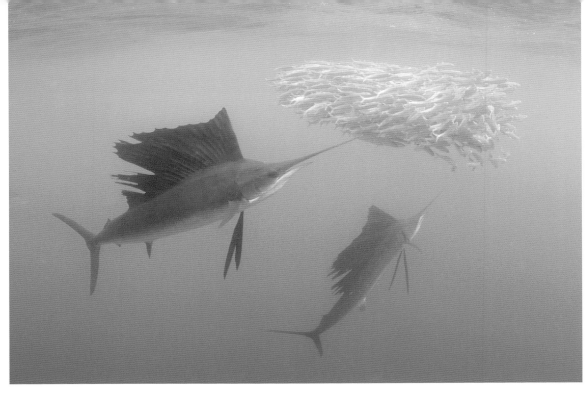

The concentration of sailfish in this area north of Isla Mujeres is highly unusual.

Sailfish use their bills to stun the sardines.

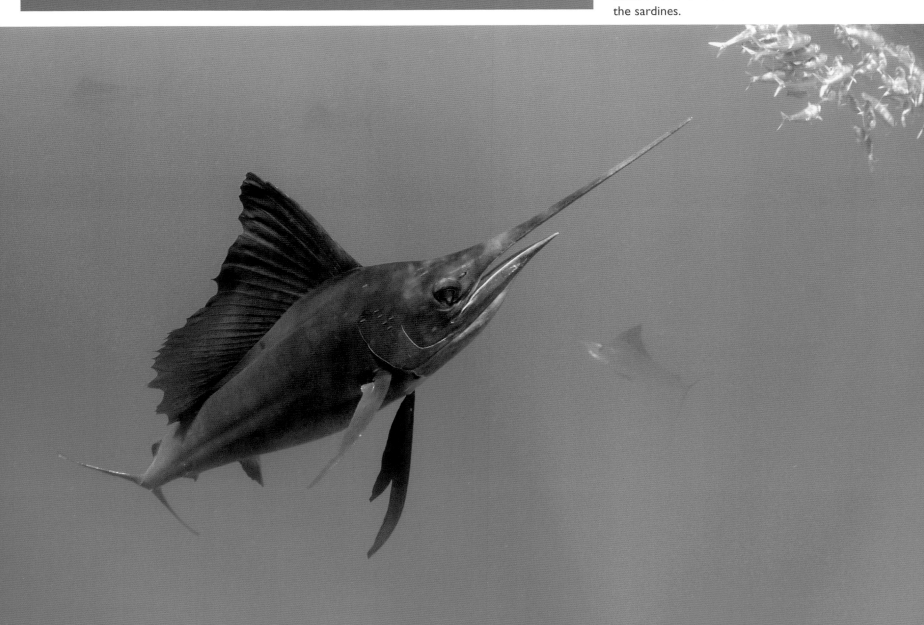

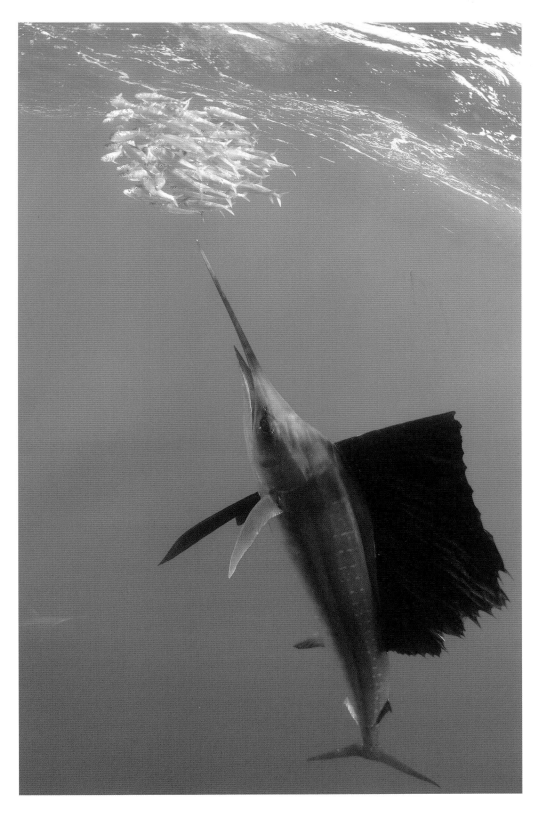

illusion of the small combating the large. This effect does not change the outcome. The motor drive of my camera whirred and I finned as fast as I could to record the onslaught. Faster than bluefin tuna, wahoo, or swordfish, sailfish are the fastest fish in the ocean and known to reach speeds of almost 70 miles per hour. That's twice the speed of a panicky barracuda and about fourteen times faster than Olympic medalist Mark Spitz in his prime. Sailfish in the Gulf of Mexico are typically six to seven feet long and weigh in at thirty to forty pounds. When threatened or excited, the fish hoists its dorsal fin, or "sail," to make itself look bigger and thus an even greater threat. The majestic sailfish and the remarkable experience of observing the predator-prey-scavenger interacting behaviors are etched in my mind forever.

Sailfish use their bills to stalk their prey.

2

The Northern Coast of Cuba from Cayo Levisa to Cabo San Antonio

Soon after making landfall at Cuba in October 1492, Christopher Columbus reported it to be "the most beautiful land that human eyes have ever seen." Within two decades, Cuba had been colonized and become a territory of Spain. The European colonials mixed with the indigenous peoples and later with African slaves and Asian immigrants, making Cuba a unique racial and cultural melting pot. Today the tasty food, legendary cocktails, rumba, jazz music, and eclectic art of Cuba all reflect the distinctiveness of the island nation. The country stands out educationally as well. It boasts a literacy rate of 99.8 percent, sharing the top ranks with Norway and Greenland, and also takes pride in having forty-seven universities. Perhaps most important, Cubans are known worldwide for their friendliness toward visitors from other countries.

Cuba lies at the juncture of three major bodies of water: the Atlantic Ocean, the Caribbean Sea, and the Gulf of Mexico. The land mass of Cuba, offset from the American continent and straddling the peninsulas of Yucatán and Florida, creates the influx and outflow of the fast-moving, warm, oceanic Loop Current, which sweeps through the Gulf of Mexico in a dynamic and variable fashion. Being 780 miles long and 190 miles across, Cuba is the largest island in the Caribbean, nearly the size of Pennsylvania. The closest neighbors include Haiti, Jamaica, the Bahamas, and Florida. Also, Cayman Brac is less than one hundred miles south of Cuba. With more than thirty-five hundred miles of coastline and more than four thousand cays and islets, Cuba boasts the largest wetlands area in the entire Caribbean. Also, like the United States and Mexico, Cuba has three major bodies of water touching its coastline, giving it an oceanic diversity unmatched by any other Caribbean island.

The eleven million inhabitants of Cuba enjoy a pleasantly mild,

subtropical climate. Refreshing ocean breezes from the trade winds are a big reason for the average annual temperature of 77 degrees Fahrenheit. There are two seasons in Cuba: the wet season (May to October) and the dry season (November through April).

Cuba has four mountain ranges. The highest elevation on this island is Pico Turquino, in the Sierra Maestra in the southeast. At 6,476 feet, it's a mere 200 feet lower than Mount Mitchell in North Carolina, the United States' highest peak east of the Mississippi River. The mountain range known as Sierra Cristal is also in the southeastern part of the country, while the Sierra Escambray is in the central region and the Sierra del Rosario is in the northwest.

Cuba's oldest city, Baracoa, is located near the far eastern tip of the island. It was founded by the Spanish conquistador Diego Velázquez de Cuéllar in 1511 and was the first capital of Cuba.

To most visitors today the entire country of Cuba appears frozen in time. Juxtaposed with striking visuals of stately colonial buildings, cobblestone plazas, and ornate cathedrals, the vintage American cars and trucks seen everywhere—1950s Cadillacs, Oldsmobiles, Chevys, Fords, and Studebakers—present a fascinating anachronism. Although a few are for show, the trucks and

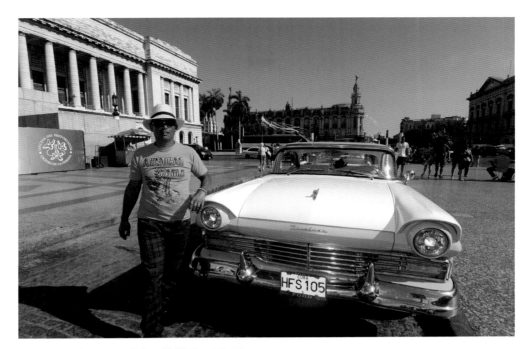

A man in Havana with his 1957 Ford Fairlane.

almost all of the cars are utilized daily. When replacement engine parts are needed, clever Cuban mechanics either make them or install an engine from another source, such as a Russian Lada or Moskvich.

The economic embargo that began in 1960 cloistered Cuba from Americans and American businesses for more than five decades, while the terrestrial and marine wildlife have thrived. Some biologists speculate the embargo has been a blessing of sorts for the marine wildlife by stifling coastal development and limiting farmers to organic fertilizers that are less harmful to coral reefs than the runoff from chemical fertilizers.

The Coral Reefs of Cuba

Cuba, sometimes called the "Pearl of the Antilles," has wonderful, healthy coral reefs along almost all of its 3,500 miles of shoreline. Some are virgin or nearly so, and American divers are astounded to learn there are live coral reefs with tropical fishes near the shores adjacent to Havana, Cuba's largest city. In addition to gorgeous gorgonians, sea whips, sea fans, and hard coral formations, Cuba has a kaleidoscope of tropical fishes that include blue tang, yellowtail snapper, and brown chromis, to name a colorful few. The northwestern coastline, which touches the Gulf of Mexico, stretches for more than

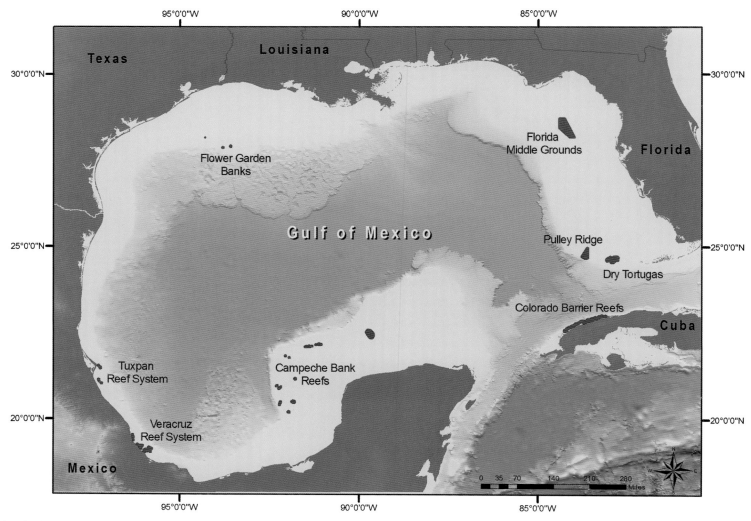

Map 2. Coral reefs in the Gulf of Mexico

150 miles, from Cabo San Antonio eastward to longitude 83° west (see Note below), due south of Dry Tortugas and approximately 40 miles west of Havana. Steady streams of crystal-clear oceanic waters bathe this mostly wild stretch of coral reef communities.

Of the fourteen provinces of Cuba, only two directly contact the Gulf of Mexico: Pinar del Río and Artemisa. Some biologists report that the waters off Cuba today look much like the Caribbean of fifty to one hundred years ago: again and again, the one word most often used to describe the northwestern coastline is *pristine*. But that is not to say Cuba is free of threats to these wonderful reefs. Illegal fishing, coral collection, and industrial outfalls continue to threaten marine environments there. Still, marine biologists say threats in Cuba are much milder than most other places in the Caribbean.

The reefs in the Havana area mentioned earlier are, of course, affected by their close proximity to the major port yet have been managing to survive.

NOTE: The International Hydrographic Organization defines the southeastern limit of the Gulf of Mexico as longitude 83° west. At longitude 24° 35° the boundary doglegs east to Rebecca Shoal, which lies at 82° 35° or forty kilometers (about twenty-five miles) east of Dry Tortugas. There it cuts north through to Florida Bay.

In numbers, Cuba has more than 40 of the 57 Caribbean species of corals and some 282 species of reef fishes. Besides the Nassau grouper, moray eel, and spiny lobster, Cuban coral reefs feature plentiful schools of French grunt, yellowtail snapper, and blue chromis. Eagle rays, whale sharks, and Caribbean reef sharks are some of the larger sensations of underwater Cuba.

Think what you like of the socialist dictator Fidel Castro, himself a scuba diver. There is no denying that his enthusiasm for the ocean and coral reefs, along with his collaborations with the famed Jacques Cousteau, inspired him to establish marine sanctuaries in Cuba as early as 1997. Yet, marine conservation began in Cuba even earlier than that. In the late 1970s queen conch was identified "at risk," and no-take laws were put in place in 1978. Laws to protect turtles were enacted in 1992. Lobster catches were regulated as early as 1998. Today nearly 25 percent of the marine life of Cuba is protected by law; in Los Jardines de la Reina, Cuba boasts the single largest marine reserve in the Caribbean.

Arrecifes de los Colorados

The 150-mile-long Archipiélago de los Colorados includes hundreds of small, sandy islets and

In Cuba it's common to buy your seafood dinner from the person who caught it.

mangrove-fringed barrier islands that stretch along the northwestern coast of Cuba in the Pinar del Río and Artemisa provinces. This string of barrier islands and reefs extends from the far western cape, Cabo San Antonio, where the Gulf of Mexico meets the Caribbean, to a point within 40 miles of Havana, on longitude 83° west. Scientists have only recently begun to study this mostly desolate expanse of marine habitats in the Gulf of Mexico.

Cayo Levisa is the only island of Los Colorados east of Cabo San Antonio that has overnight accommodations for divers and snorkelers. The small, rustic, but comfortable getaway resort with thirty bungalows lies on an unspoiled two-mile-long island accessed by a forty-five-minute ferry ride from Palma Rubia, 145 kilometers (90 miles) west of Havana. Palma Rubia is also about an hour's drive from Viñales, an enchanting town in a picturesque valley, part of the mountain range known as the Cordillera de Guaniquanico. In the surrounding rural areas life is simple, and very little has changed over the past century. Cayo Levisa is a well-off-the-beaten-track destination and boasts wonderful white beaches and dense red mangrove jungles on the leeward side. In the 1940s Ernest Hemingway often visited Cayo Levisa and had

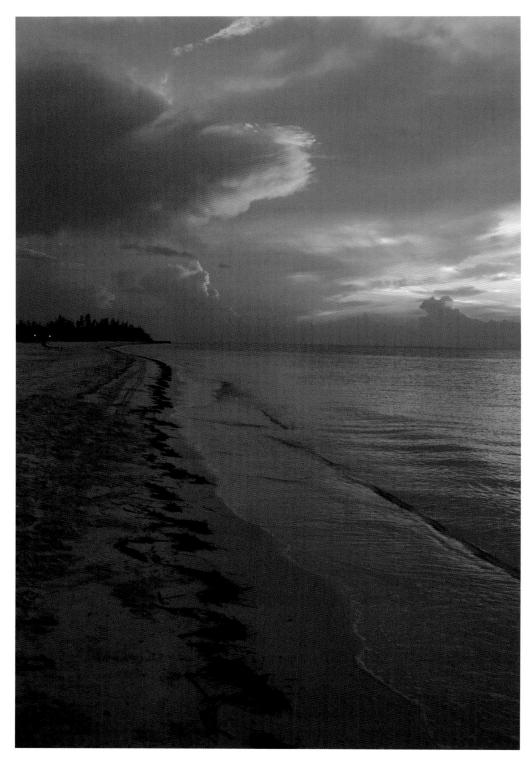

The Gulf coastline of Cuba and the coral reefs near Cayo Levisa are isolated and unaffected by development.

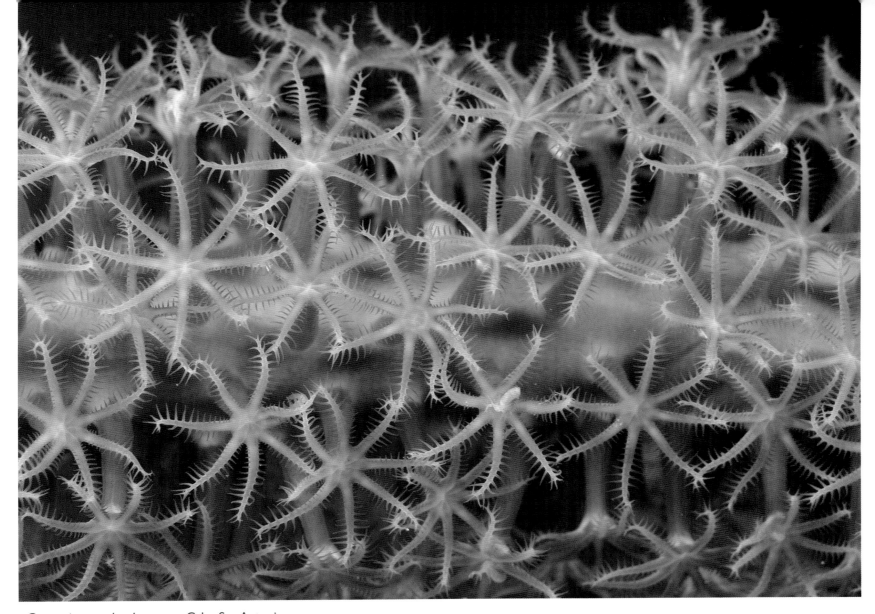

Gorgonian coral polyps, near Cabo San Antonio.

a fishing camp at Cayo Paraíso, another tiny island in the Los Colorados archipelago.

As I finned my way through the coral reefs in this far southern Gulf of Mexico locale, I was amazed by the thickness of the brown gorgonians and feathery sea whips swaying in the gentle currents and the number of unblemished purple sea fans lightly swaying with the currents while anchored to the coral ledges. These types of soft corals are totally absent from my "home" reefs more than a thousand miles to the north. But like the northern reefs, Cayo Levisa has massive star coral and symmetrical brain coral, *Diplora strigosa*, formations in every direction for as far as the eye can see. The most impressive corals at Cayo Levisa by far are the giant stands of golden-brown, branching elkhorn corals. The Los Colorados archipelago may have the healthiest population of elkhorn corals in the entire Gulf of Mexico and Caribbean. Nearly as impressive are its racks of yellow staghorn corals.

At Cayo Levisa, mounds of colorful sponges form gardens of

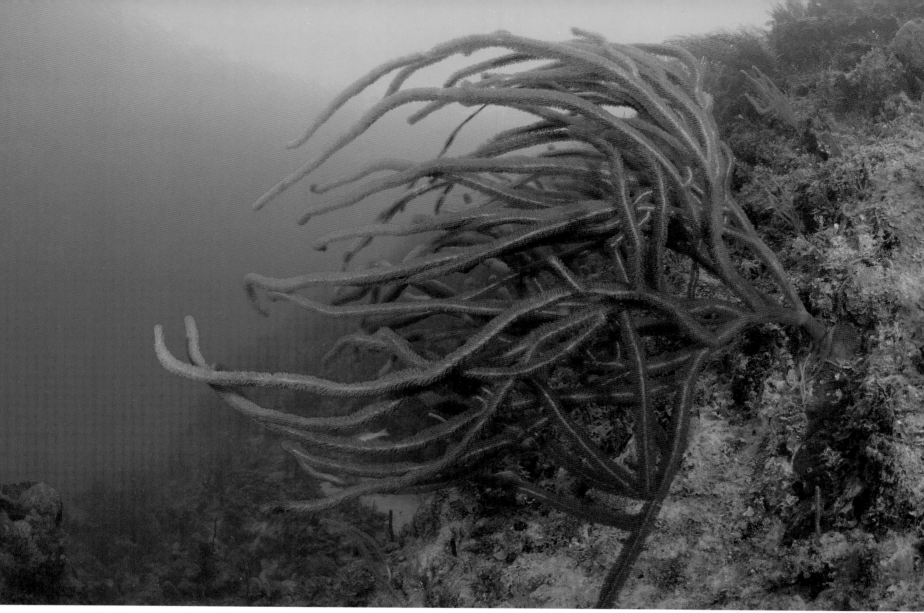

Off a Cayo Levisa drop-off, gorgonian whips sway in the currents and filter feed on plankton.

living animals that cannot move around but manage to fulfill their community service by filtering water and collecting bacteria for the colony to consume. The list of local tropical fish varieties may be one of the longest in the region. Divers and snorkelers will see stoplight parrotfish graze on algae, peer at longspine squirrelfish that lurk in the shadows of the reef, and experience face-to-face standoffs with curious but reticent graysbies. In sandy areas, one is likely to spot the unusual peacock flounder, a flat, bottom-dwelling fish so well camouflaged that only its reticulated eyeball gives it away. On my last dive at Cayo Levisa, at more than a hundred feet deep, my guide motioned me to a sandy area at a part of the reef. When I drew close, I recognized the huge, light-gray disk, only partially exposed in the sandy bottom, as a giant roughtail stingray, one of the largest rays in the Western Hemisphere—a spectacular way to end the dive!

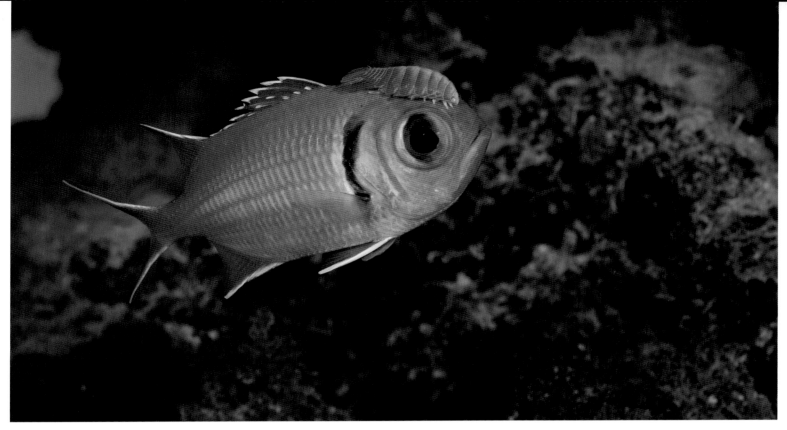

A blackbar soldierfish with a small parasitic isopod.

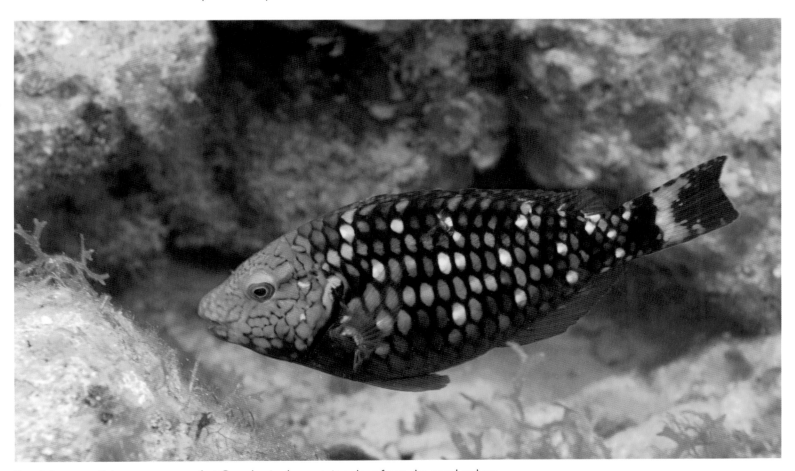

Stoplight parrotfish graze on a reef at Cayo Levisa by scraping algae from the coral polyps.

The longjaw squirrelfish commonly seen at Cayo Levisa is the largest in the squirrelfish family and has a distinctive yellow dorsal fin.

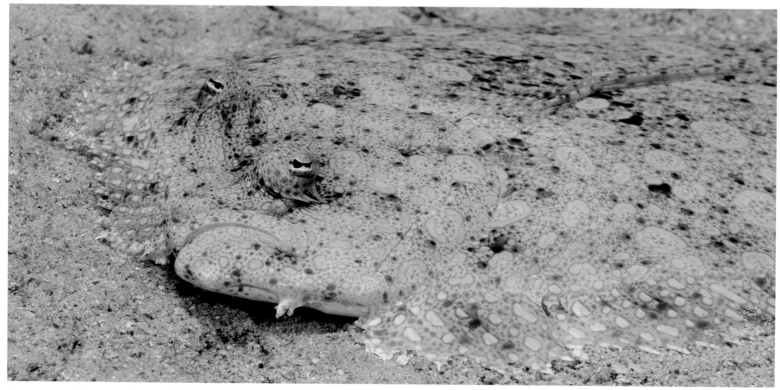

The low-profile peacock flounder has distinctive blue-ringed markings and an asymmetrical pair of eyes.

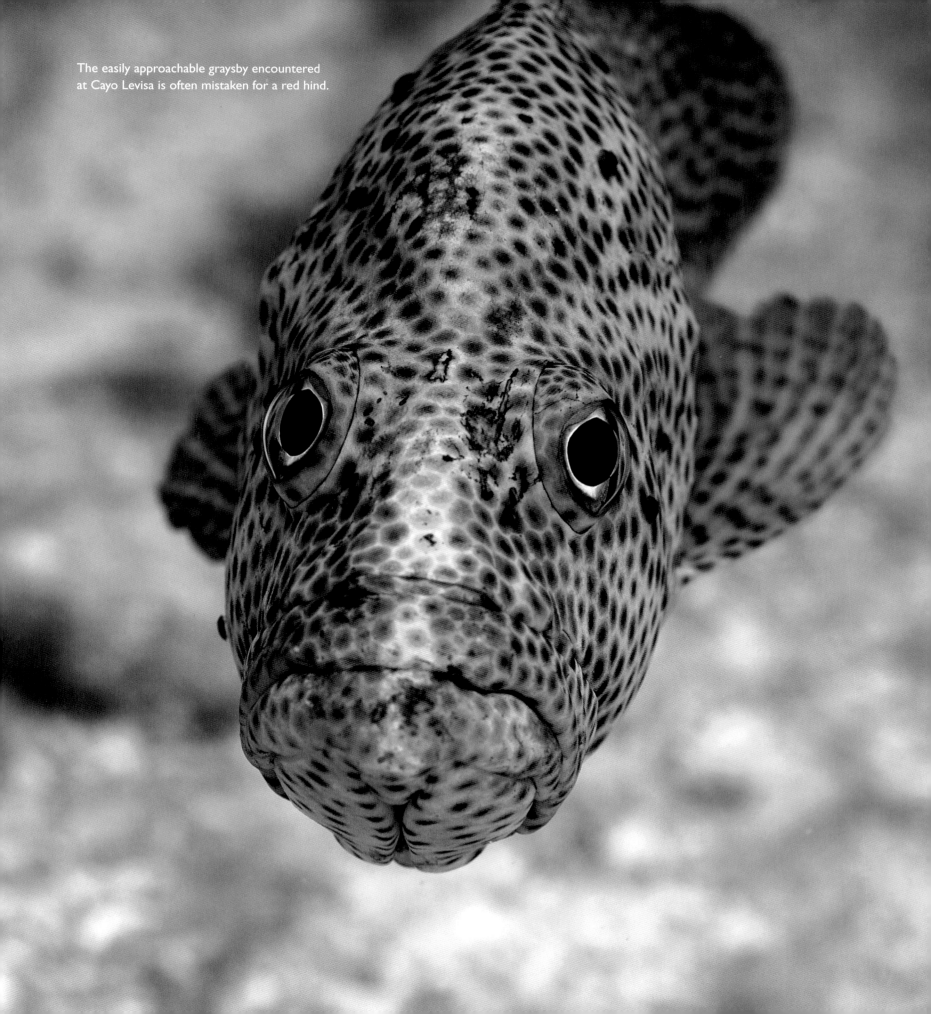

The easily approachable graysby encountered
at Cayo Levisa is often mistaken for a red hind.

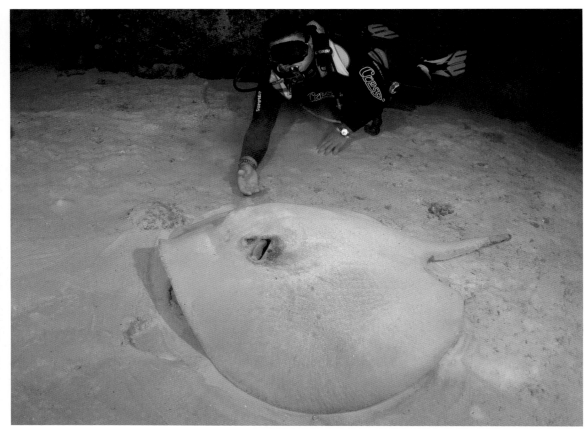

The roughtail stingray is known for its short, stubby tail.

Cabo San Antonio

The point of land near the historic Faro Roncali lighthouse (1849) on Cabo San Antonio marks the boundary between the Caribbean and the Gulf of Mexico. Cabo San Antonio is the cape at the western-most point of Cuba. The boundary between the two bodies of water runs southwest to Cayo Catoche at the eastern tip of the Yucatán Peninsula.

Cabo San Antonio, even today, is an extremely remote destination with limited accommodations for overnight stays. When I first visited Cuba in 2012, the closest diving operation at María la Gorda, was about forty kilometers (twenty-five miles) to the east by boat or as the crow flies. The forty-mile coastal drive between the two is on a rough road riddled with potholes and takes more than an hour.

Although Cabo San Antonio is remote and difficult to access, I was able to capture images of marine life just around the corner from Cabo San Antonio in a small body of water known as Bahía de Carrientes, by way of the María la Gorda dive boats. So, technically, my west-end images are from just outside the Gulf of Mexico.

The coral reefs between Cabo San Antonio and María la Gorda are among the healthiest, most diverse, and most colorful in all of Cuba. The elephant ear sponges there are the size of smart cars and look like porous orange blobs sitting on top of the reef. Giant purple sea fans, with their fine-mesh-patterned flattened branches, share dominance of the reefscape. Farther down the reef I spotted a giant barrel sponge with an invasive lionfish meandering up its side. Nearby, a photogenic congregation of bluestriped grunt under a coral ledge caught my attention. Back on the reef, I captured a resplendent and active queen angelfish blushing for a close-up. Creating camouflage against the backdrop of a reef with so many colors can be tough sometimes, even for a reef octopus that regularly blends into the reefscape for protection and to prey on unsuspecting crabs. A couple of little creatures that are tiny but don't go unnoticed are the lettuce sea slug and the sun anemone shrimp, which often hang out on the tentacles of pink-tipped anemones.

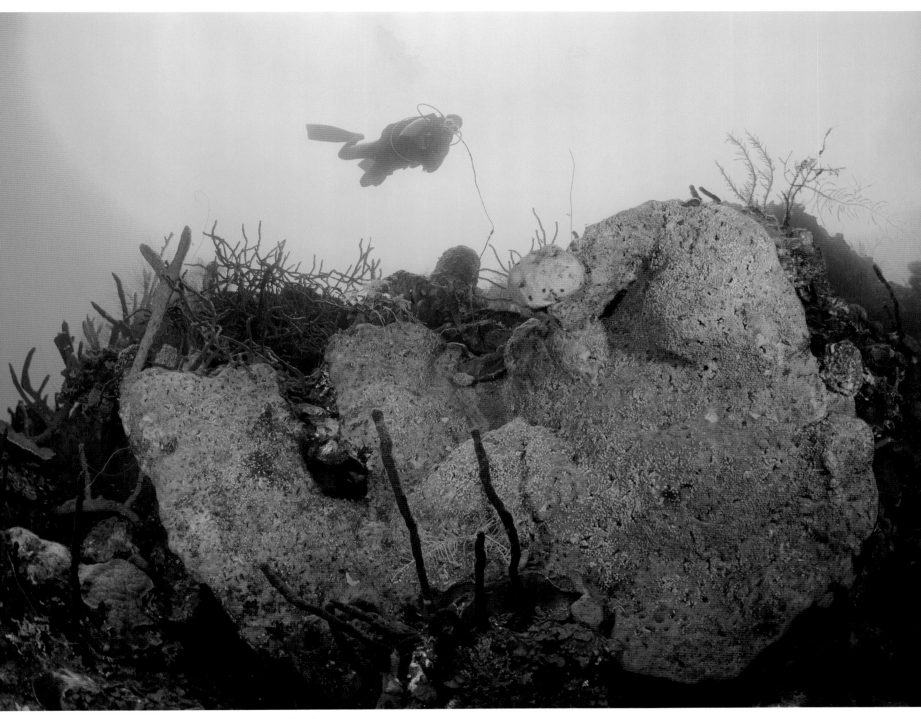

Orange elephant ear sponge near Cabo San Antonio.

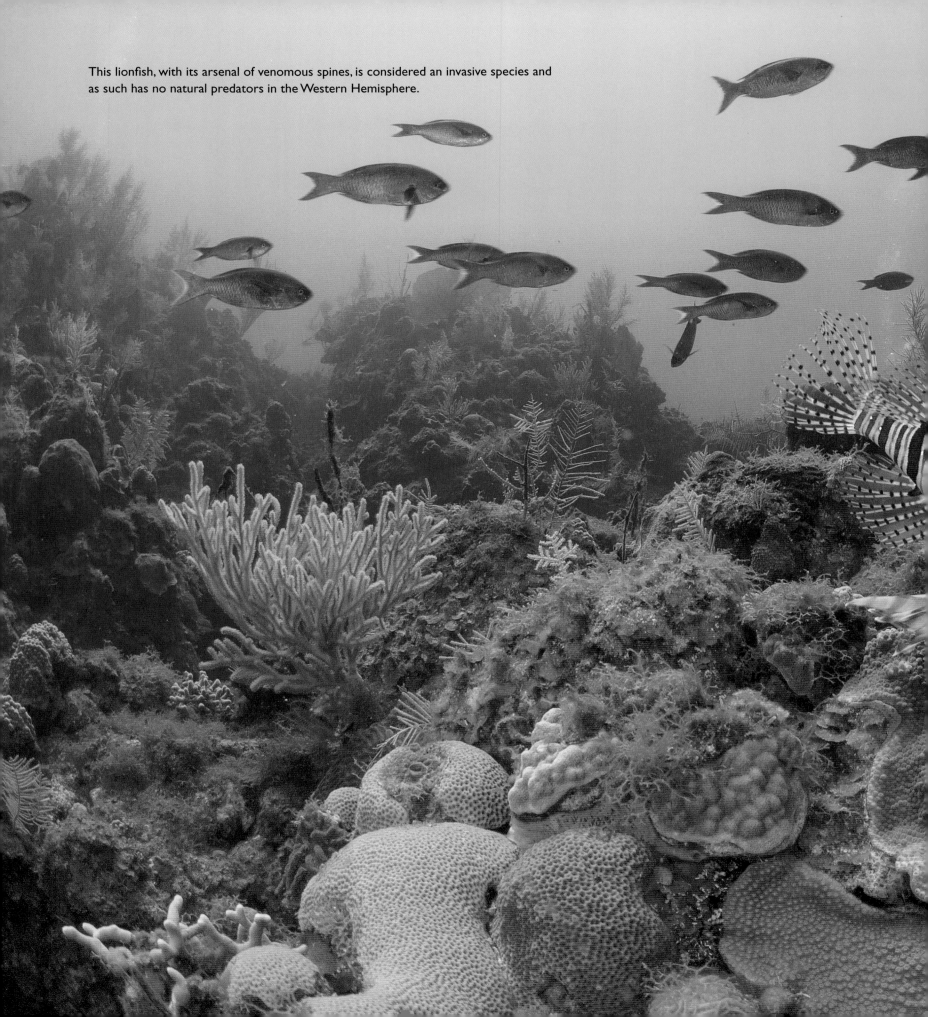

This lionfish, with its arsenal of venomous spines, is considered an invasive species and as such has no natural predators in the Western Hemisphere.

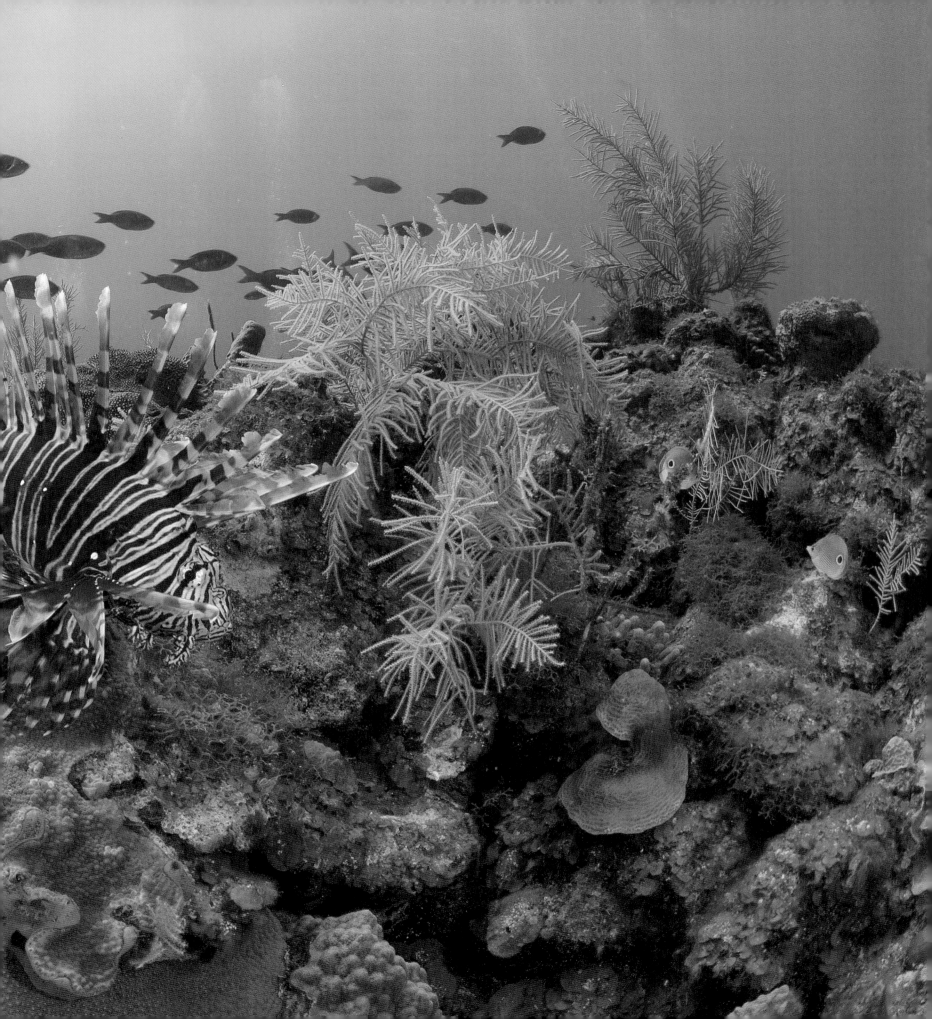

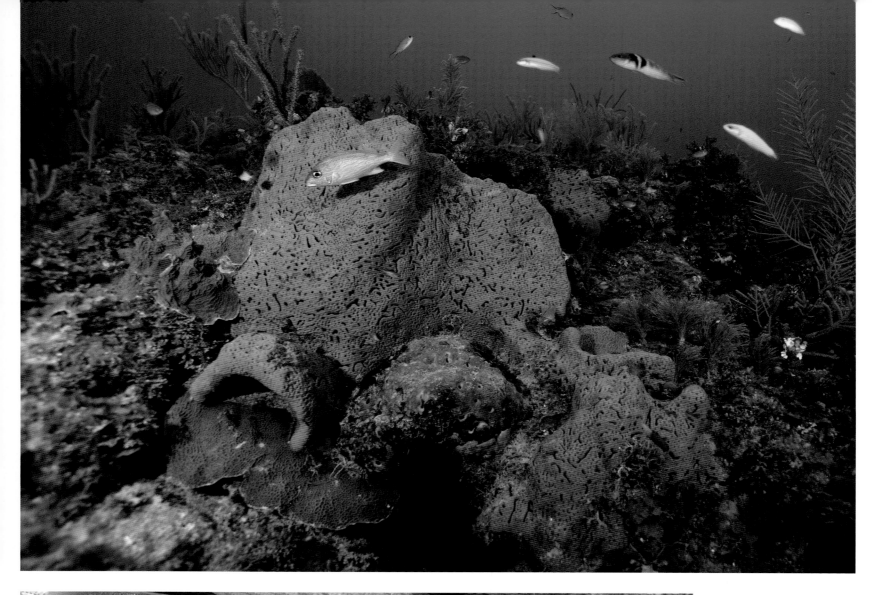

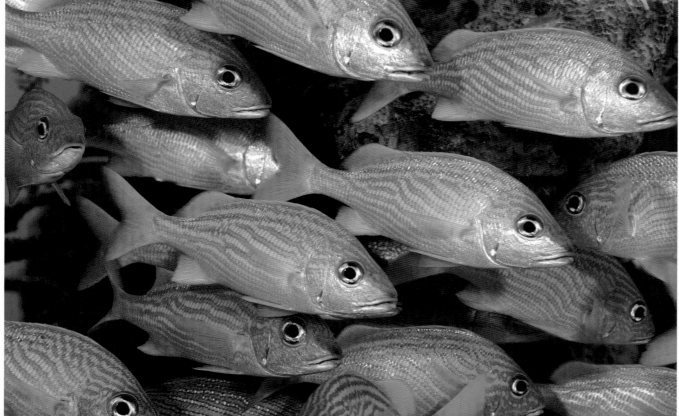

(above) An orange elephant ear sponge accentuates a thriving coral reef community at Cabo San Antonio.

Bluestriped grunt, like these near Cabo San Antonio, often congregate in schools and make unusual sounds by grinding their teeth.

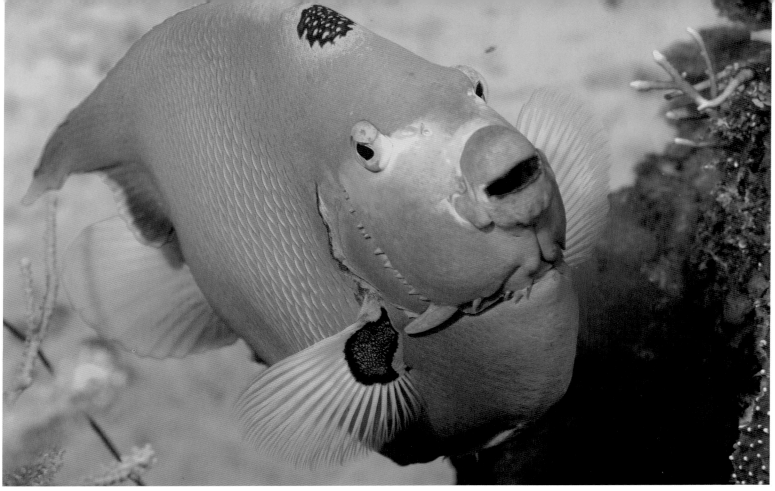

The magnificent and graceful queen angelfish, near
Cabo San Antonio.

A master of camouflage, the spotted scorpionfish, like this one near Cabo San
Antonio, has venomous dorsal spines but is not aggressive toward divers.

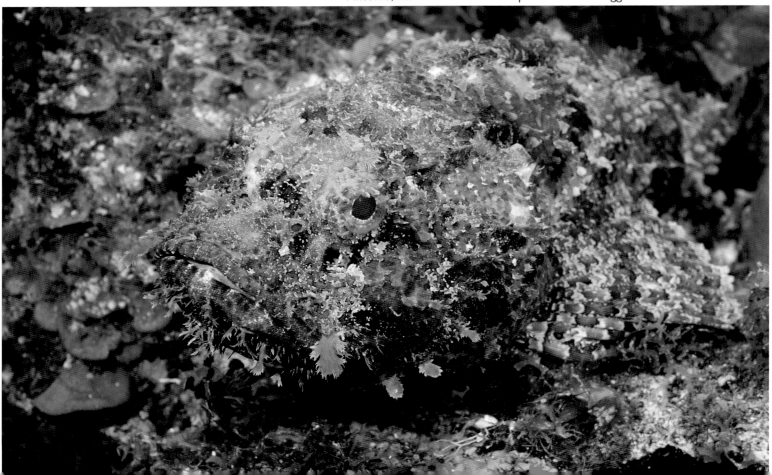

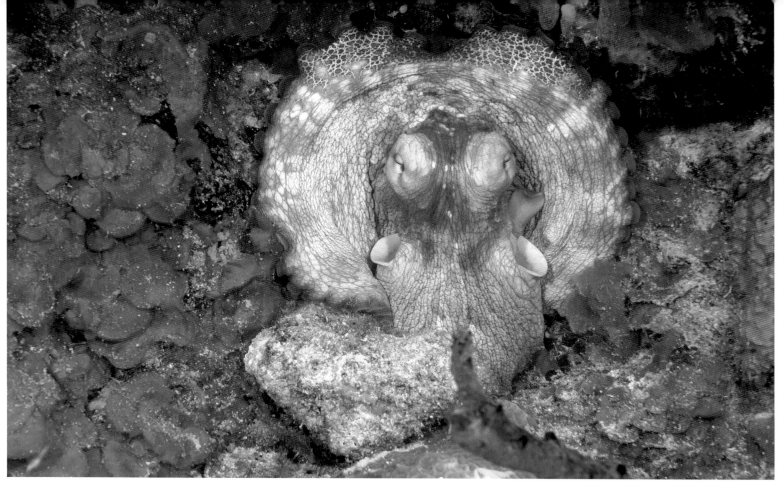

A Caribbean reef octopus, near Cabo San Antonio.

A tiny Caribbean lettuce sea slug, near Cabo San Antonio.

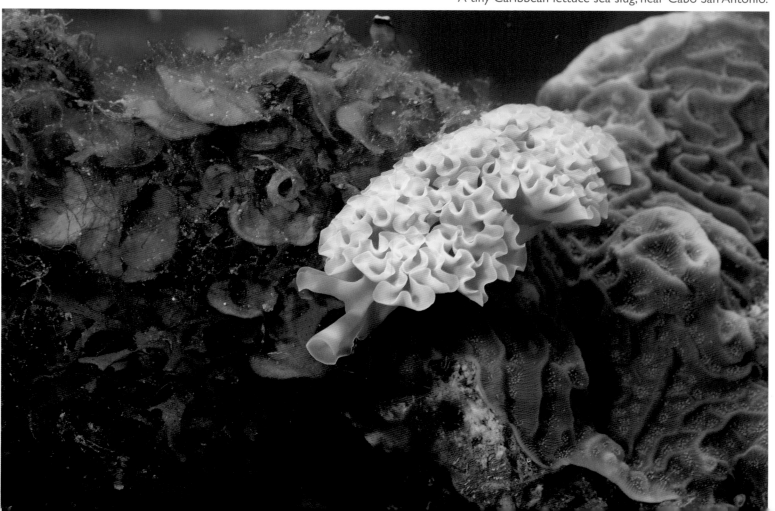

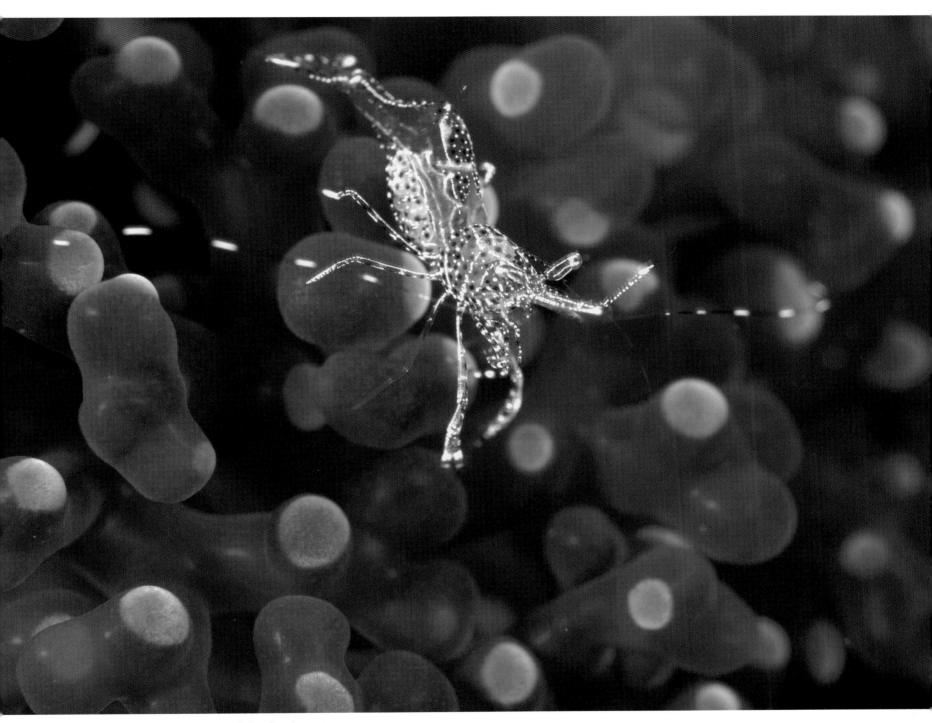

A sun anemone shrimp, near Cabo San Antonio.

3

The Dry Tortugas of Florida

The Loop Current

The Loop Current in the Gulf of Mexico is a warm ocean current beginning near the tip of the Yucatán Peninsula, where it is fed by Caribbean currents. From there, it flows north in a "bulge" toward Mobile, Alabama, a distance of roughly four hundred miles, before turning east toward Tampa and then southward to the southernmost tip of Florida. Eddies from this warm oceanic river separate and spin away from the main loop on a random basis into the northwestern Gulf.

Dry Tortugas National Park, a group of several low-lying keys, spreads into the Gulf of Mexico near where the Loop Current merges with the Florida Straits, part of the Atlantic Ocean. The centerpiece of this cluster of coral islands, Garden Key, lies seventy miles west of Key West. It hosts a historic lighthouse and Fort Jefferson (named after the third president of the United States), a massive relic of nineteenth-century US naval defense.

Dry Tortugas History

The famed Spanish explorer Ponce de León anchored off this group of limestone keys in June 1513. He named them Las Tortugas for the abundance of sea turtles, which included greens, hawksbills, loggerheads, and leatherbacks—four of the seven species in the world. The "Dry" descriptor was added later as a warning to mariners that these islands have no fresh water.

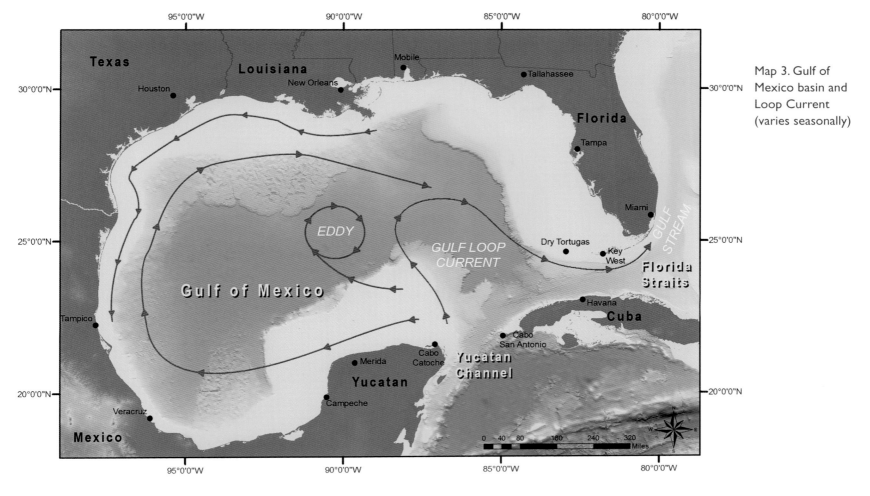

Map 3. Gulf of Mexico basin and Loop Current (varies seasonally)

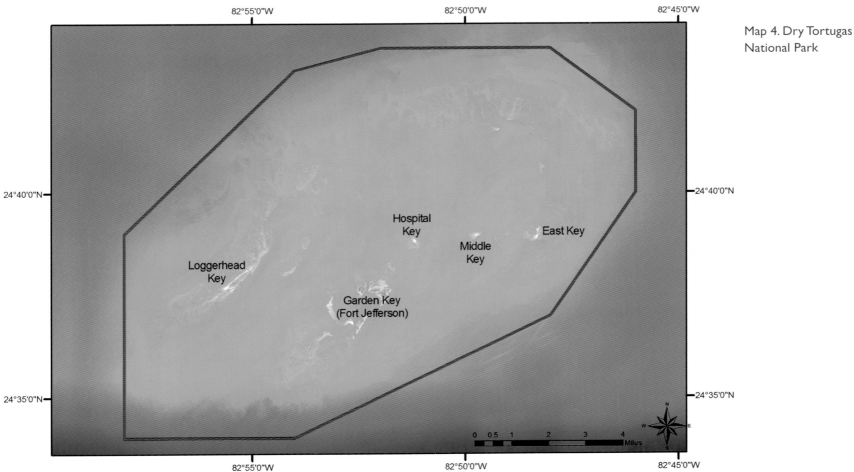

Map 4. Dry Tortugas National Park

Nineteenth-century military defense experts, recognizing this location as strategic for protecting ship traffic between Gulf ports and those along the Atlantic Seaboard, constructed one of the largest forts in the United States. Forty-five feet in height and hexagonal in shape, Fort Jefferson has three levels, with space for 420 guns and accommodations for 1,500 troops. Although most of the 16 million bricks used in its construction were sourced from Pensacola, Florida, some arrived from as far away as Maine. During the Civil War, the red-brick fort was integral to Union efforts to blockade Southern ports, and it later gained notoriety when Dr. Samuel Mudd, convicted of treating Lincoln's assassin, John Wilkes Booth, was imprisoned there.

Construction of Fort Jefferson began in 1846 around the original Garden Key lighthouse, which had been completed twenty years earlier. (More recently, following hurricane damage, the original brick lighthouse was dismantled; the cast-iron replacement stands atop the wall of the fort.) In 1857, a 150-foot-high lighthouse—more than twice the height of the one at Garden Key—was erected on nearby Loggerhead Key, usurping the role of the Garden Key light.

Hospital Key, an island just northeast of Fort Jefferson, has ruins of a hospital built in 1861 for personnel stationed at Fort Jefferson. The hospital building was later destroyed by hurricanes. The US military abandoned Fort Jefferson in 1874, and in 1888 the US Army transferred administrative control of the fort to the Marine Hospital Service, which used the facility as a quarantine station.

In 1908 Pres. Theodore Roosevelt issued an executive order designating Dry Tortugas a wildlife refuge. At that time, the concern was for protecting bird rookeries, not the coral reefs. Coral reefs back then were considered more of a nuisance for navigation than a commercial or environmental asset. More than twenty-five years later, Pres. Franklin Roosevelt went a step further when, in 1935, he designated the key a national monument.

Later designated a national park, in 1992, Dry Tortugas has two separate "no-take" marine reserves that fully protect 220 square miles of coral reefs. Many Floridians label Dry Tortugas "Our Yellowstone."

In 1926 the coastal waters of Dry Tortugas became the site of a significant photographic milestone. William Longely, director of the Tortugas Laboratory at Loggerhead Key, who at the time was conducting studies on systematics and behavior of tropical Atlantic fishes, collaborated with a *National*

Fort Jefferson, at Dry Tortugas National Park.

Geographic photographer to capture successfully the first-ever underwater color photographs. The flash needed to overcome muted colors was made by an explosion of magnesium powder from a raft floating on the surface. The remarkable color photos of the tropical reef fishes (the first one being a hogfish) served to further Longely's research—while bringing a whole new realm of underwater beauty to the world at large.

In the 1880s there were eleven sand keys in the Tortugas group; now there are only seven (see map of Dry Tortugas National Park). Over time and as a result of seasonal storms and hurricanes, one key has disappeared entirely and three others merged with adjacent islands.

In 1886 the federal government erected a lighthouse on iron pilings at Rebecca Shoal, twenty-five miles east of Garden Key. As noted in chapter 2, this location is the point at which the Gulf of Mexico transitions to the Florida Straits and Atlantic Ocean.

The Reef

Geographically, Dry Tortugas is a remote elliptical coral reef formation at the western reach of the Florida Keys. Gin-clear waters bathe the area, supporting some of the healthiest coral reefs in the entire Gulf of Mexico. Located just upstream of the Florida Straits, Dry Tortugas is an important nursery for all of the downstream Florida Keys. A series of yellow buoys mark the protective boundaries. Many of the Tortugas reefs are in relatively shallow waters (20 to 40 feet deep), in contrast to the much deeper reefs in the northwestern Gulf (60 to 140 feet deep) off Texas and Louisiana. Bright sunlight easily penetrates 20 to 30 feet and effectively illuminates the corals and tropical fishes so they can be seen and enjoyed by snorkelers at the surface. The multitudes of tropical reef fishes are as vivid and inviting as the colorful corals, anemones, and sponges that shape the living outcroppings from the limestone base. At least 30 species of corals decorate the bottom in a magical

Thriving coral reef off Dry Tortugas with scores of juvenile yellowhead wrasse.

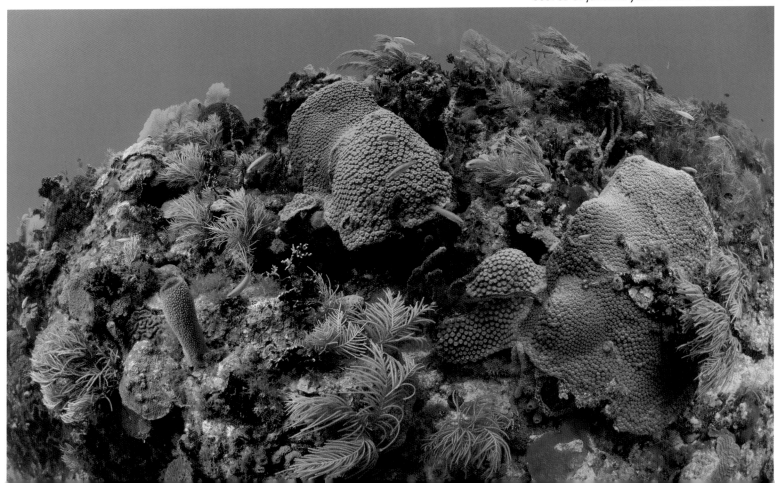

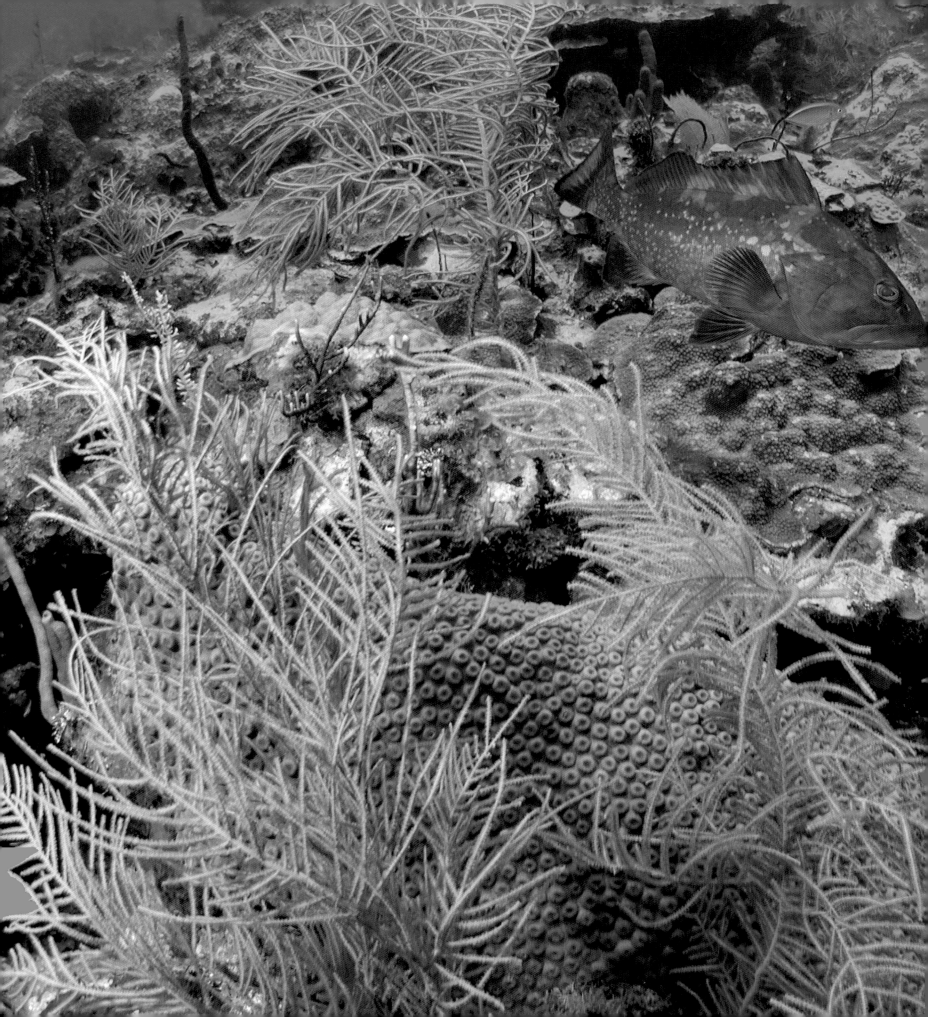

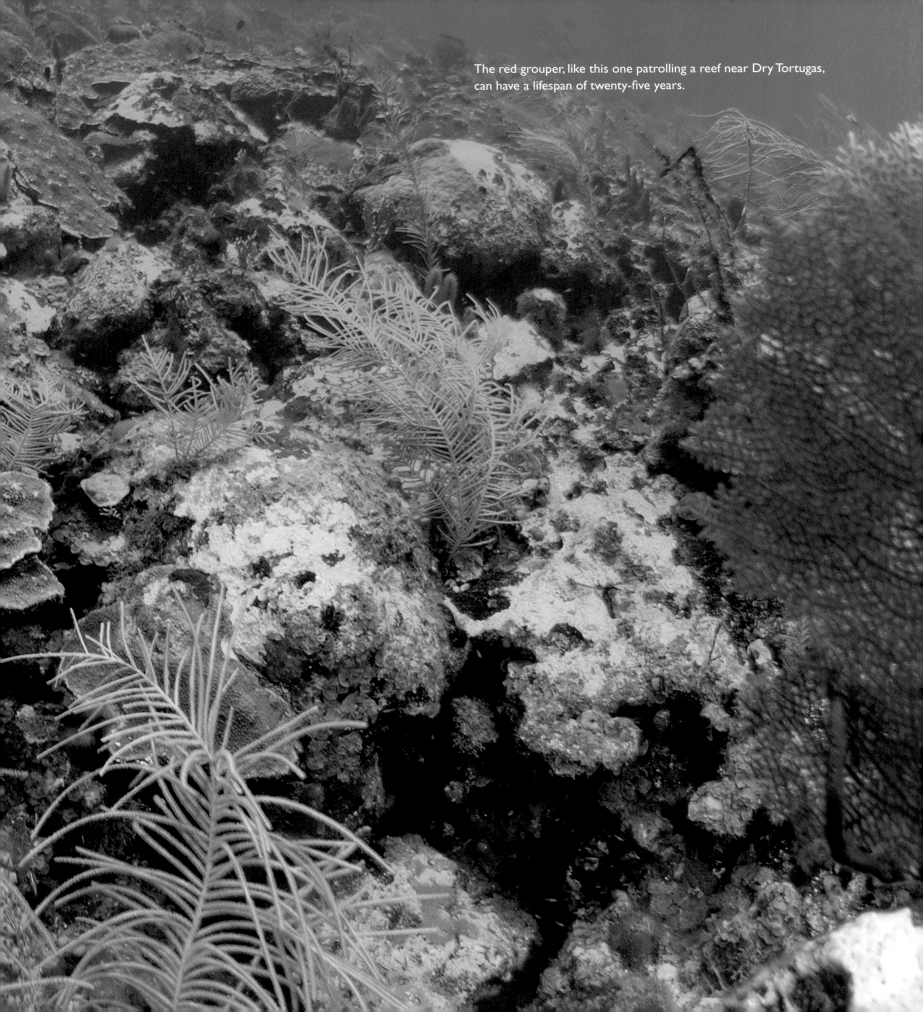

The red grouper, like this one patrolling a reef near Dry Tortugas, can have a lifespan of twenty-five years.

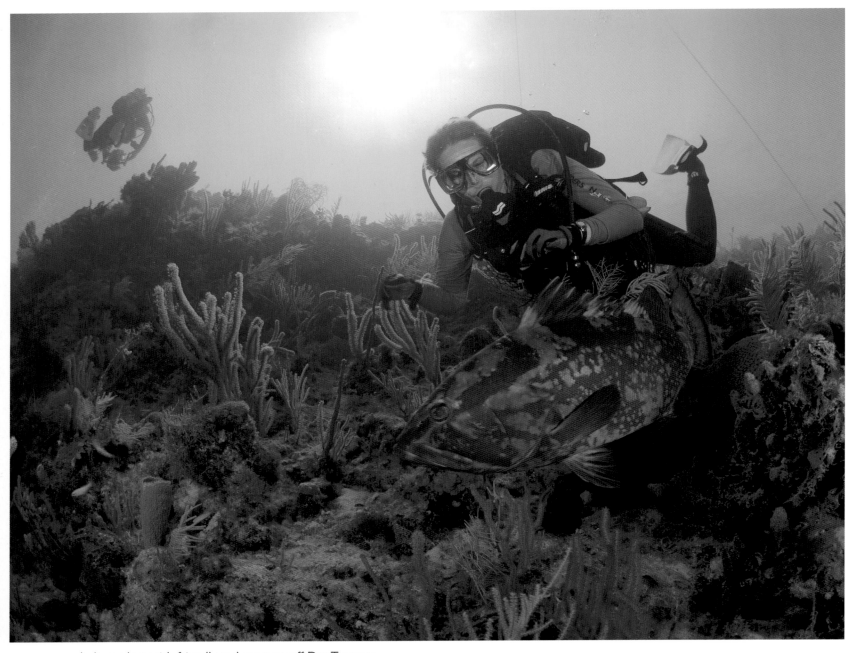

A diver plays with friendly red grouper off Dry Tortugas.

maze, and with impressive productivity they form a living housing complex for hundreds of other species of fishes and encrusting organisms—make that 275 species of fishes and hundreds more species of plants and other animals. Some of the corals seem like mushrooms or huge boulders that scarcely move, while others, the softer corals, such as the purple sea fans and lavender sea plumes, are in constant motion, swaying in the currents. Tortugas also has a few formations of the precious and

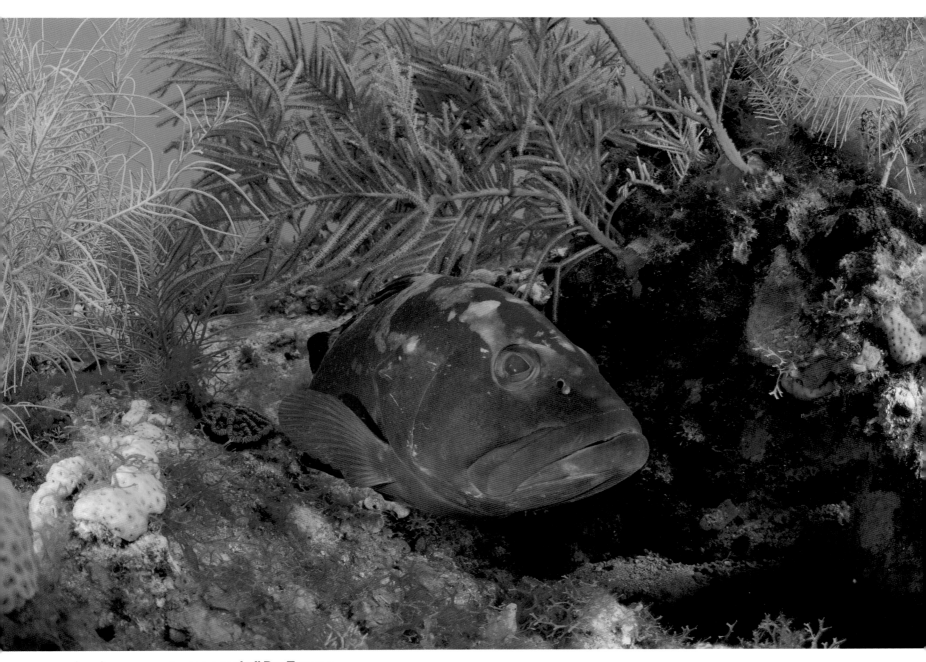

A red grouper rests atop a reef off Dry Tortugas.

stately elkhorn and staghorn corals. Hiding in the nooks and crannies of the reef are innumerable invertebrates, some of which come out only at night.

Red grouper, *Epinephelus morio*, are abundant on the Dry Tortugas reefs, and these gentle, curious fish are both friendly and photogenic and appear to know

it. Like little red puppies, they follow divers around on nearly every dive. I'd take a picture of one and turn away, only to see the little scamp again, posing anew! Not

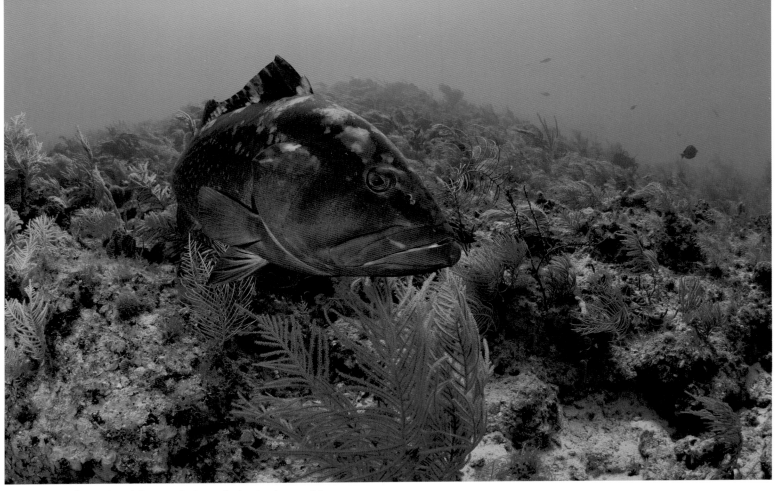

Red grouper have the ability to dig large holes in the sand bottom, helping the environment to support additional life.

The hogfish is a member of the wrasse family and can weigh more than twenty pounds and reach three feet in length.

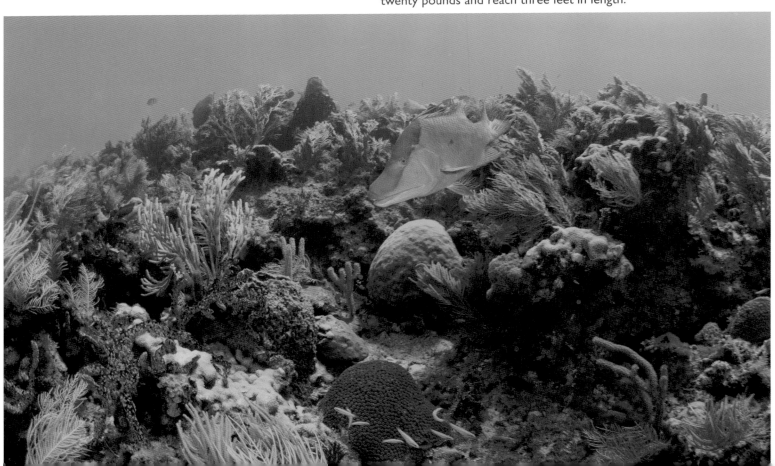

nearly as approachable are the hefty-snouted hogfish, not to be confused with Spanish hogfish, which cruise the reef in solitary fashion hunting for meals and seem to have the demeanor of a reef security guard.

Located within the sanctuary boundary, the iron-hulled, 261-foot-long *Avanti*, also known as the French Wreck, rests in 20 feet of water and provides a marvelous and very fishy complement to the surrounding natural reefs. This former merchant windjammer sank in January 1907 en route from Pensacola to Montevideo, Uruguay, and almost instantly became an unintended artificial reef. The wreck is blanketed with assorted hard corals and sprouts jumbles of ruby-red sea whips. Lobsters hide within the steel framework, but their swaying antennae are always a giveaway, and pink-tipped sea anemones attached to the artificial reef capture and feed on microscopic plankton. As if that's not enough, the *Avanti* teems with schooling fishes—chubs, snappers, and damselfish—and provides a safe habitat for tiger and goliath grouper. Not far from the wreck, I spotted several queen conchs inching their way along the sandy bottom. In this region where the Gulf of Mexico meets the Atlantic Ocean, loggerhead turtles, *Caretta caretta*, largest of the hard-shelled marine reptiles, are found in greater concentration than anywhere else in the Western Hemisphere. Weighing up to half a ton, loggerheads normally cruise

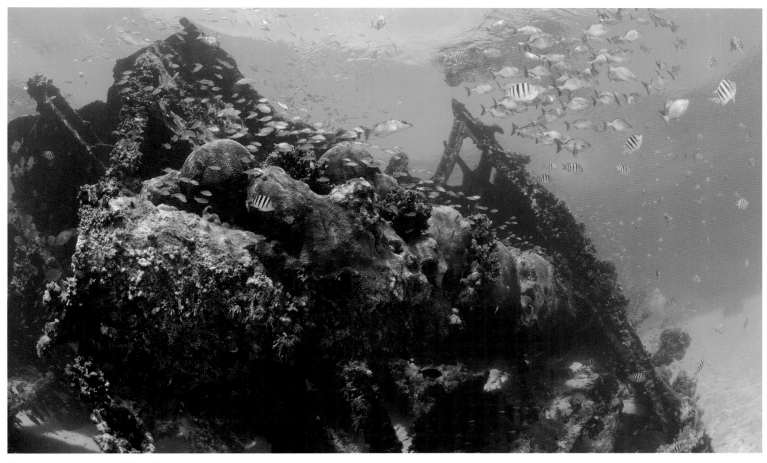

The French Wreck off Dry Tortugas is host to an amazing array of fish life.

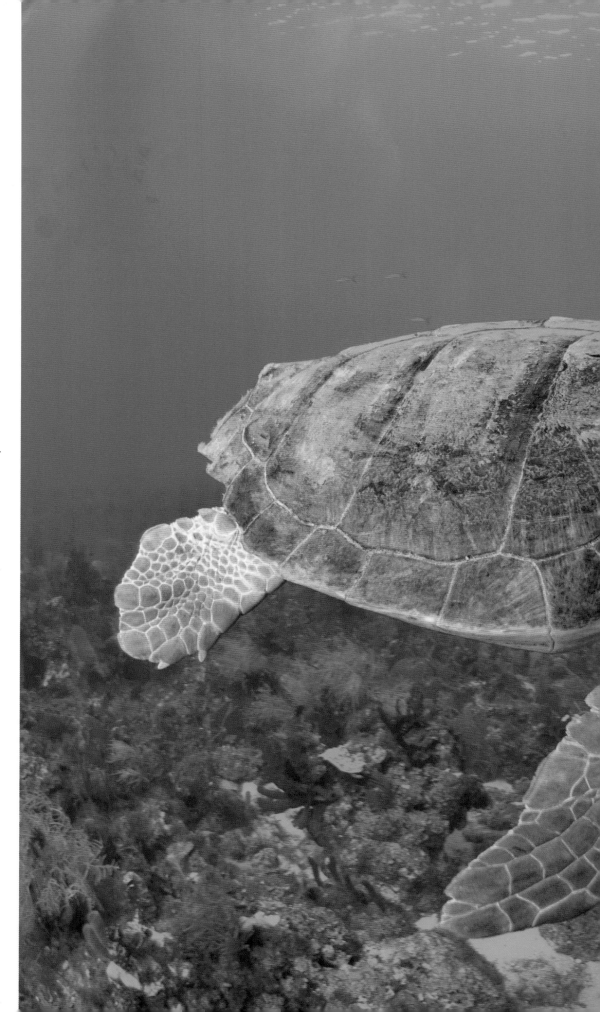

slowly through the reefs as they forage on sponges, jellyfish, crabs, or small fishes, but when chased they can crank it up to speeds of almost 15 miles per hour through the water column.

Tangles of light-brown sargassum seaweed mats floating and drifting their way through the national park serve as oases to shelter and supply food for an array of fishes and invertebrates, including pre- and postlarval life. Shrimp, crabs, nudibranchs, and a host of juvenile fishes make these drifting mats their home for some or all of their lives. The masses of brown algae rely on tiny air-filled bladders to keep them afloat. Juvenile fishes that find protection and food in these floaters include filefish, triggerfish, jacks, flying fish, and even dolphinfish (also known as dorado or mahi mahi), not to mention the prized sargassum fish.

Not far outside the sanctuary, on heading north to Naples I had a chance to dive on an obsolete and decommissioned LORAN station (used by the US Coast Guard for long-range navigation) off the southwestern coast of Florida. It was here I experienced an artificial reef structure hosting more goliath grouper, *Epinephelus itajara*, than I've ever seen anywhere. Never had I encountered these monster-sized grouper so approachable and willing to be photographed.

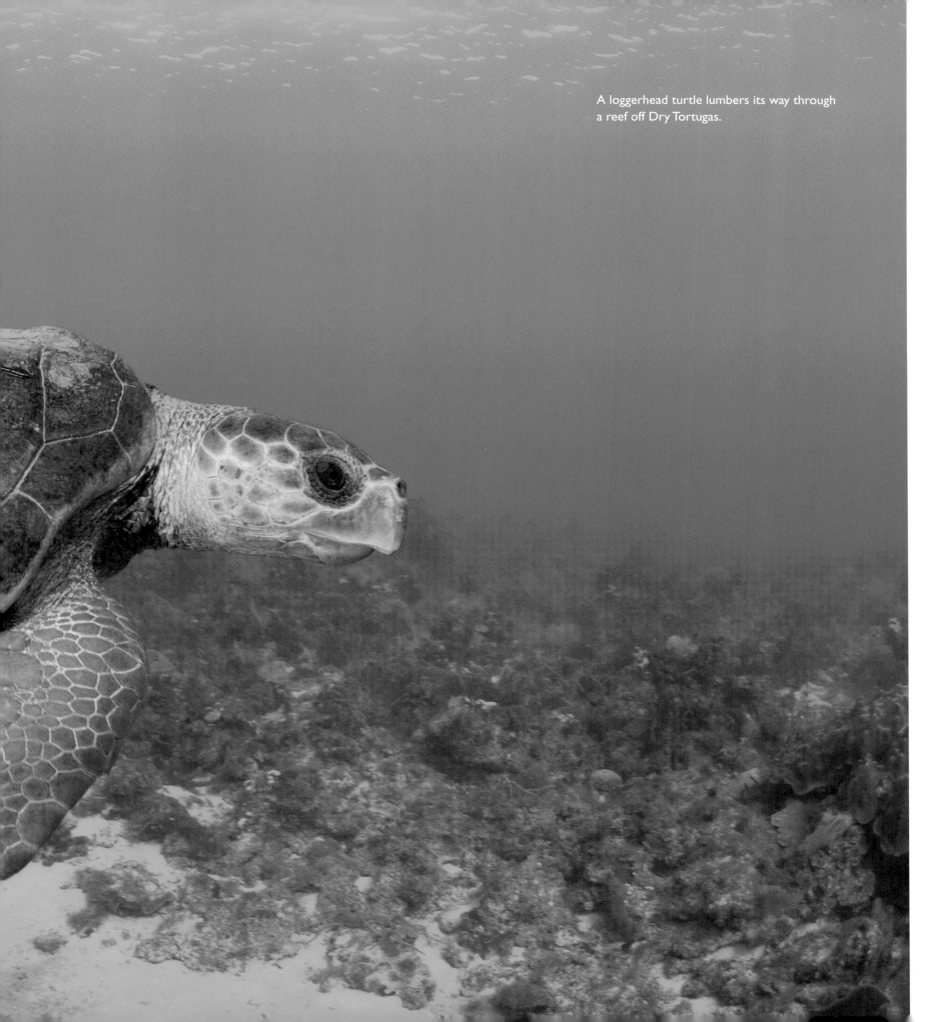

A loggerhead turtle lumbers its way through a reef off Dry Tortugas.

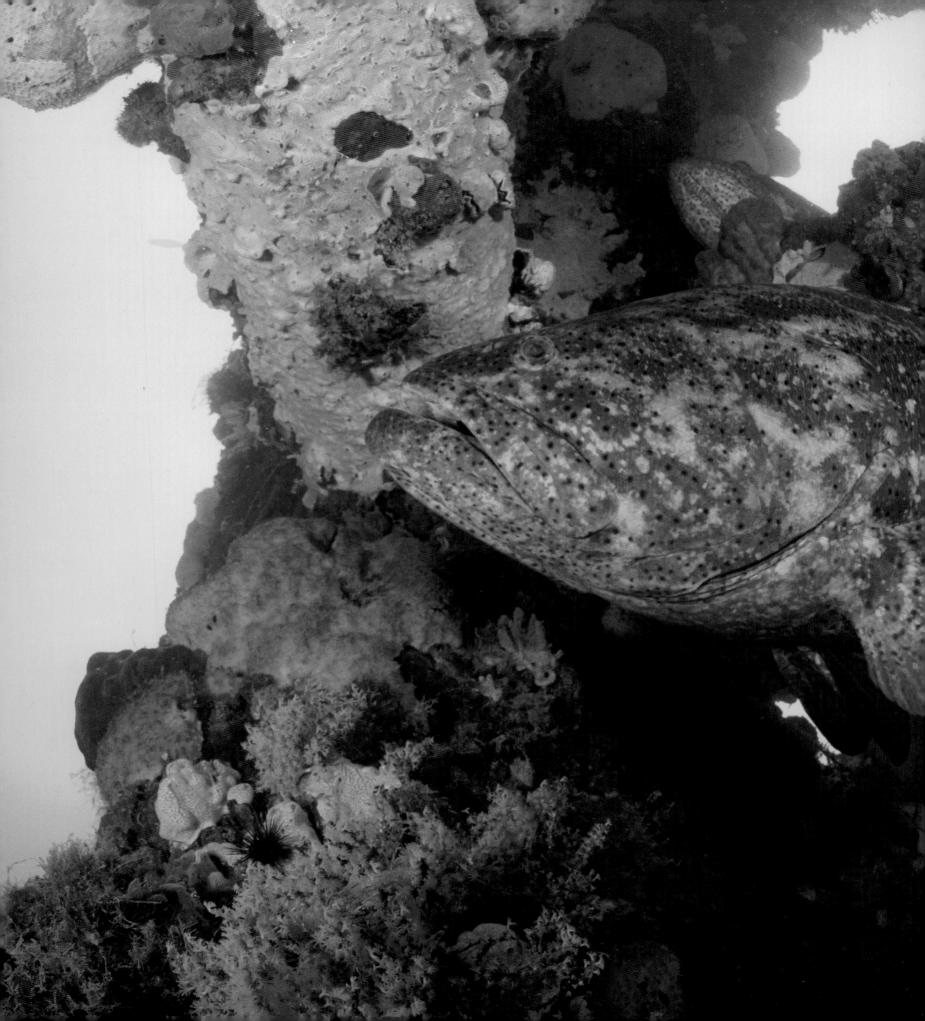

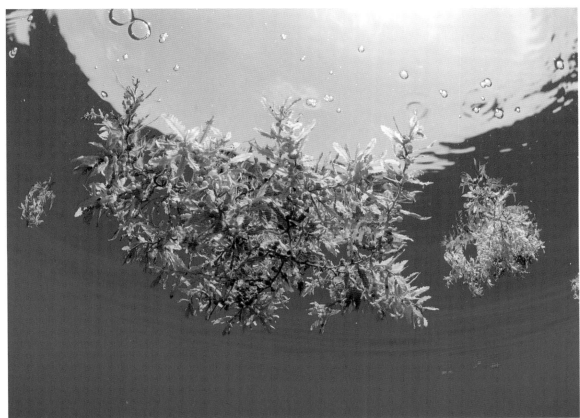

Floating sargassum seaweed mats off Dry Tortugas serve as surface nurseries thriving with life.

Pulley Ridge

I have yet to document Pulley Ridge, an important reef in this region of the eastern Gulf. Approximately 155 miles west of Cape Sable, this deepwater ridge was once a line of barrier islands. At 200 feet deep, Pulley Ridge has a surprisingly dense array of scleractinian corals and tropical fishes. Platelike sunray lettuce coral is one of the most dominant species seen there. Marine scientists contend that the profusion of life at this depth is unusual. The Loop Current is one possible explanation for this unusually deep coral reef community in the Gulf of Mexico.

Dozens of goliath grouper hang out on a LORAN tower off the coast of Naples, Florida.

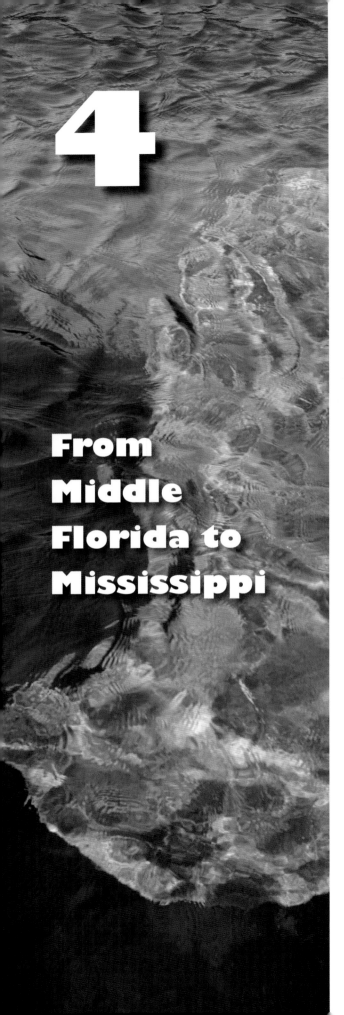

4

From Middle Florida to Mississippi

The Florida Middle Grounds

The area off the west coast of central Florida was once a shallow reef and is known today as the Florida Middle Grounds. Extending roughly eighty miles, from Apalachicola in the north to Tarpon Springs to the southeast, the Middle Grounds are a concentration of limestone ledges and pinnacles at depths of 80 to 150 feet. Visibility in these waters is often a hundred feet or more. An extensive area thirty-seven miles long and approximately ten miles wide, the series of banks that make up the Middle Grounds trends north to northwest nearly parallel to the Florida peninsula. Throughout are thick clusters of coral and sponge gardens separated by sand patches and alleyways. Some of the carbonate pinnacles in the northern section project as high as 12 feet from the base and bottom features at some areas include caverns, overhangs, and swim-throughs. The colorful reef life includes soft corals, tube sponges, and vase sponges, to name a few. Fire corals and vase sponges dominate many of the reef areas. Tropical fishes thrive at the Middle Grounds, as do game fishes, making it a special destination for those who spearfish. The distance from shore allows this area to thrive with sought-after amberjack, red and mango snapper, and gag grouper, but the goliath grouper that are plentiful throughout the Middle Grounds are protected by the State of Florida and off-limits for fishing. Unfortunately, the Florida Middle Grounds have not escaped the lionfish invasion of the Atlantic.

Geologists believe these reefs formed twenty thousand years ago, when ocean levels were much lower and sunlight penetrated deep enough to enhance coral growth. The substrate at the Middle Grounds is calcium carbonite, but it was formed predominantly by mechanical means rather than by hermatypic,

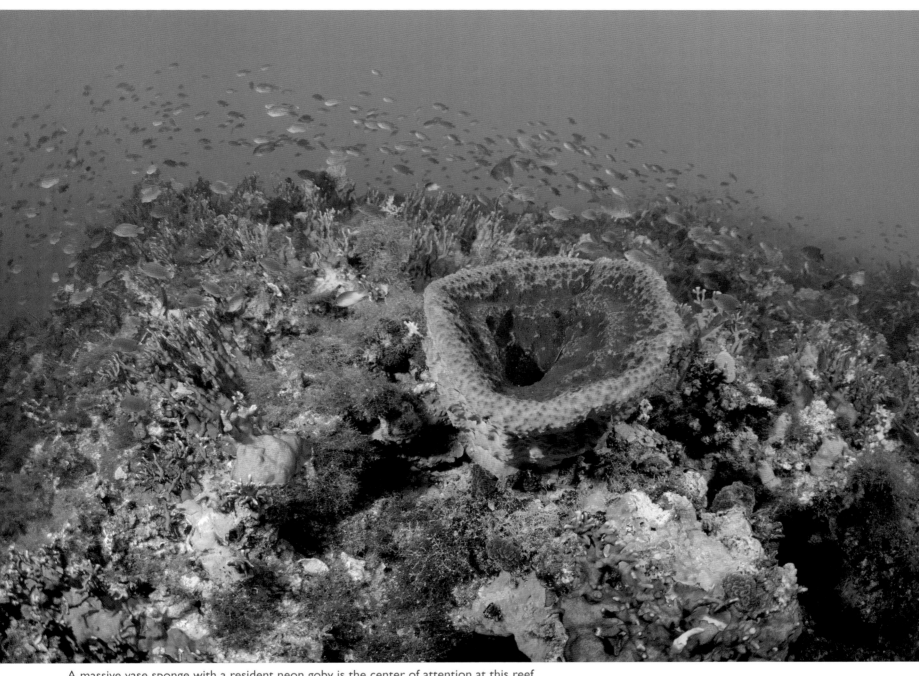

A massive vase sponge with a resident neon goby is the center of attention at this reef studded with fire corals.

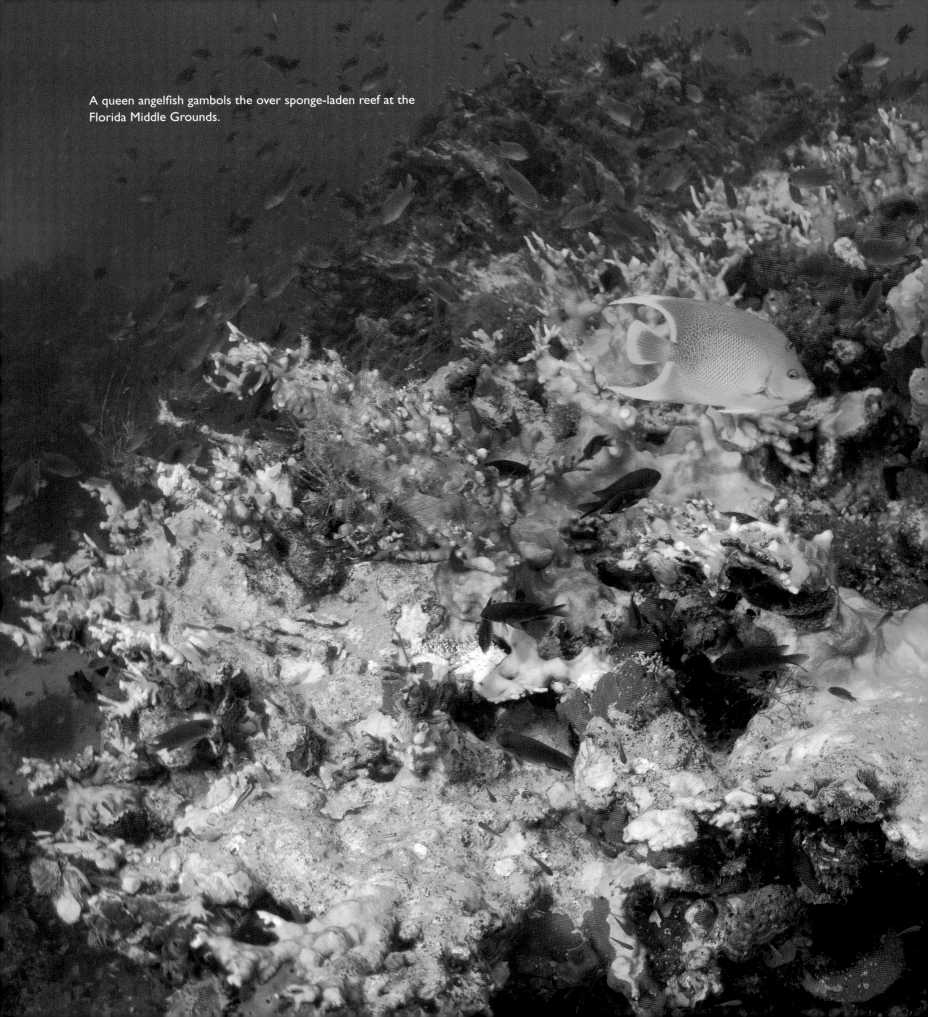

A queen angelfish gambols the over sponge-laden reef at the Florida Middle Grounds.

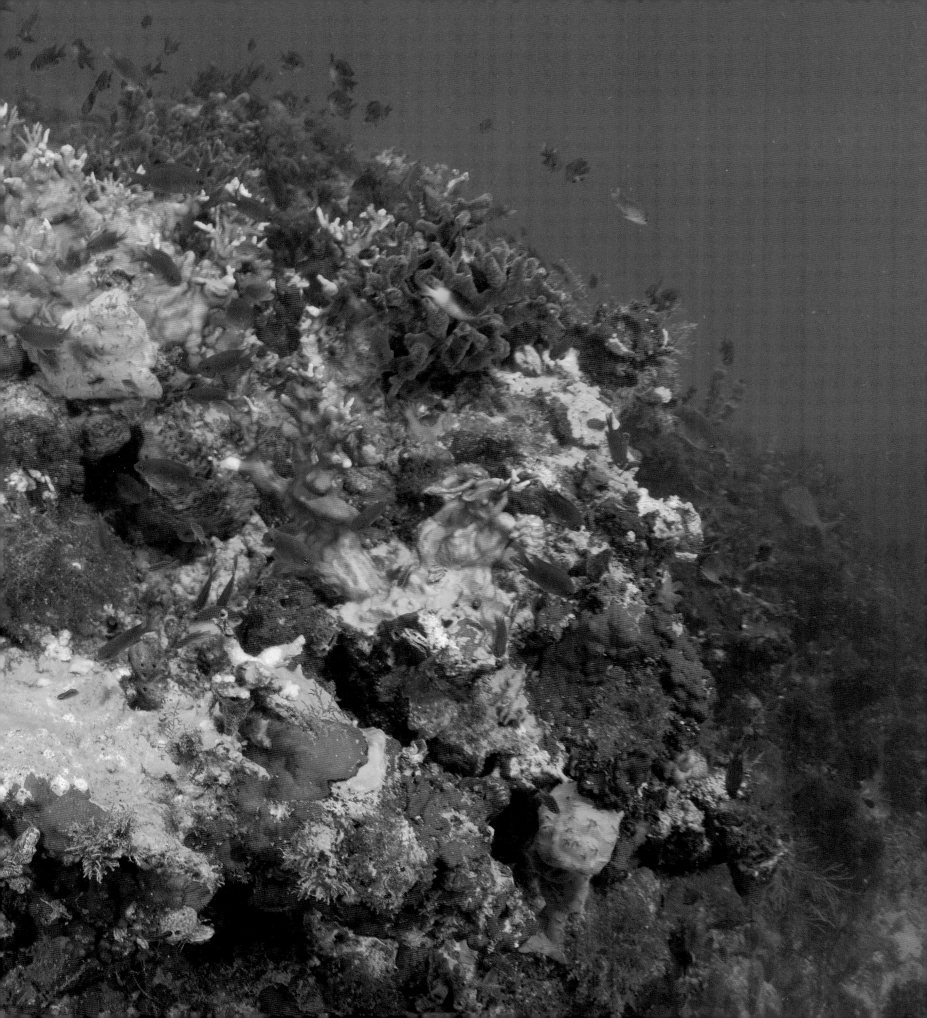

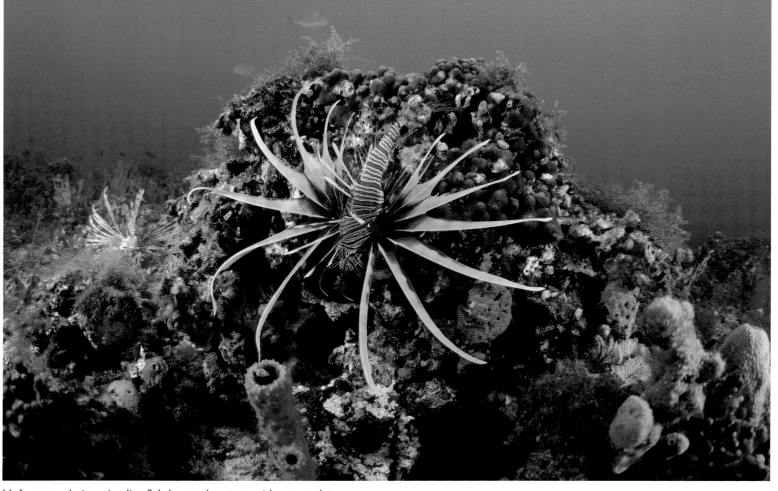

Unfortunately, invasive lionfish have taken up residence at the Florida Middle Grounds.

A massive goliath grouper effectively camouflages itself as it nestles between the reef and bunches of soft corals.

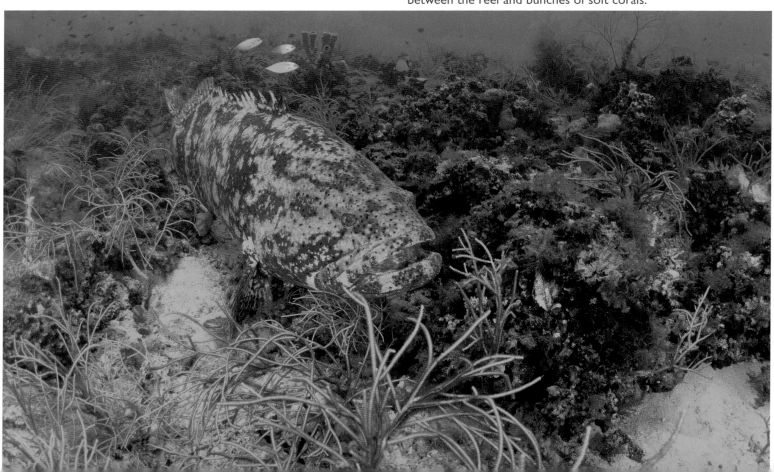

reef-building corals. So, even though the Middle Grounds are the northernmost "coral community" on the continental shelf of the United States, it's not a true coral reef. Biologists suggest the Loop Current in the Gulf supports the sponges, stony corals, and gorgonians that cover so much of this area. Additionally, researchers report 170 species of fishes, 41 species of sponges, and 23 species of stony corals at the Florida Middle Grounds.

The One-Ton Mermaids of Florida

The west coast region of central Florida boasts other marine wonders, among them a huge population of West Indian manatees. Manatees are massive (up to fifteen feet long and a ton in weight) yet are easily approached, harmless marine mammals found in the Gulf of Mexico and in many of Florida's, estuaries, rivers, and canals. Manatees are also found in the Mexican state of Tabasco and in Cuba.

During the winter months, from November to February, the manatees leave the colder coastal Gulf waters and tend to congregate into a number of Florida rivers and springs, where the water maintains a constant 72-degree temperature year round. Two of the more famous shallow areas for manatee aggregations are King Springs, on the Crystal River, and the Homosassa River.

During winter months the manatees leave the Gulf waters for the warmer rivers and springs of Florida.

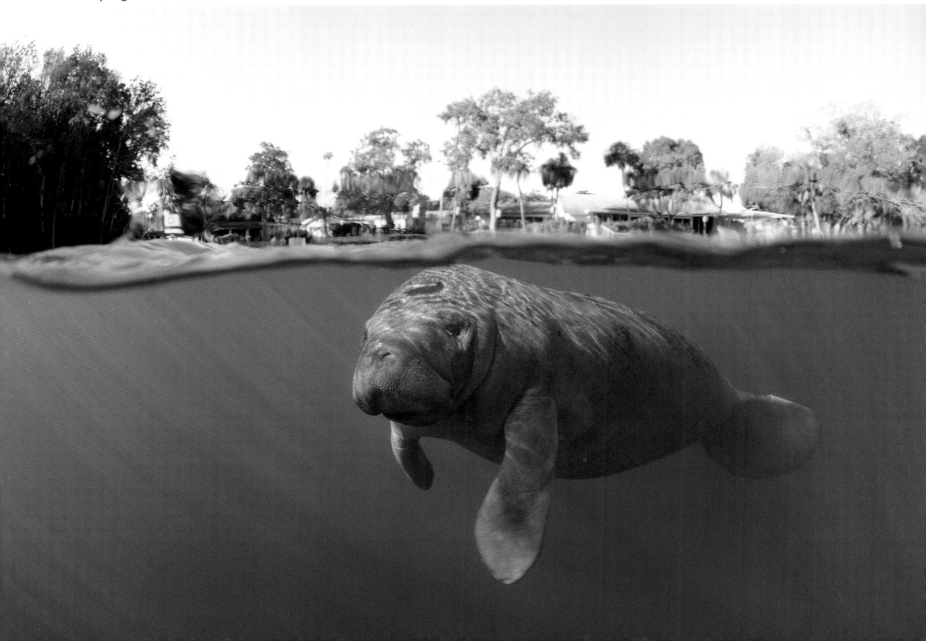

Christine Cancelmo swims alongside a gentle, slow-moving manatee or "sea cow" at Homosassa, Florida.

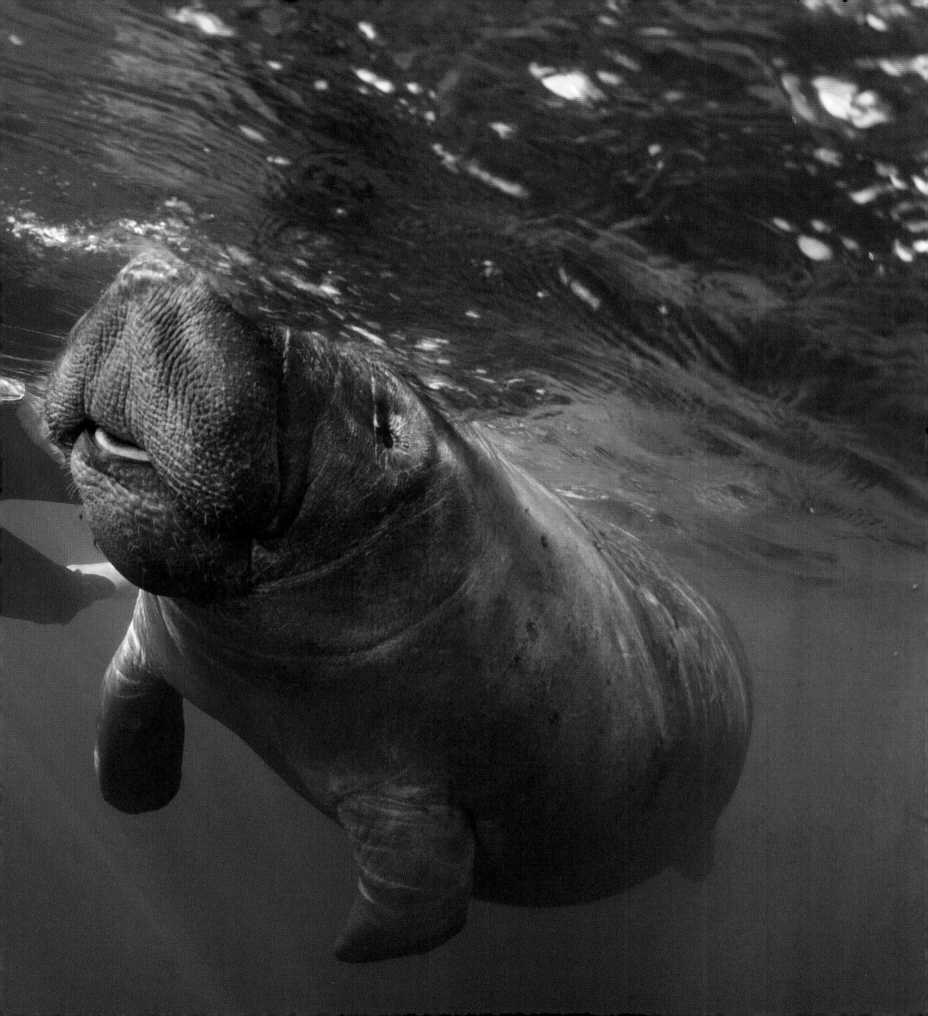

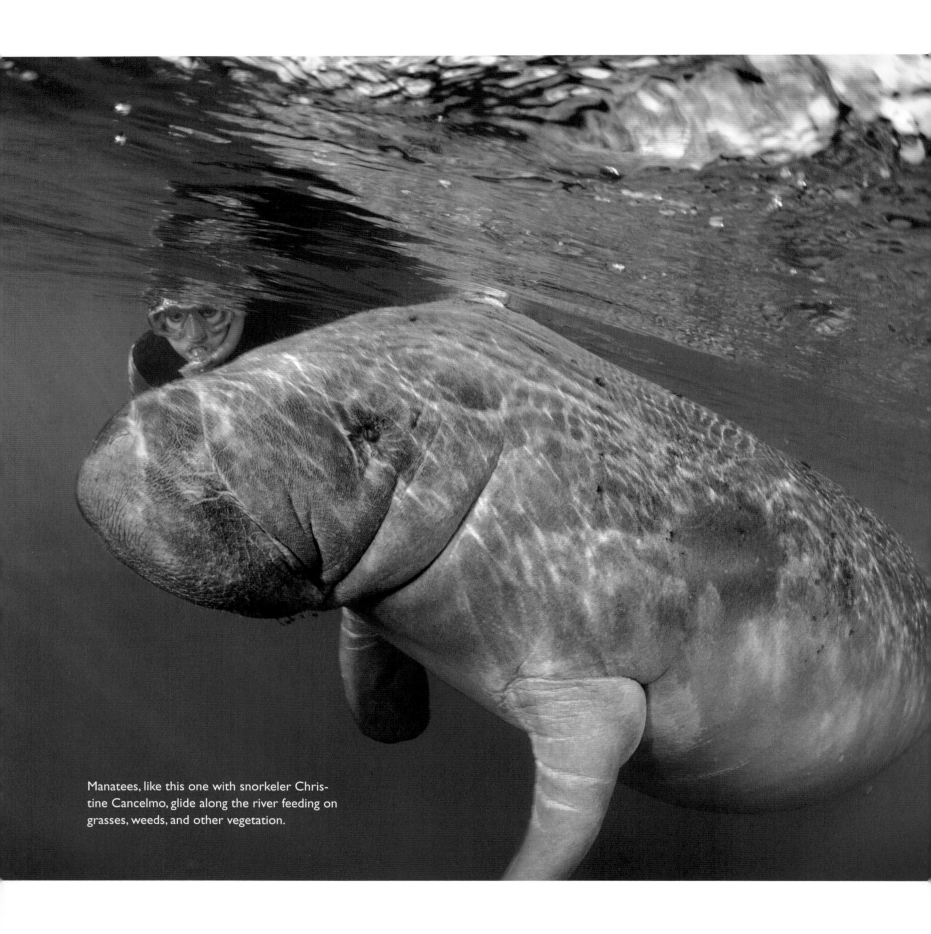

Manatees, like this one with snorkeler Christine Cancelmo, glide along the river feeding on grasses, weeds, and other vegetation.

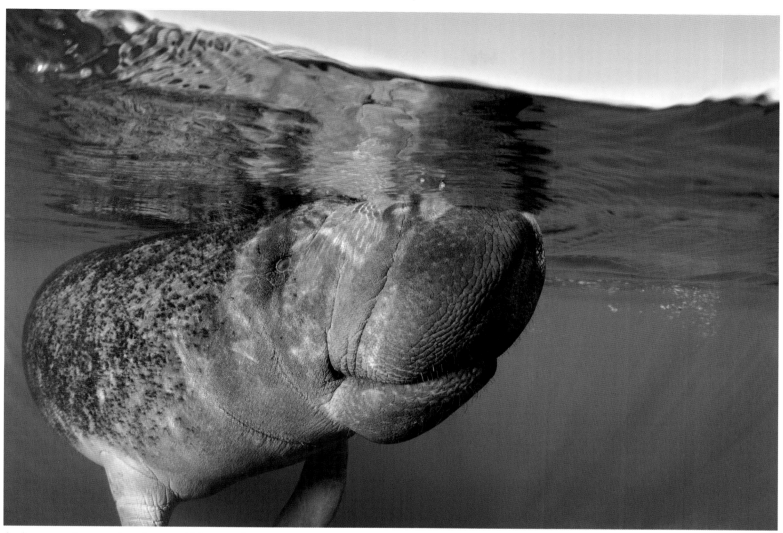

A close-up of a manatee shows whiskers and tiny, light-sensitive eyes.

Manatees are air-breathing marine mammals but can stay submerged for ten to fifteen minutes between breaths of air.

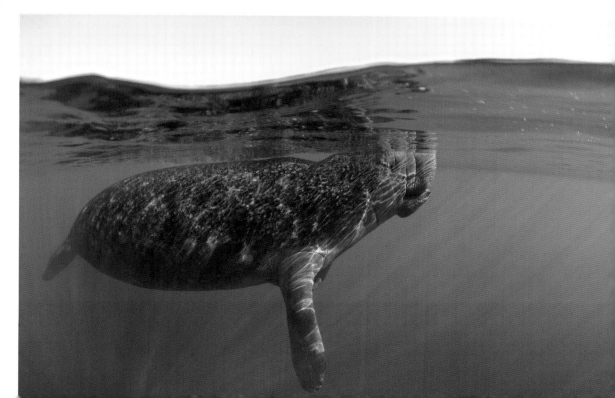

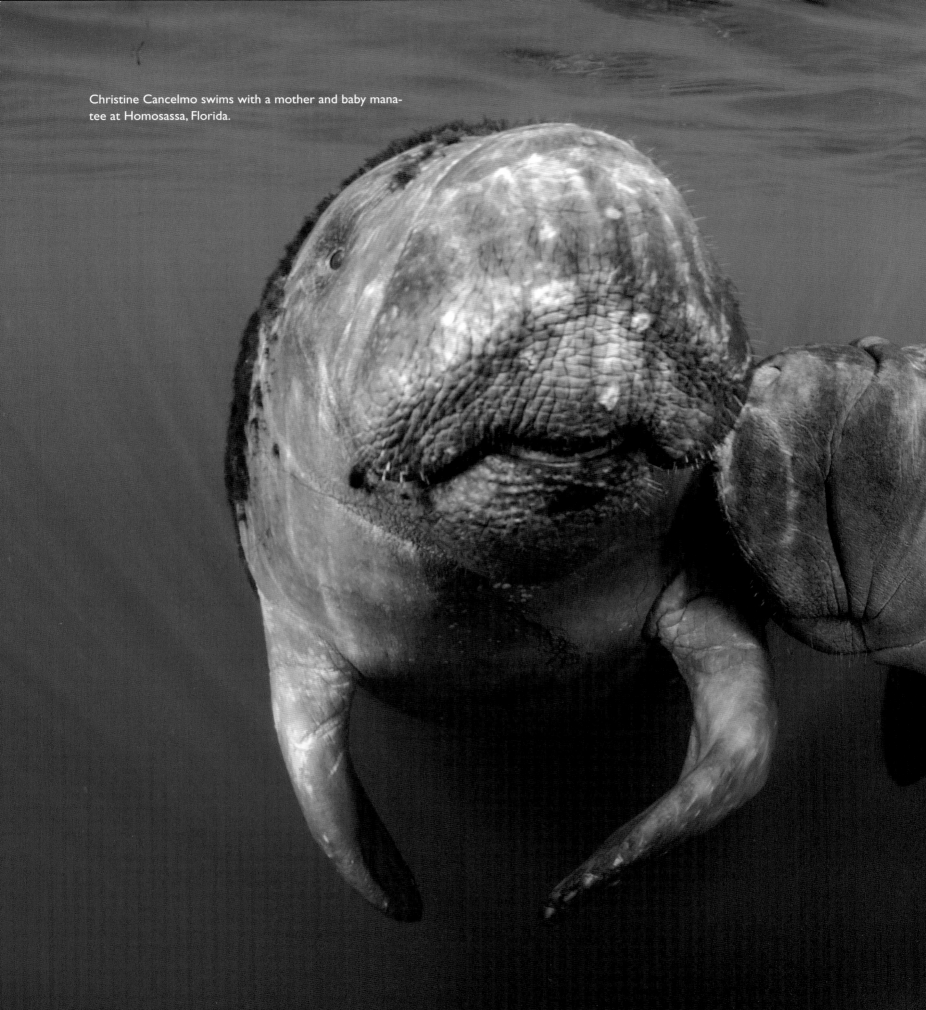

Christine Cancelmo swims with a mother and baby mana-
tee at Homosassa, Florida.

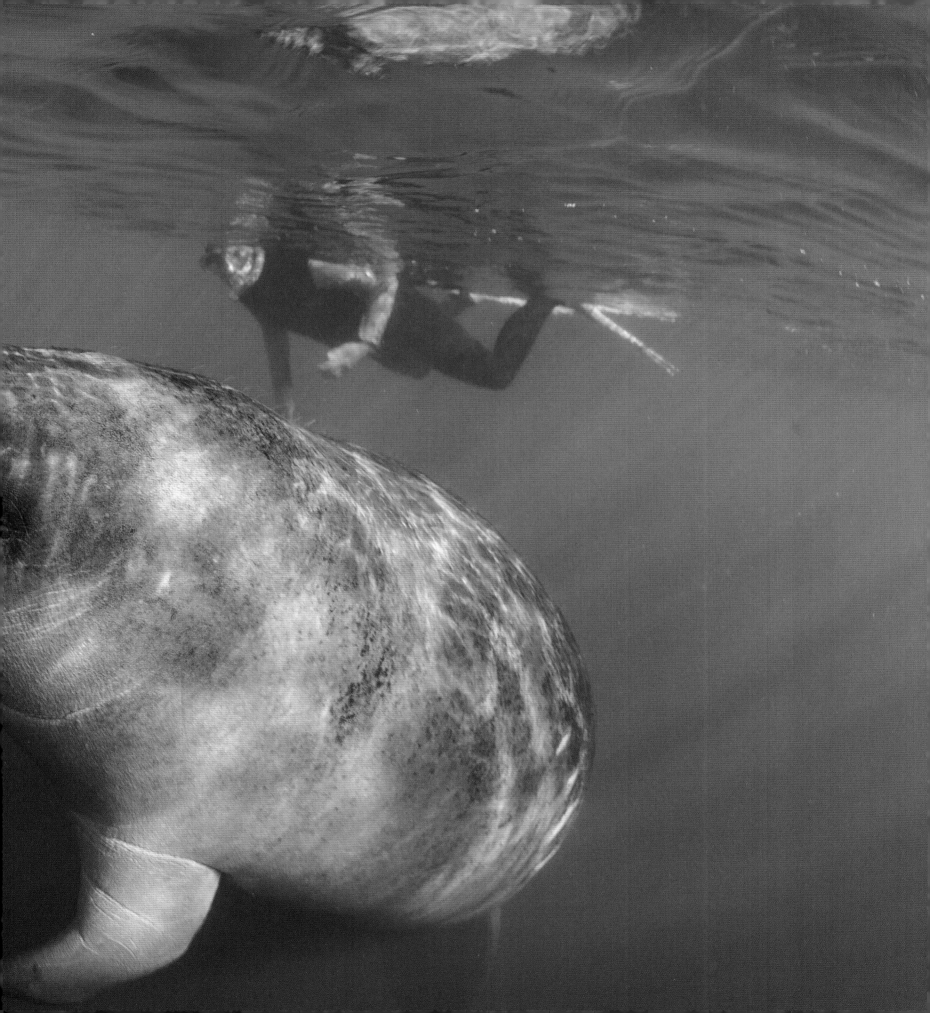

Although equipped with a broad, spatulate tail capable of providing quick propulsion, these gentle sirenians, *Trichechus manatus*, typically move slowly or simply rest on the bottom. Manatees have thick, wrinkled gray skin, a small head with beady eyes, and distinctive whiskers on the snout. They also have two forelimbs with three to four nails on each flipper. Snorkelers often spot one or more of these giant but shy vegetarians either grazing on submerged freshwater or saltwater plants or nestled on the sandy bottom in prayer-like poses. Much of their time is spent resting, and manatees are able to lie on the bottom for more than ten minutes before surfacing for a breath. My wife and I snorkeled for hours with manatees in the Homosassa River and even encountered a mother swimming with her baby.

Manatees, also called sea cows, face no natural predators and once proliferated throughout the waters of the southeastern United States and in the Caribbean as far south as northeastern South America. Unfortunately, up until the middle of the twentieth century, these defenseless, unwary creatures were hunted for their meat, hides, oil, and bones. Manatees are currently protected by federal statutes such as the Endangered Species Act and the Marine Mammal Protection

Gentle vegetarians, manatees are vulnerable to power boats and often exhibit arc-shaped scars from propellers.

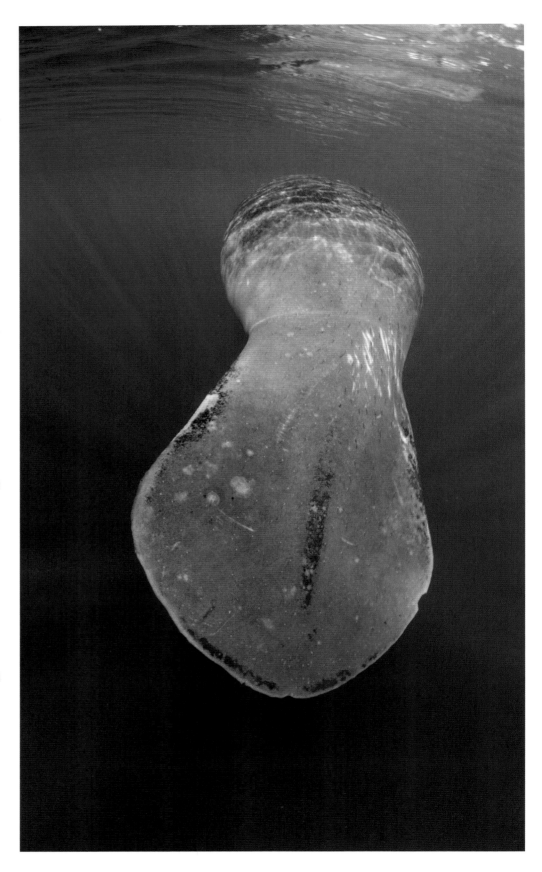

Act, as well as the Florida Manatee Sanctuary Act of 1989. Even with this protection, manatees are threatened by harassment, habitat loss, and inhalation of red tide neurotoxins. They are also vulnerable to boat propeller strikes. The manatee population in Florida is estimated at near five thousand, and the annual mortality rate is 8 to 10 percent.

Wakulla Springs in northern Florida is rich in scenic vegetation and wildlife, which includes alligators and manatees.

The Limestone Peninsula

The Florida limestone peninsula has some of the most diverse landscapes and seascapes in the United States. Mangrove thickets, pine forests, cypress domes, freshwater springs, and of course the Everglades cover Florida. There are oyster beds, coral reefs, and the colorful but little-publicized limestone ledges. Then there are the Gulf of Mexico shipwrecks and assorted artificial reefs, which draw divers from around the world

and serve as important marine habitats. Sunken ships off the Florida coast include small and simple tugboats and barges, as well as mammoth and complex wrecks like that of the USS *Oriskany*, which was decommissioned and sunk off Pensacola to serve as an artificial reef.

Limestone Ledges

The limestone ledges off Florida are important natural formations that are seldom described on diver forums

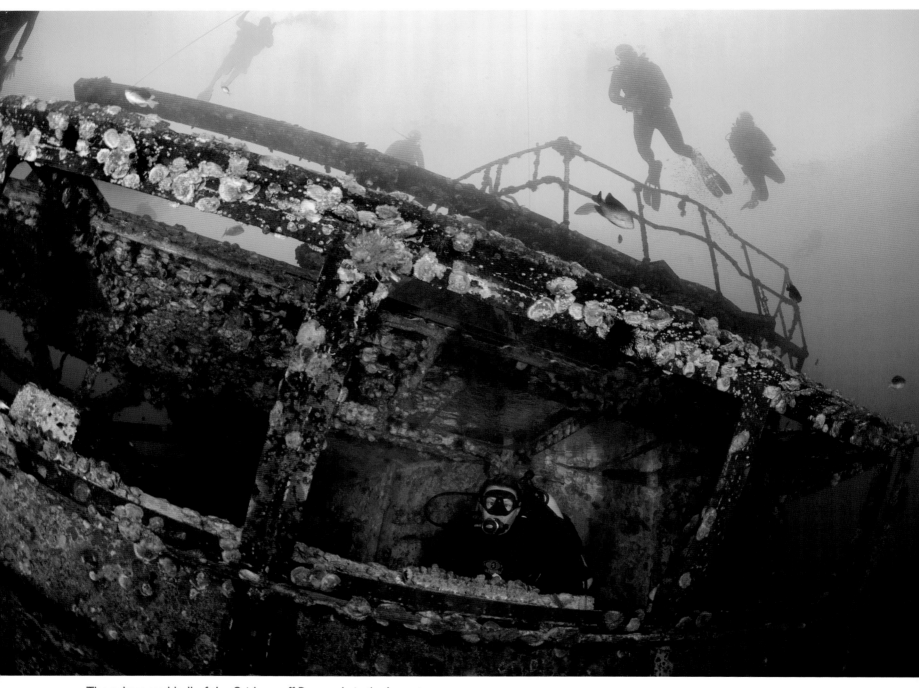

The submerged hull of the *Oriskany* off Pensacola is the largest artificial reef in the Gulf of Mexico intentionally placed to bolster the marine community.

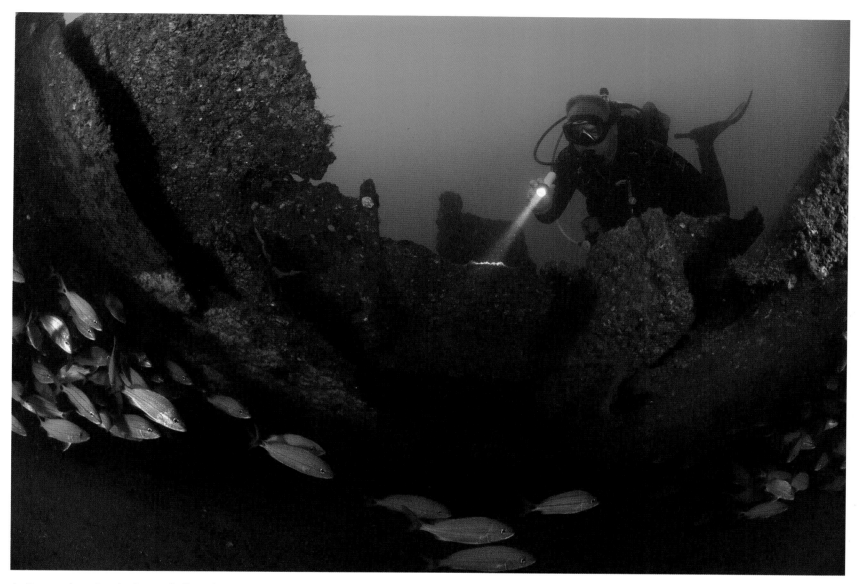

A diver and a school of juvenile French grunt on a barge wreck near a limestone ledge off Destin, Florida.

and remain for the most part "under the radar," yet these submerged ledges support a profusion of colorful and varied undersea life that has tremendous value.

Approximately twelve thousand years ago, when the sea level was much lower than today, limestone rock ledges and overhangs were formed as wave action carved the limestone coastlines. Today the ledges run intermittently along many parts of the west coast of Florida and the Panhandle area, from Panama City to Pensacola. Most are five to twenty miles offshore and at depths of 50 to 120 feet. The tops, sometimes referred to as "live rock," are laden with life such as soft and hard corals, sea fans, sponges, feather dusters,

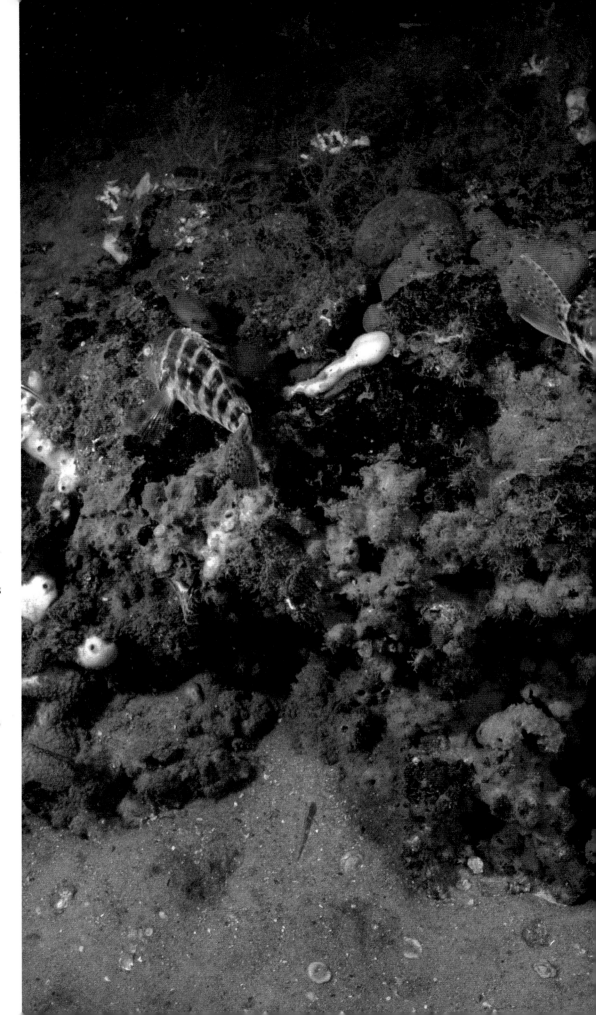

hydroids, and starfishes. The steep faces of the limestone ledges range from 3 to 10 feet high and normally face the shore. Significant undercuts provide safe havens for giant grouper, turtles, lobsters, and even nurse sharks. Sandy areas surround the ridges and also form winding alleyways where the ledges have broken apart. Meanwhile, mackerel, amberjack, and even sharks are sometimes seen circling above the ledges. At a limestone ledge off Destin, I captured an image of a sand perch resting near stinging hydroids and colorful sponges. Moving along the mini-wall, I came across a gray triggerfish and a Gulf toadfish, with its distinctive chin barbels, fat lips, and bulging eyes.

One of the premier limestone ledges in the Panhandle region is a spot nine miles off Pensacola called Timberholes. This 10-foot-high ledge hosting limestone-based marine wonders is the size of two football fields. The name comes from the many holes in the limestone substrate that are indicative of the trees that grew there when it was part of the Florida coastline. Local divers describe parts of the bottom as having a "moonscape" appearance with crops of sponges, gorgonian corals, and sea fans. At 100 to 110 feet deep, Timberholes hosts gag and black grouper, and divers

Sand perch resting on a limestone ledge filled with sponges and hydroids off Destin, Florida.

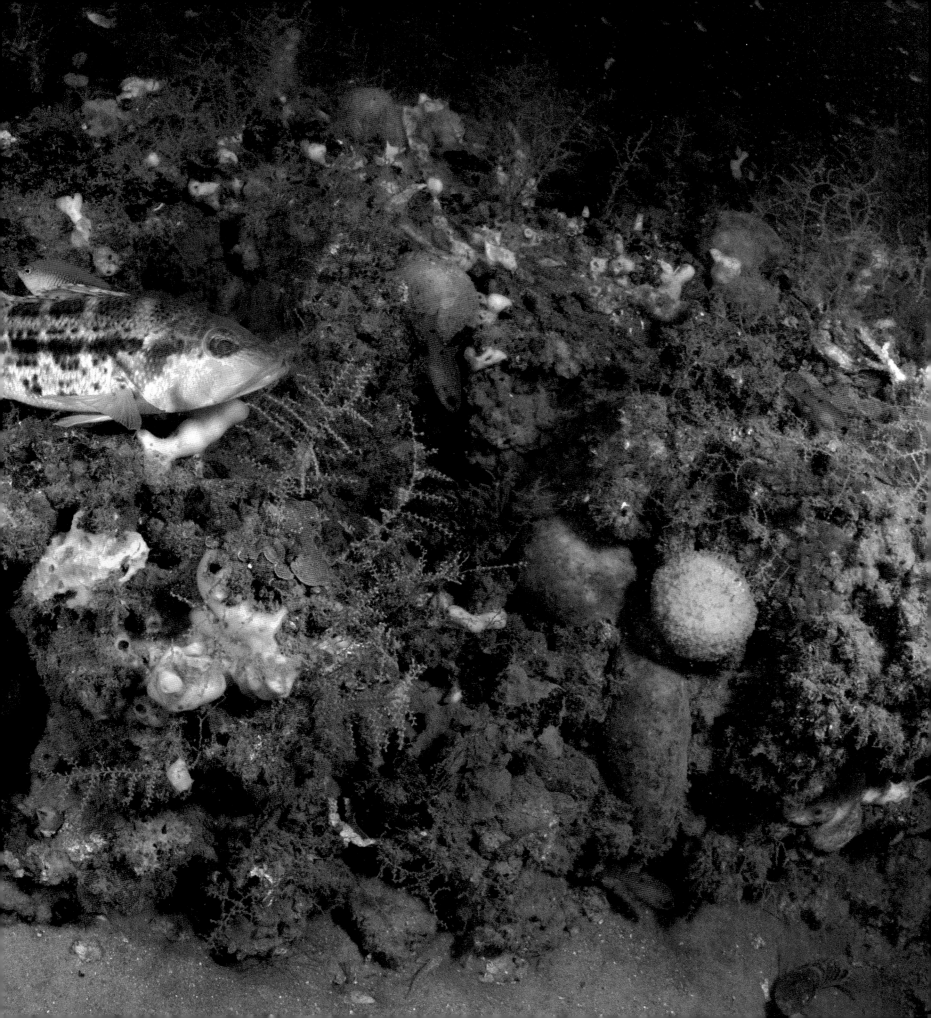

Gray triggerfish at a limestone ledge off Destin, Florida.

who venture there on a regular basis have logged encounters with manta rays, whale sharks, and even sailfish.

The stretch of intermittent limestone ledges does not end at the Florida state line. The staggered system of natural limestone life extends west of Florida along the Alabama coast. Trysler Grounds, about twenty-five miles south of Orange Beach, is a favorite destination for local divers from Alabama, Mississippi, and Florida. The hard bottom is at 120 feet and has an assortment of vase, barrel, and encrusting sponges, along with scatters of hard corals. The relief (height from bottom) is generally only 2 to 4 feet, but the limestone formation has endless hiding places for fishes and lobsters in the many deep crevices and under ledges. Farther east, the limestone remnants of the old coastline are buried in the silt that emanates from Mobile Bay and the Mississippi River.

The Gulf toadfish, like this one at a limestone ledge off Destin, Florida, is noted for its oversized, bulging eyes, fat lips, and chin barbels.

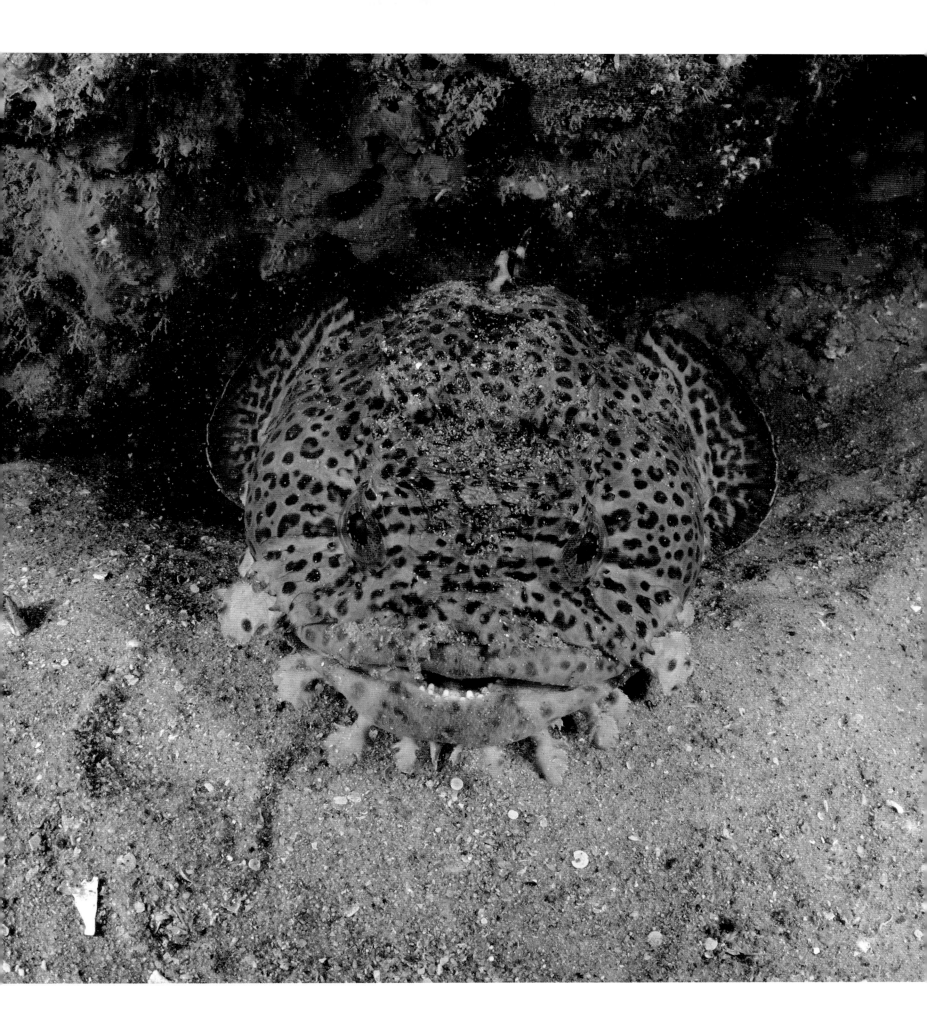

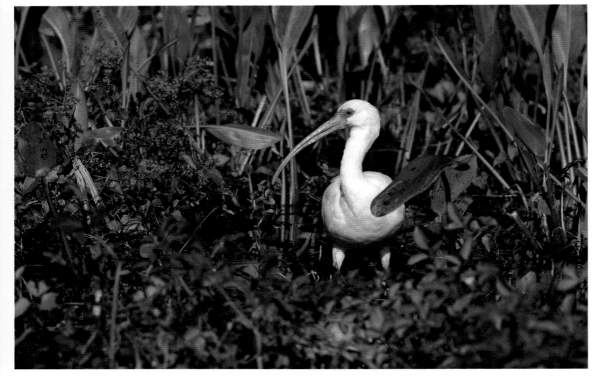

The ibis uses its long, downward-curved bill to feed on crustaceans in the mud.

The Ancient Underwater Forest of Alabama

A submerged fifty-thousand-year-old cypress forest was recently discovered off Mobile, Alabama, by anglers. Buried in the mud until Hurricane Katrina swept by in 2005, the cypress trees were uncovered and presented a new habitat for an array of marine life. According to reports from local divers and anglers, fishes, anemones, and turtles now thrive between the massive stumps of ancient wood. The area of the underwater forest is estimated at half a square mile and lies in sixty feet of water, but the exact location has been kept secret because of concerns of unchecked exploitation. As of this writing, petitions have been sent to the National Oceanic and Atmospheric Administration (NOAA) requesting designation as a national marine sanctuary.

Alabama and Mississippi Artificial Reefs

Although it possesses only sixty miles of coastline, Alabama maintains the largest artificial reef program in the United States. During the past six decades, the state has deployed thousands of artificial reefs of all shapes and sizes, from old bridge members to boats and planes. The mix of objects, strategically placed to maximize their benefits for marine resources, even includes several World War II Liberty ships and a hundred outmoded military combat tanks. Many of the artificial reefs are at depths of 70 to 120 feet. These stabilized, artificial reef materials with vertical relief provide substrates for highly developed ecosystems and attract marine life ranging from red snapper, grouper, and reef tropicals to the host of tiny critters and encrusting organisms that inhabit the lower levels.

Unlike the other four Gulf states, Mississippi has virtually no hard-bottom areas that support substantial amounts of marine life. The generally featureless mud bottom is a result of massive silt deposits from the Mississippi River. However, the State of Mississippi does have an artificial reef program that addresses both nearshore and offshore opportunities. The program utilizes Liberty ships, concrete culverts, oil platform structures, and pyramid-shaped limestone reefs. The artificial limestone reefs are composed of a patented composite of clamshells, concrete, and limestone rock that simulates a natural reef in terms of substrate composition and acidity. Up to twenty-five feet tall, they form cavernous habitats for an array of fishes and invertebrates. Many of these artificial reefs are accessible to scuba divers.

Northernmost Coral Reefs

The northernmost coral reefs on the US continental shelf are 100 to 120 miles due south of the Texas-Louisiana state line at the 28th parallel, 28 degrees north of the equator. In this area of the Gulf of Mexico, there are not just two but a trio of true coral reefs, that is, reefs where the dominant substrate was produced by reef-building corals—the East and West Flower Garden Banks and McGrail Bank. The first two are well known to divers and Gulf lovers alike and were designated the Flower Garden Banks National Marine Sanctuary (FGBNMS) in 1992. The third, McGrail Bank (formerly known as 18 Fathom Bank) is a much deeper coral reef known by few, and, although currently not a part of the FGBNMS, it is being considered as a future addition to the sanctuary. This recently recognized true coral reef is located 60 miles east of the East Flower Garden Bank. Blushing coral dominates the top of the reef, which lies at a depth of 151 feet. The bank is 17 square miles (10,880 acres) in size and features a pair of ridges separated by a long valley. The live coral cap takes up a very small area of only 36 acres. By comparison, the East and West Flower Garden Banks have reeftops that cover 350 acres and 100 acres, respectively.

The Flower Garden Banks formed ten thousand years ago on top of salt domes that pushed the ocean floor upward. There, brain and star coral mounds are massive, profuse, and healthy. The mounds stretch in a maze as far as the eye can see and constitute perhaps the most unique formations of live hard corals in the hemisphere. Sandy channels wind their way between the buttresses that teem with a multitude of wonderful life.

5

The North-western Gulf Waters of Louisiana and Texas

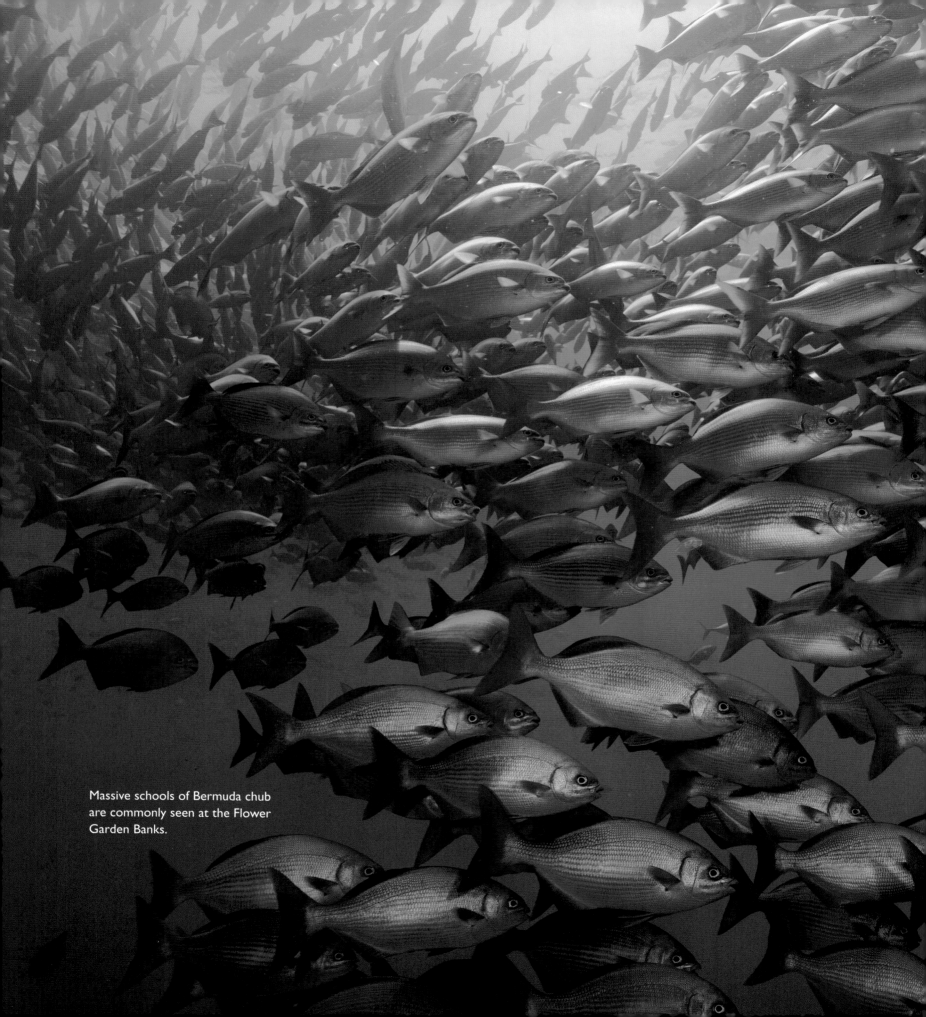

Massive schools of Bermuda chub are commonly seen at the Flower Garden Banks.

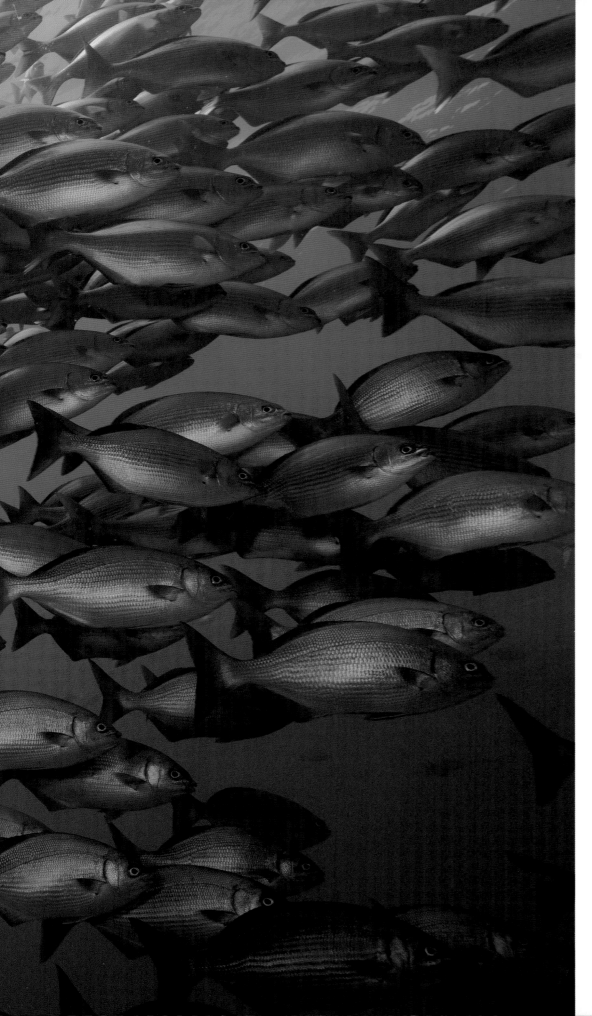

Stetson Bank, a formation of sensational life seventy miles southwest of Freeport, Texas, sits atop a salt dome formed by a process that began 190 million years ago. Unlike the limestone substrates at the East and West Flower Garden Banks, the substrate at Stetson Bank has layers of harder siltstone and sandstone and softer beds of claystone. The tiny reeftop of thirty-six acres is about the size of twenty-seven football fields. The top of the northern ridge of the bank has a series of upward outcroppings or pinnacles that approach heights of ten feet. They are blanketed with fire coral and colorful encrusting sponges. Massive schools of chromis often hover above these stately formations. Because it has bountiful sea life and value as a critical marine habitat, Stetson was added to the sanctuary in 1996. Stetson Bank is hands down the hotspot for fish watching and photography in the northwestern region of the Gulf of Mexico. Macro critters abound at Stetson as well and include the distinctive sailfin blennies and mantis shrimp.

The health of these reefs for four decades and more sets an example for how all coral reefs should be: sustainably healthy, productive, and mostly pristine. Unlike many coral reefs in the world, the FGBNMS reefs and McGrail Bank enjoy a one-hundred-mile

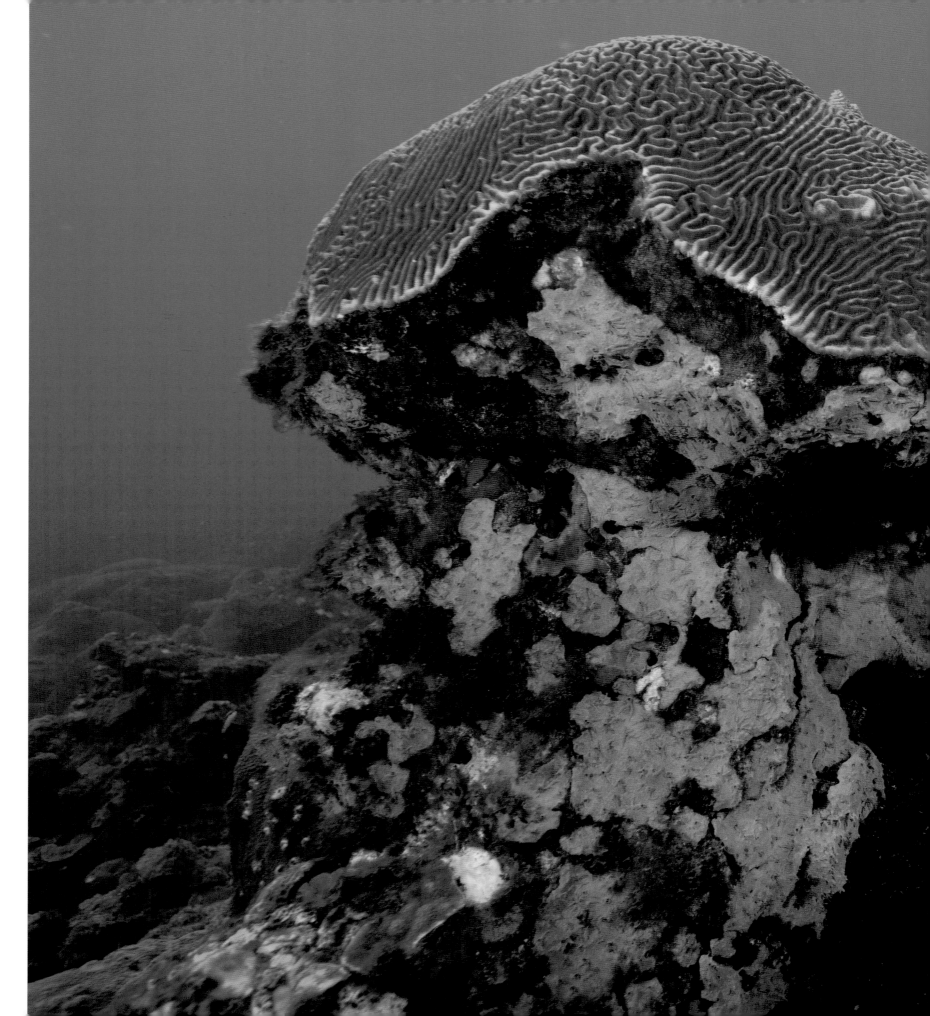

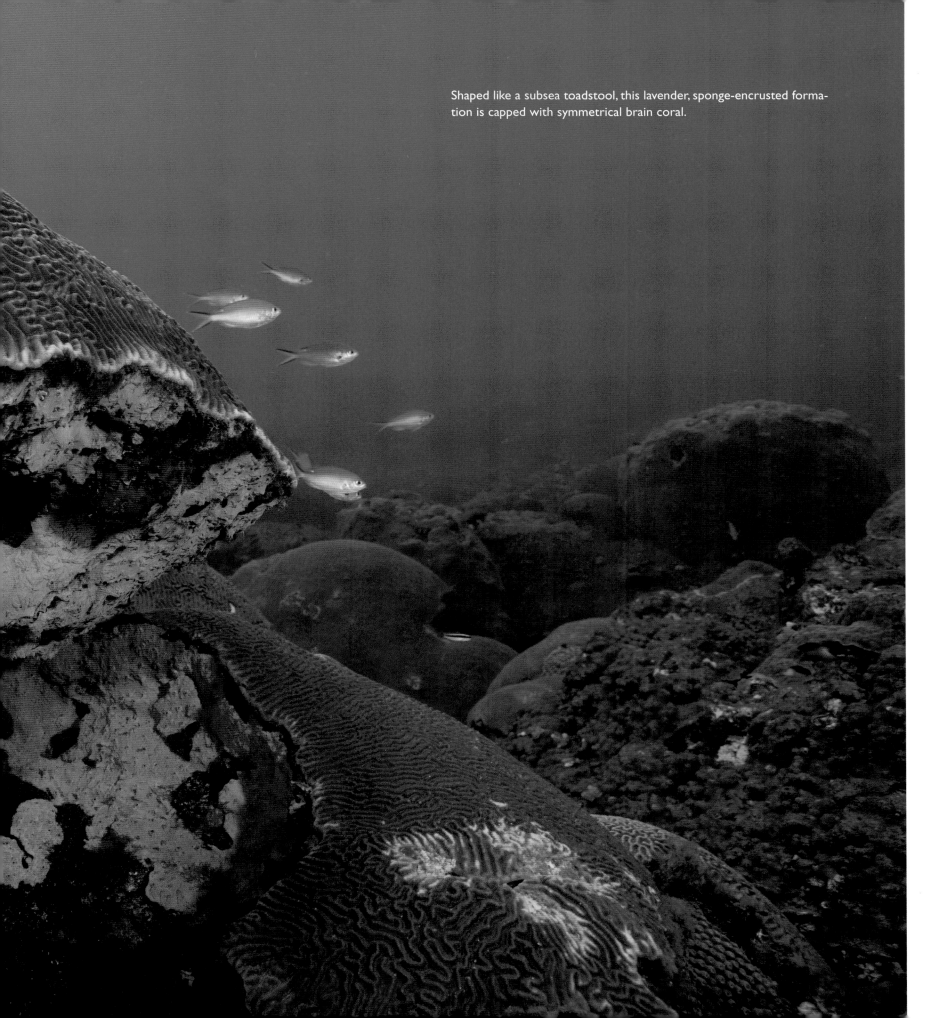
Shaped like a subsea toadstool, this lavender, sponge-encrusted formation is capped with symmetrical brain coral.

buffer of ocean between them and coastal development threats. The steady supply of drifting oceanic larvae and food arrives by way of circular eddies that spin off the Loop Current, which enters the Gulf of Mexico at Cayo Catoche, Mexico, and exits near Dry Tortugas. Wind-driven currents also add to the "Caribbean effect" experienced one hundred miles off the Texas and Louisiana coasts.

If perusing a nautical chart of the northern Gulf of Mexico from South Padre Island to Venice, Louisiana, and following the 100-meter (328-foot) bottom contour, one will see not just a few natural banks protruding from the ocean floor but more than thirty. The largest cluster of banks—up to a third of the count—lies off the coast at the Texas-Louisiana state line. These offshore banks are treasure troves of marine life, and many are virtually unexplored. Only seven of the banks are shallow enough for recreational diving (130 feet [40 meters] or less below the surface). They are the two Flower Garden Banks reefs, Stetson Bank, Sonnier Bank, Claypile Banks, Bright Bank, and Geyer Bank (the last three are just barely within the limits of recreational diving).

The reefs in the northwestern Gulf and surrounding region are special places, and the reasons why are many.

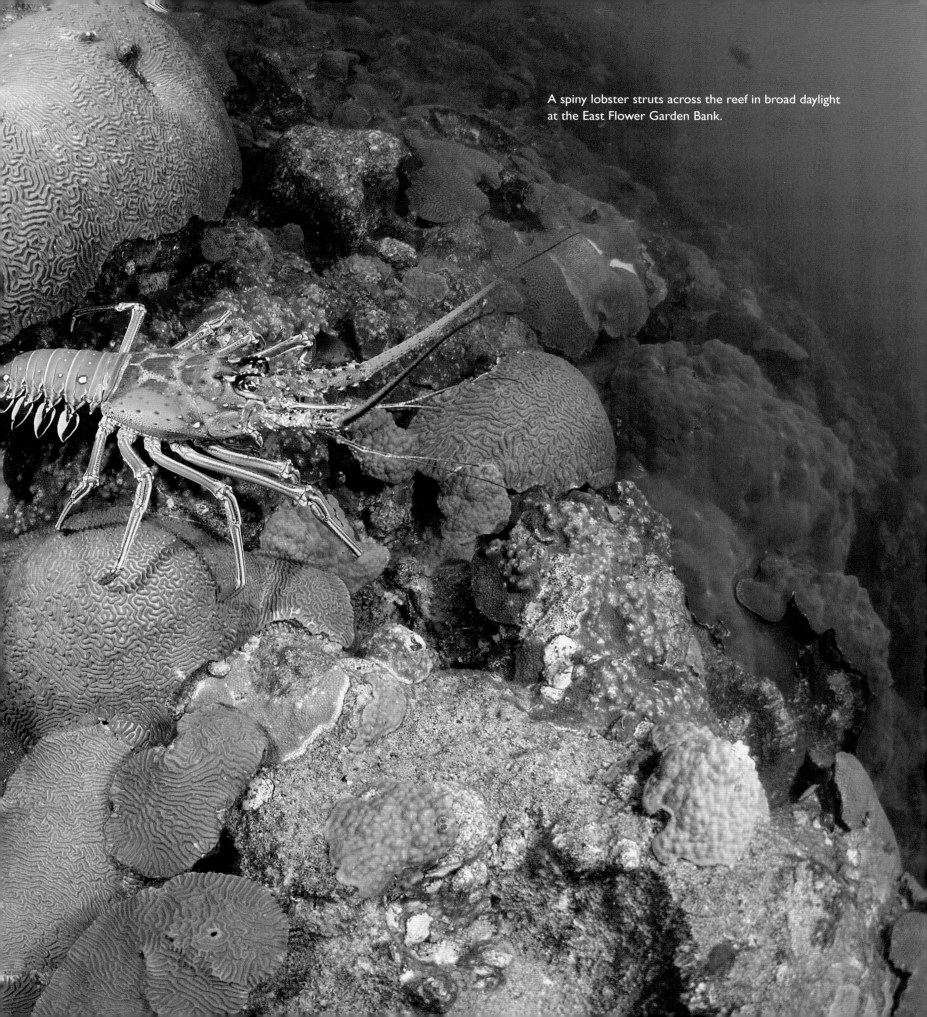

A spiny lobster struts across the reef in broad daylight at the East Flower Garden Bank.

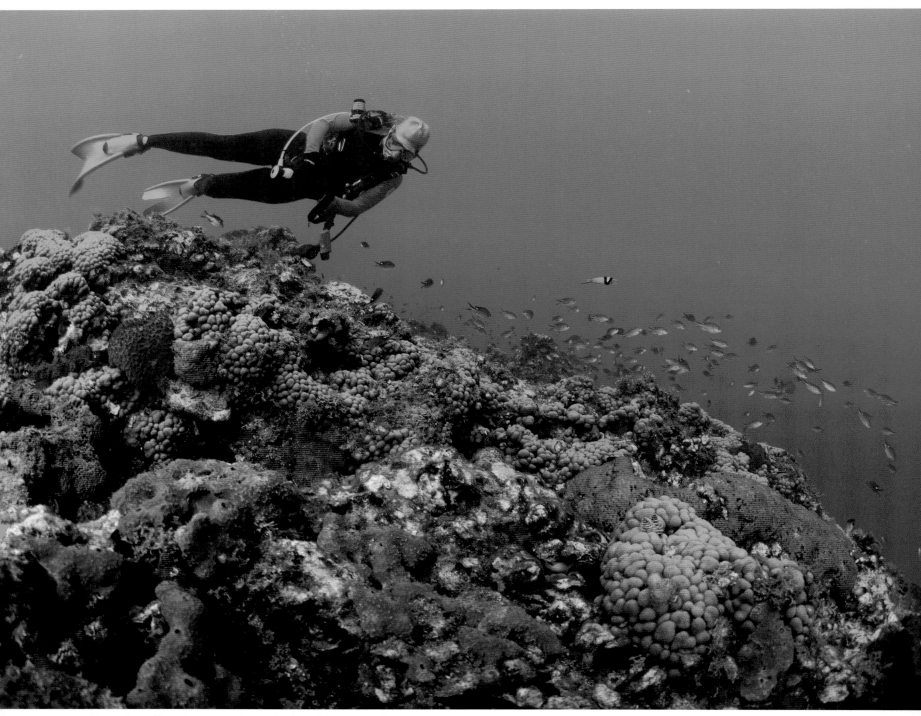

Diver Patty Donalson examines a healthy formation of ten-ray star corals, *Madracis decactis*, at Stetson Bank.

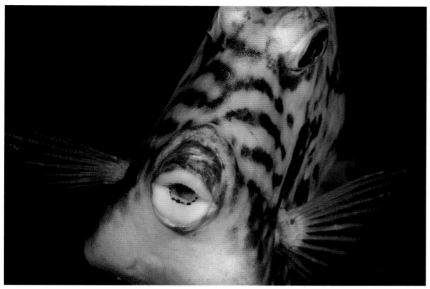

A scrawled trunkfish seems to be approaching for a kiss with "collagen-enhanced" lips and tiny dentures.

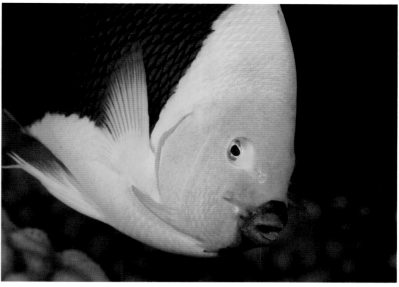

The rock beauty has a striking combination of contrasting colors unlike any other species of angelfish.

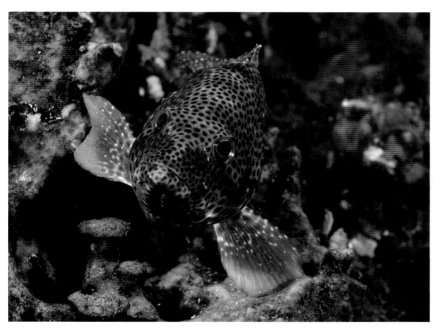

As if in a trance, a graysby stares straight into the lens.

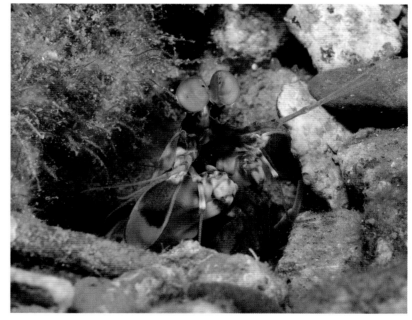

A mantis shrimp eases out of its burrow near Stetson Bank buoy number 1.

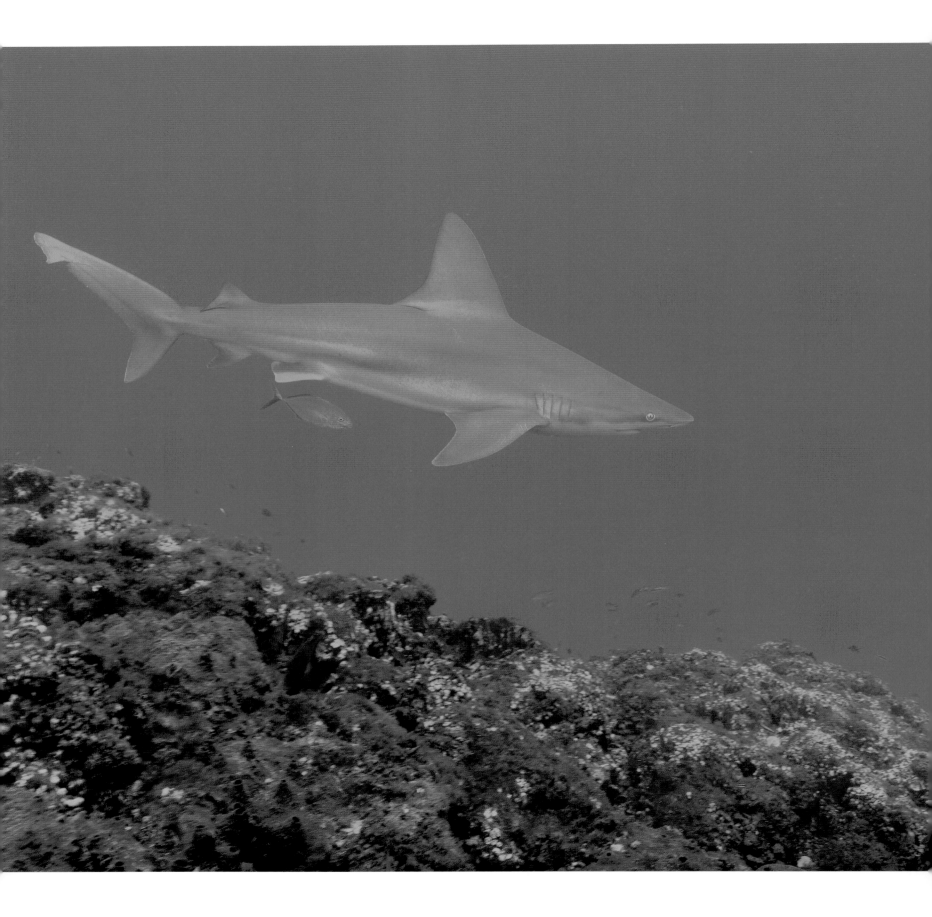

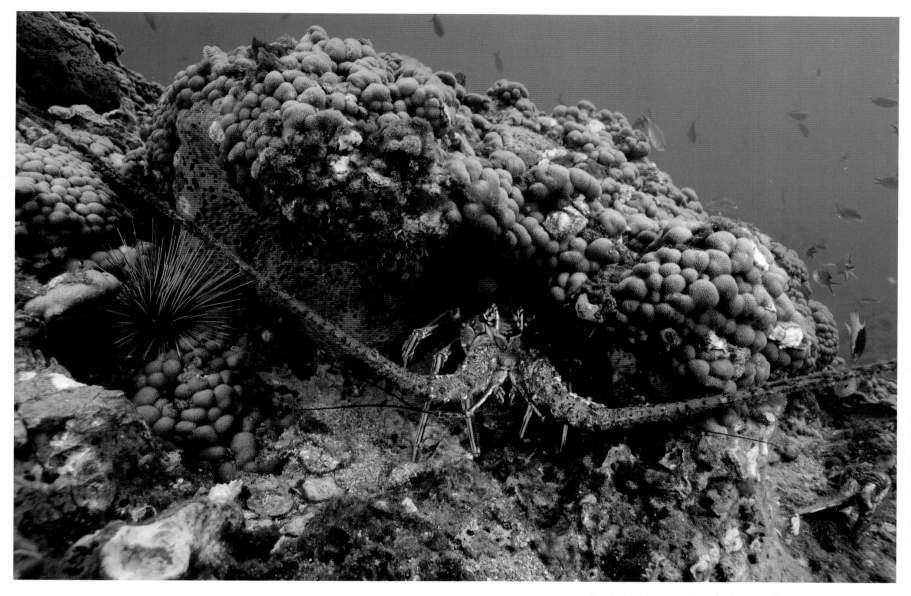

A spiny lobster under a ledge near buoy number 3 at Stetson Bank.

◀ A stocky but magnificent sandbar shark cruises along the northern drop-off of Stetson Bank.

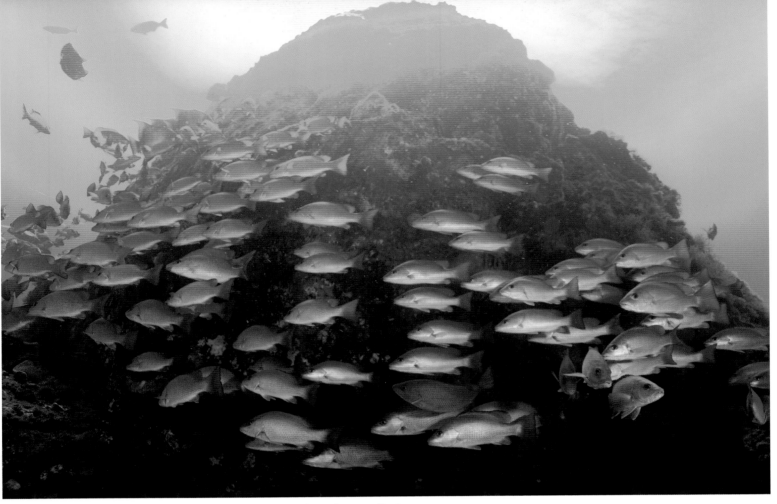

A stunning school of gray snapper wrap around a pinnacle at Stetson Bank.

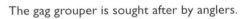

The gag grouper is sought after by anglers.

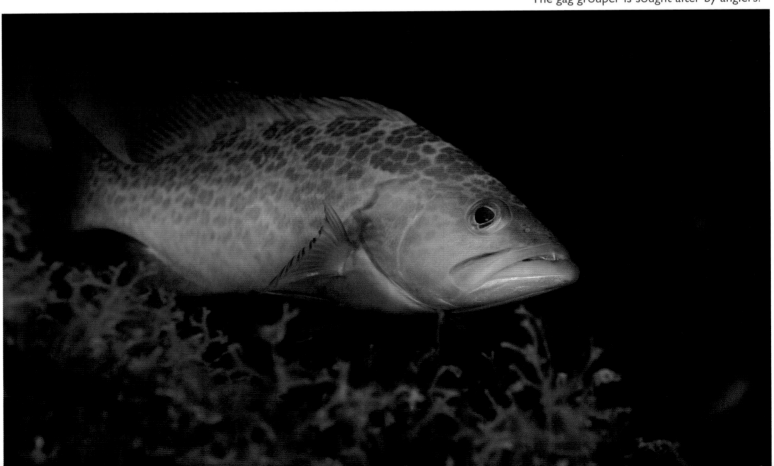

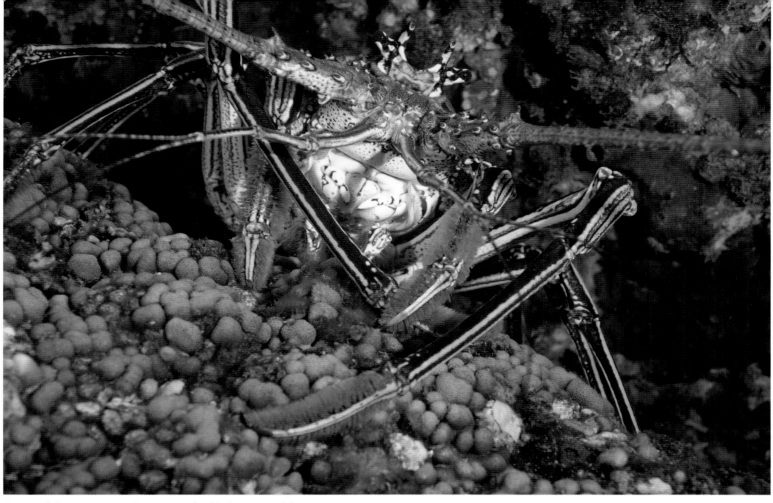

A spiny lobster in a perch on top of a *Madracis* coral formation.

Like magicians, scorpionfish can blend into the reef backdrop and be nearly invisible.

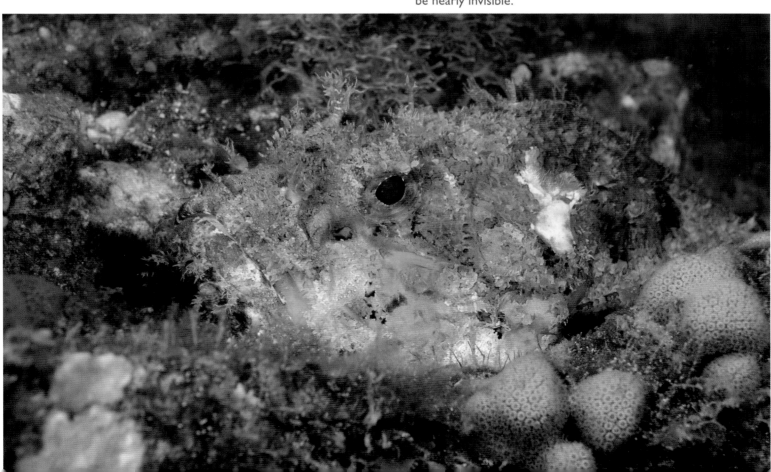

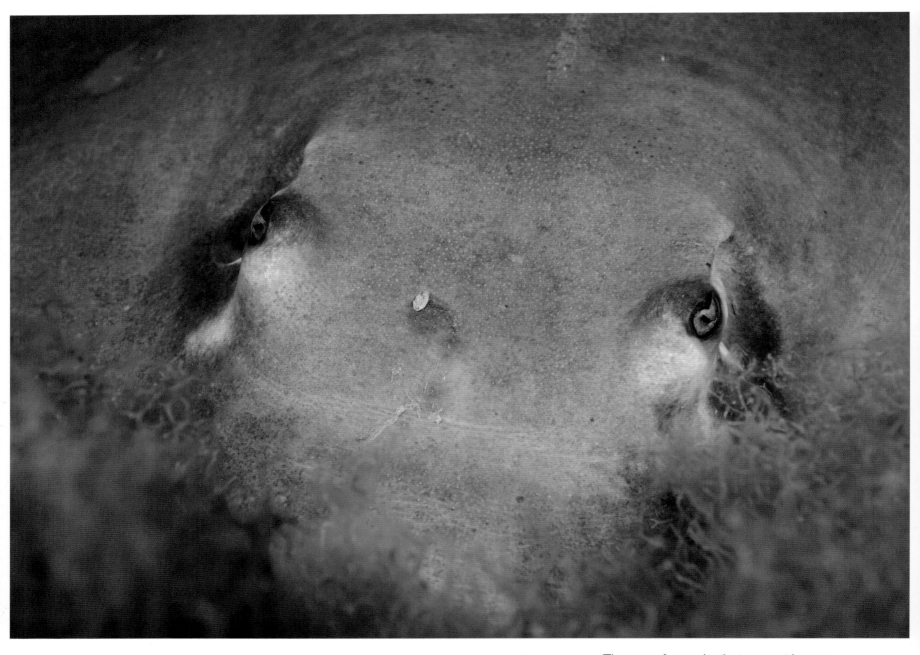

The eyes of a roughtail stingray, with a portion of its body covered by sargassum weed.

A diminutive redlip blenny resting on a sponge at Stetson Bank.

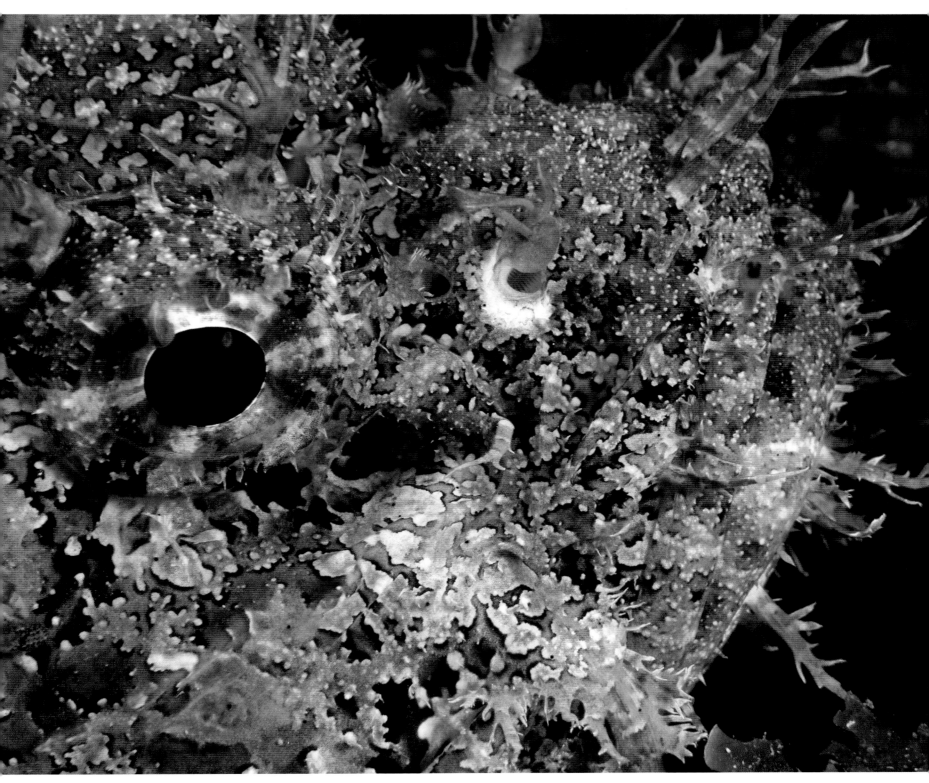

Spotted scorpionfish don't move around much and can be
difficult to spot.

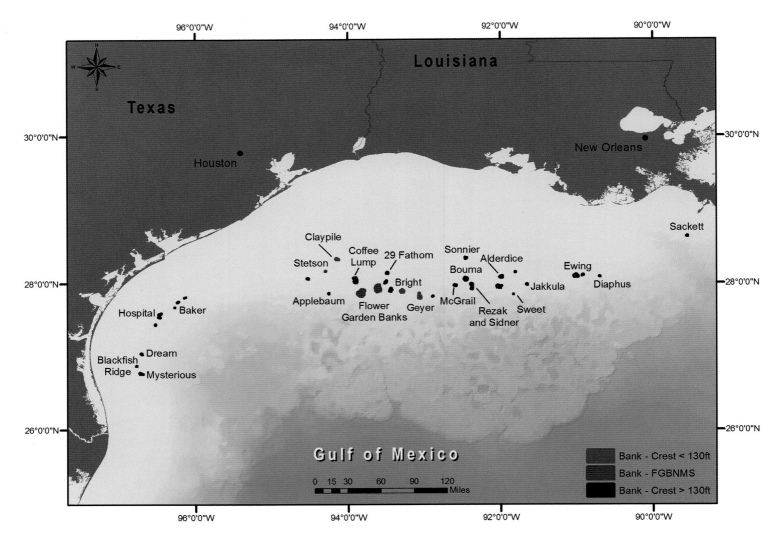

Map 5. Banks in the northwestern Gulf of Mexico

Exceptionally Healthy Corals

At the East and West Flower Garden Banks the stony coral colonies—twenty-two species in all—display remarkable health and sustainability. Marine scientists report that the amount of coral coverage at both reefs (more than 50 percent) is denser than coral reefs in the Caribbean and Atlantic Basin. Since 1988, scientists have been monitoring coral cover at the Flower Garden Banks continuously, and the trends have been remarkably positive. In contrast to the declines seen at so many coral reefs around the world (coral reefs, taken together, are home to a quarter of all creatures that live in the ocean), the data show the coral communities at both Flower Garden Banks sites holding a near steady line of high coverage, in the 50 to 55 percent range. The distance from shore (110 miles) may have a lot to do with the remarkable success of the thriving coral assets divers enjoy and treasure off the Texas and Louisiana coasts.

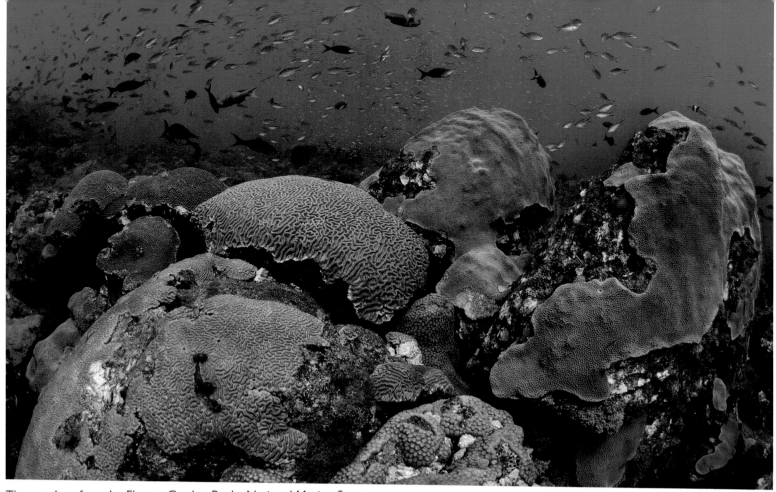

The coral reefs at the Flower Garden Banks National Marine Sanctuary are some of the healthiest in the entire Western Hemisphere.

Diver Patty Donalson examines massive sponges and corals at the East Flower Garden Bank.

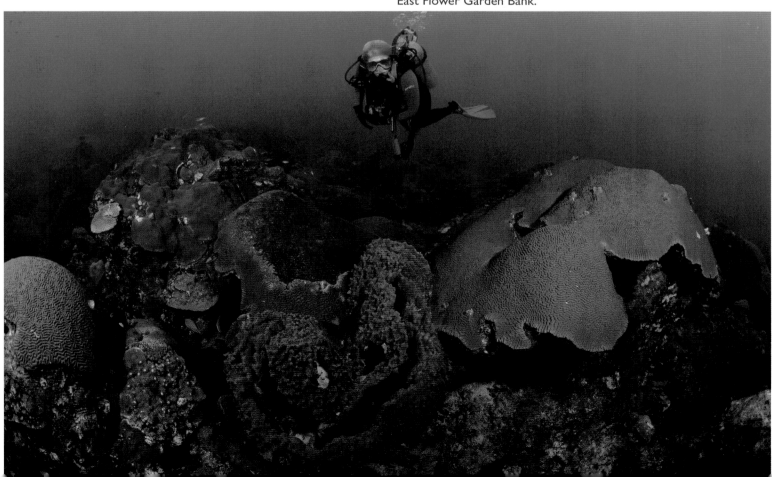

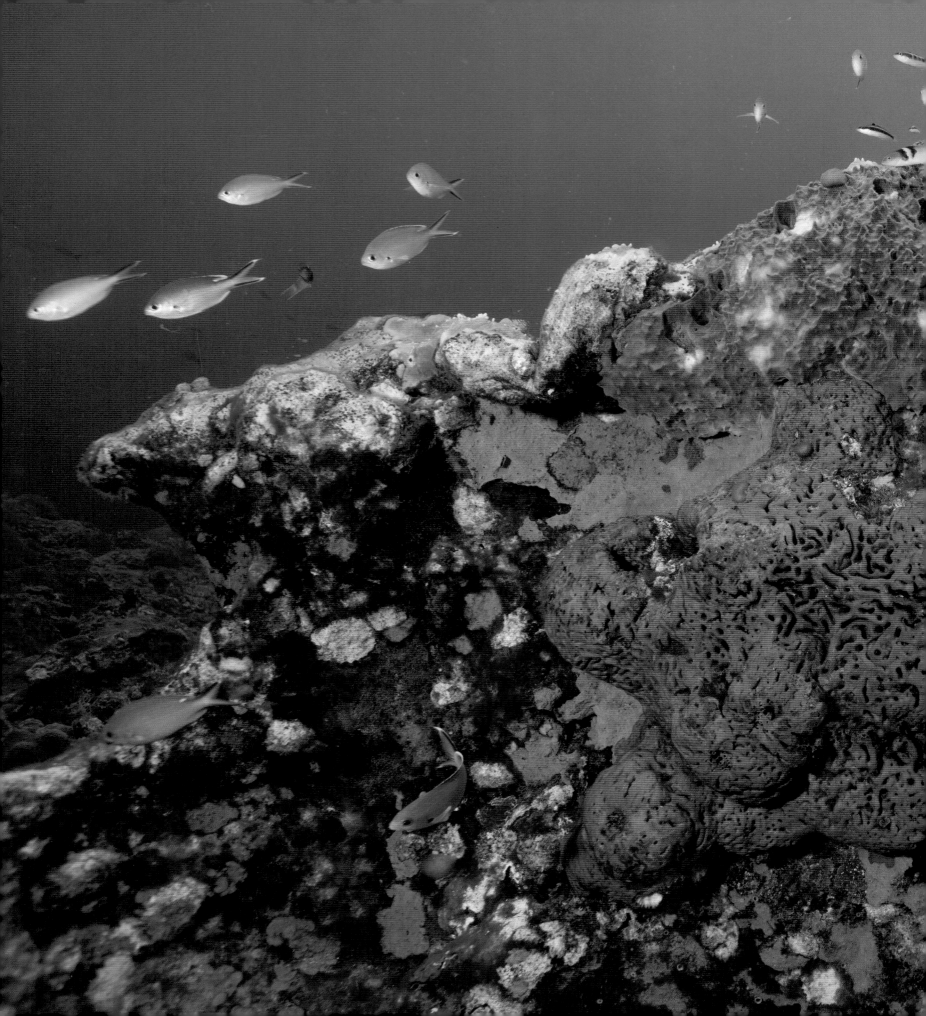

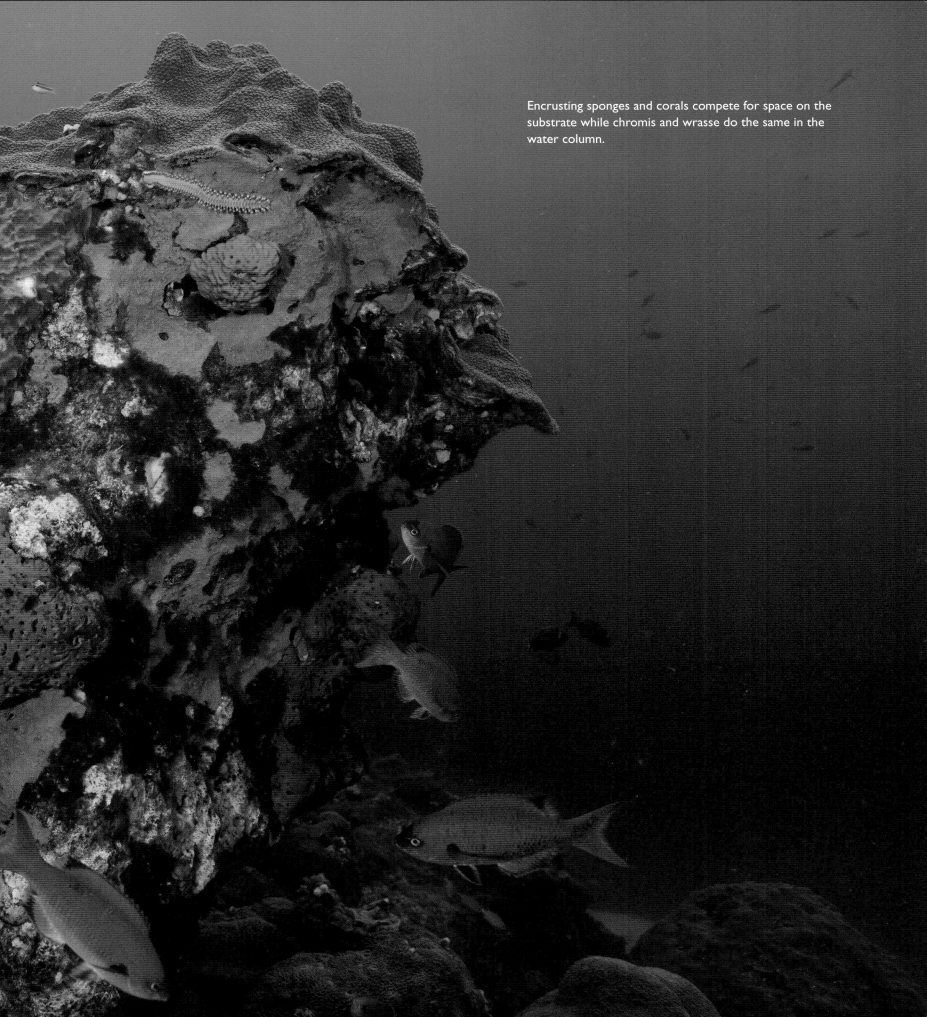

Encrusting sponges and corals compete for space on the substrate while chromis and wrasse do the same in the water column.

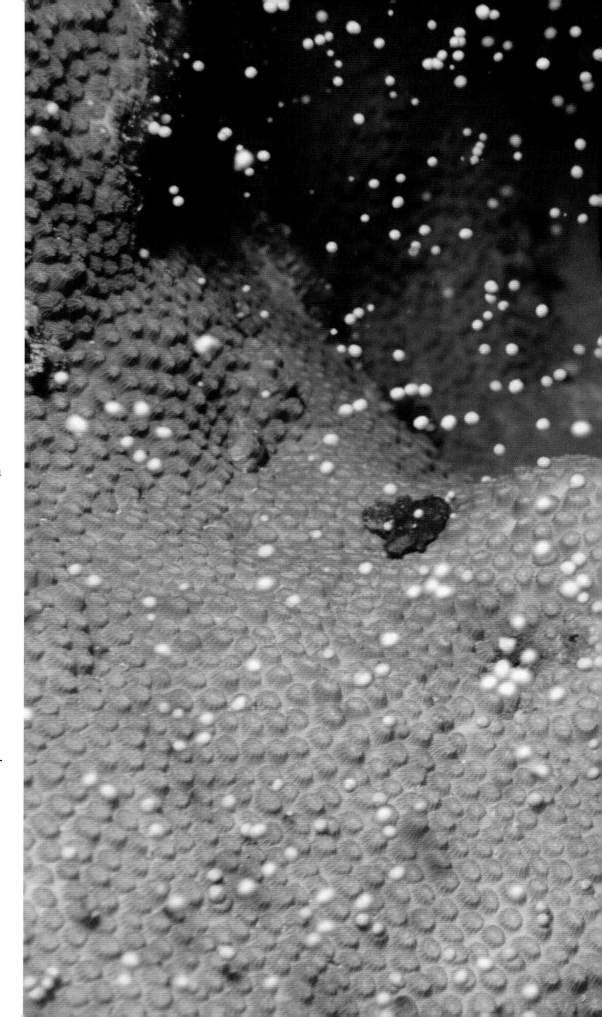

Mass Coral Orgy

Every year, seven to ten days after the August full moon, a sensational event occurs at the sanctuary reefs and displays Mother Nature at her finest. Starting a few minutes after 9:00 p.m., in near synchronization, multitudinous colonies of reef-building corals erupt, sending out plumes of spawn into the water column. The plumes are so thick that at times they cloud the reef area and significantly reduce visibility. It's a phenomenon known as mass coral spawning. Most people have heard about "whiteouts" on a ski slope, but few have ever heard of, let alone witnessed, a "pinkout" on a coral reef! Tiny, BB-sized, pinkish bundles of gametes erupt from coral polyps in a "broadcasting" type of reproduction that resembles a blizzard. The bundles of life-in-the-making gradually float to the surface, where they drift and collide to form new corals. It is then mostly a matter of chance for the free-swimming planulae to find a place to attach and grow. At least six different coral species spawn at different times in the multiday window during which this amazing annual spectacle occurs. Divers and researchers come from afar to witness this extraordinary celebration of coral reproduction.

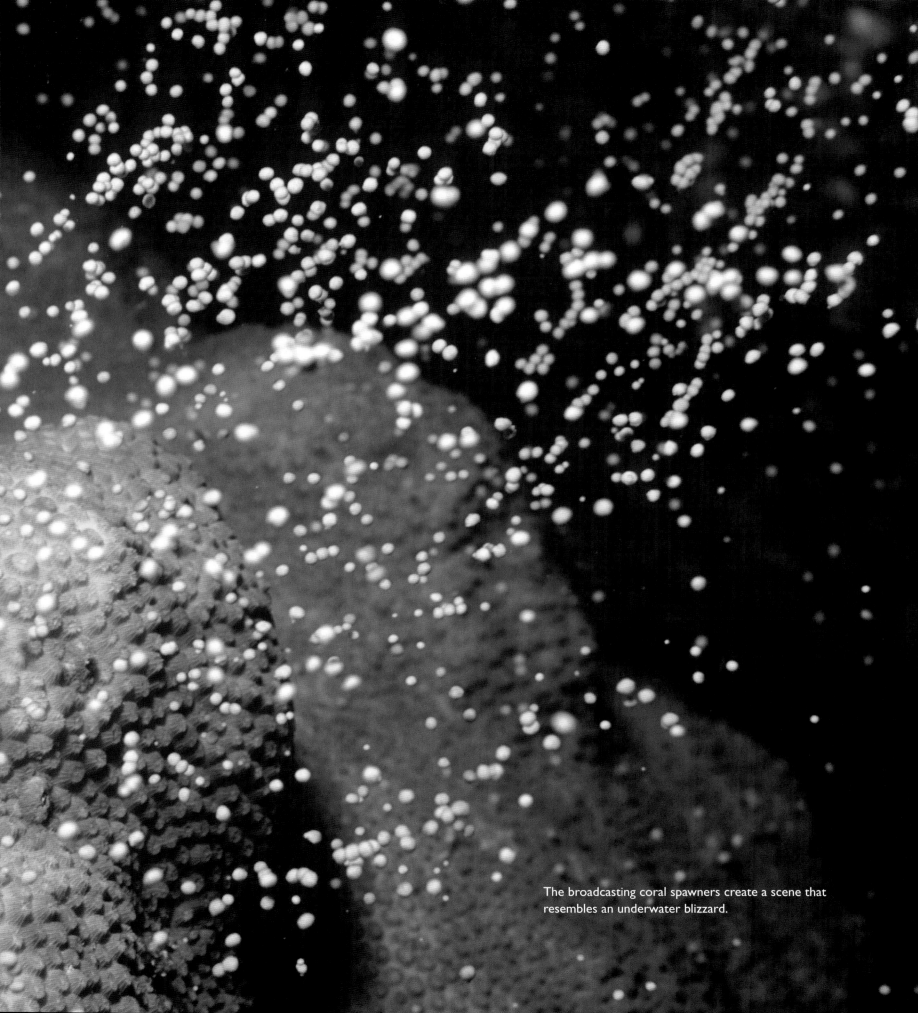
The broadcasting coral spawners create a scene that resembles an underwater blizzard.

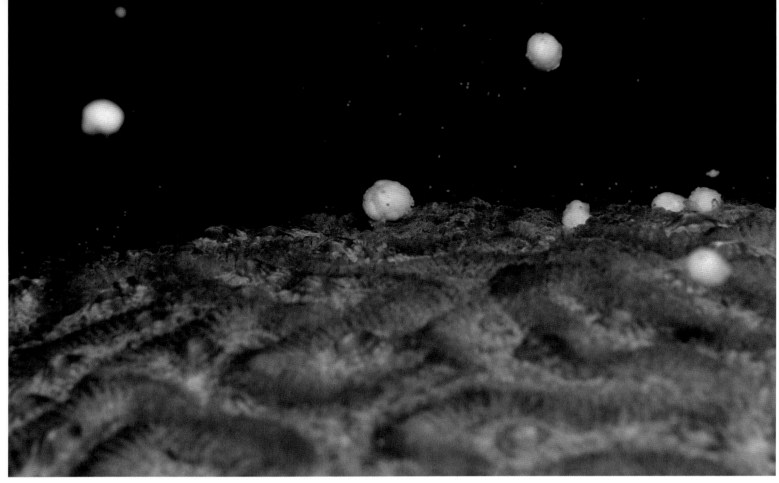

On a celestial cue, mass coral spawning occurs eight to ten days after the August full moon.

Magical Manta Rays

Manta rays are seen at the Flower Garden Banks reefs year round, and the "regulars" are easily identified by unique body-blotch prints on their undersides. These docile plankton feeders appear when least expected and often entertain divers and snorkelers with soaring maneuvers and barrel rolls. They are also known to leap above the surface. Mantas have bodies twice as wide as they are long and have enormous triangular-shaped pectoral fins or wings and a long, slender tail. They have dark upper bodies and mostly white undersides and shoulder boards. Manta rays occasionally unfurl their frontal fins (technically called cephalic lobes) to direct food into their mouths. Their small eyes are located at the base of the outer side of each cephalic scoop. Until recently, all mantas were considered a single species, *Manta birostris*. Now a somewhat smaller manta species is recognized as *M. alfredi*, which can be up to fifteen feet wide from wingtip to tip, whereas *M. birostris* reaches widths of twenty-five feet. Besides size, coloration and markings also distinguish the two species. Mantas are in the same family as eagle rays but, unlike their spotted cousins, have frontal mouths rather than mouths on the underside of their heads. In the entire family of rays, mantas are the only true filter feeders. They scoop up plankton and small fish while swimming through the water column. Their size, unusual shape, and benign behavior make them one of the most inspiring creatures in nature. It's important to note that their skin has a mucus cover to protect them from infections, so rubbing, petting, or riding a manta ray are all grossly irresponsible acts.

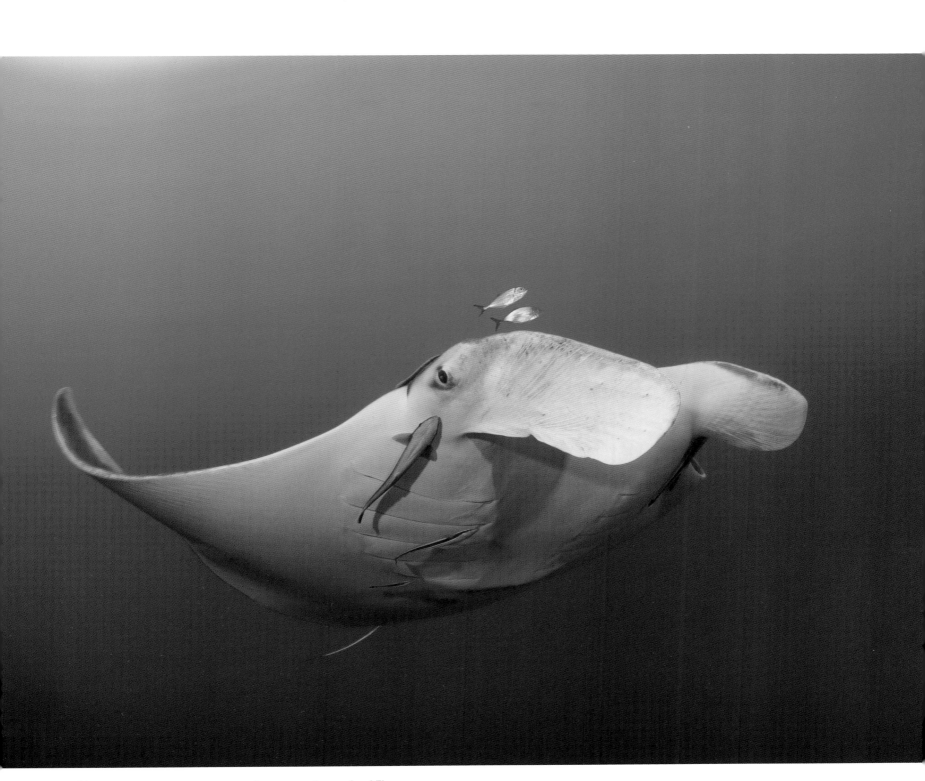

Majestic manta rays are commonly seen at the reefs of Flower
Garden Banks.

The Whale Shark

When finning along in the oceanic blue 70 to 110 miles offshore, one can always expect the unexpected. That's why regular visitors to the Flower Garden Banks reefs are never too surprised to encounter the largest fish in the ocean, *Rhincodon typus*, more commonly called the whale shark. Sometimes these gentle giants cruise straight through the reef without ever slowing down; other times they'll stop and slowly circle the boat for an hour or more. In 2010, less than a month after the BP-owned Macondo Prospect well blowout and oil spill at the Deepwater Horizon rig, scientists spotted an aggregation of more than one hundred whale sharks on Ewing Bank off Louisiana, a location 60 miles west of the well that spewed oil at the seafloor for eighty-six days. Other whale shark groupings had been reported the previous year. Scientists believe the gathering of whale sharks at Ewing Bank is due to the large concentrations of little tunny eggs (tuna spawn) floating on the surface in the early summer months. In June 2011, I accompanied a research group that spent three days cruising Ewing Bank in search of a whale shark aggregation. We saw no large groupings like the previous year, but we did manage to spot three individual giant swimmers.

The lead scientist of the group, Dr. Eric Hoffmayer, successfully attached a satellite tracking device to a whale shark. Understanding the migration trends of the largest fish in the ocean will enable us to better protect the precious population in the Gulf of Mexico. Using photographs that show the markings behind the gills, as well as acoustic devices, researchers have confirmed as many as six whale sharks that have moved between the northern Gulf and the southern Gulf off the Yucatán Peninsula, a distance of 500 miles.

The white satellite tag on this whale shark at Ewing Bank off Louisiana is used to monitor its range throughout the Gulf of Mexico.

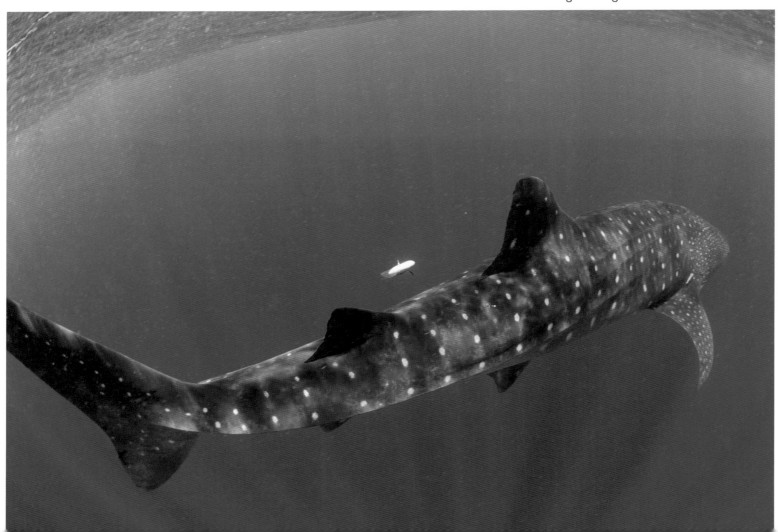

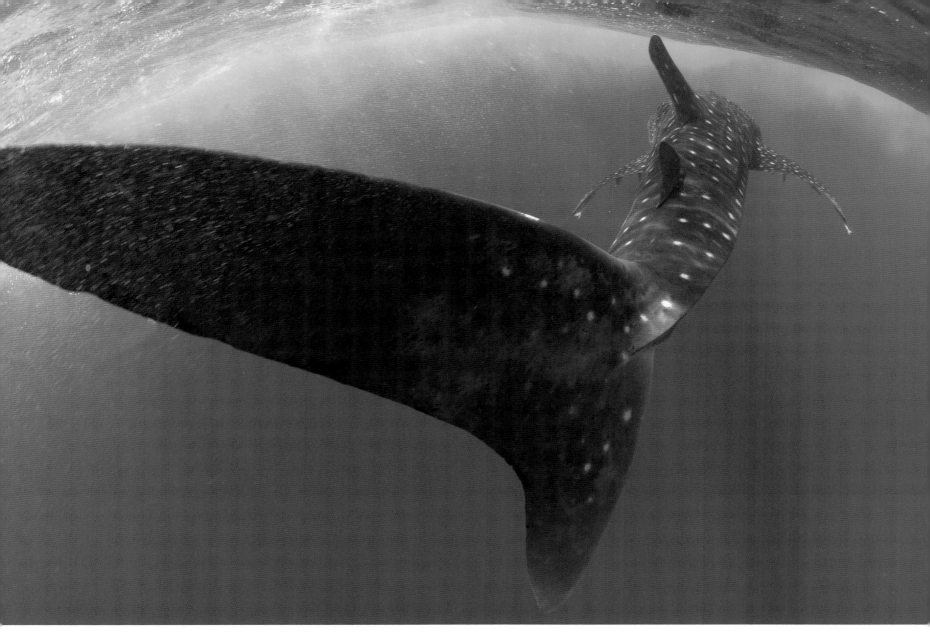

A whale shark swims away from a platform near the East Flower Garden Bank.

Scalloped Hammerheads

During the cooler months, from January to mid-April, schools of scalloped hammerhead sharks, *Sphyrna lewini*, converge at the East and West Flower Garden Banks and other banks in the northern Gulf. Unlike the great hammerhead and other sharks at the apex of the food web, scalloped hammerheads commonly swim in schools and are encountered this way throughout the world at sea mounts and pinnacles. Why this happens and how they appear to migrate from pinnacle to pinnacle or bank to bank is still not clearly understood.

Scalloped hammerheads are mostly coastal animals but also

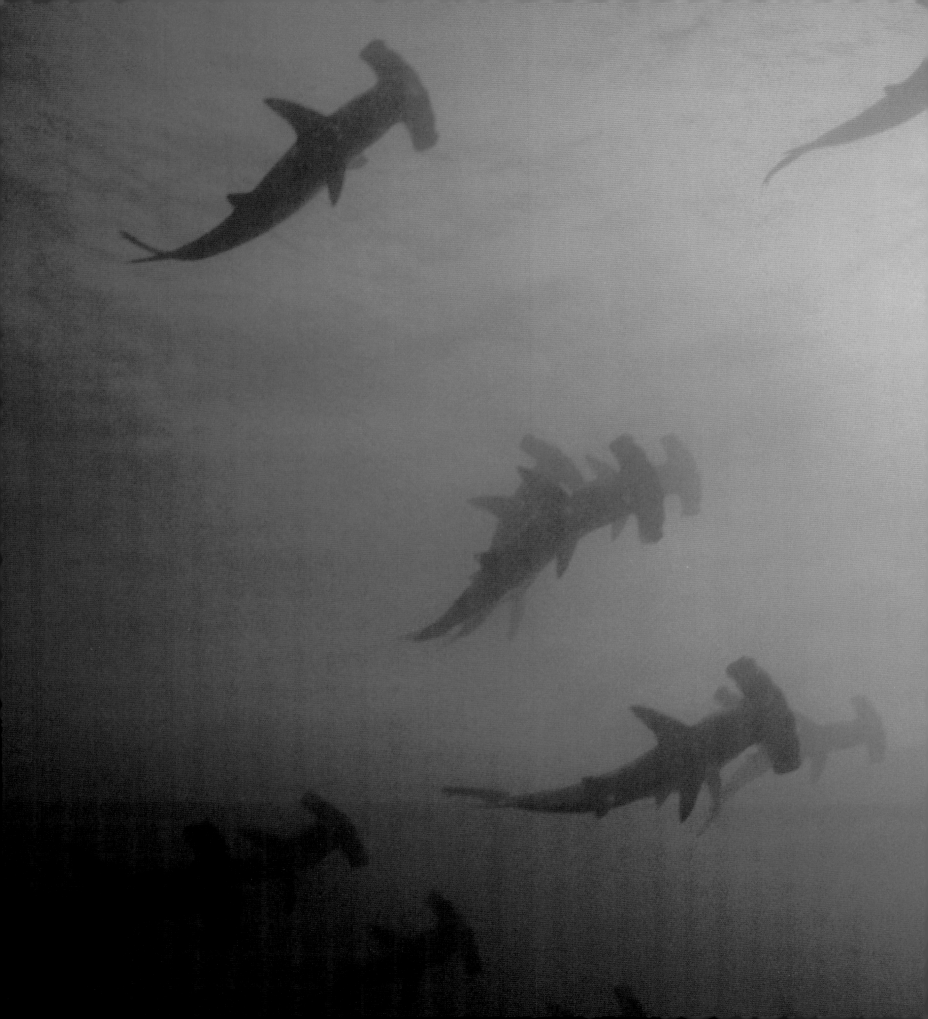

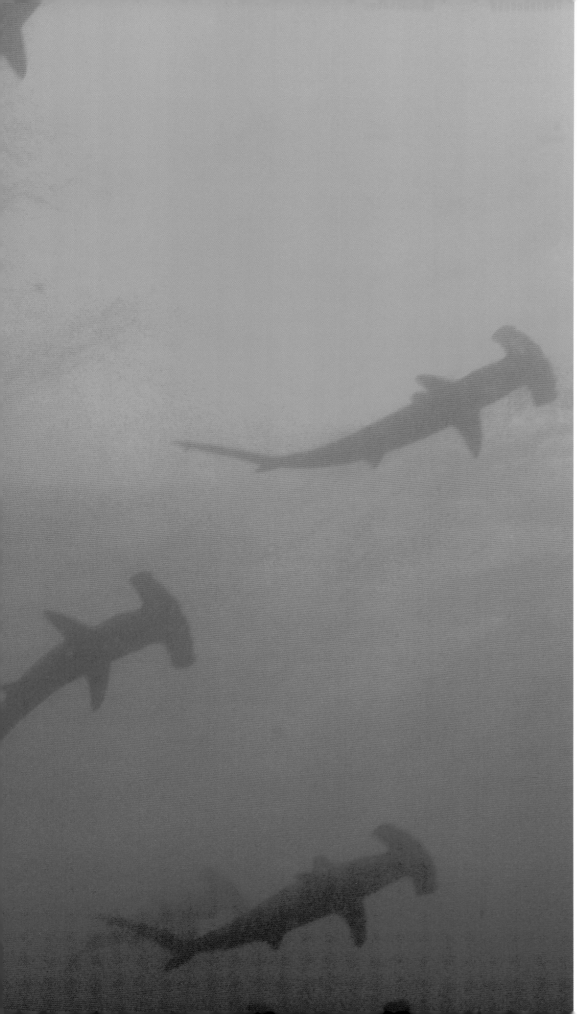

roam the open ocean. They feed on fishes such as mackerel, sardines, and smaller sharks. On occasion they eat octopus and squid. They are not aggressive toward humans and not considered a "dangerous" shark, but, as with any shark, they deserve respect. There are eight species of hammerhead sharks. They get their name from their frontal "hammer," the unusual wide and flat leading edge of their body. On the scalloped hammerhead, this bizarre-shaped head has a scalloped rather than flat front edge. Mature scalloped females can grow up to twelve feet in length; the males are smaller.

Scalloped hammerheads give birth to live young, and pups measure eighteen inches at birth. In my forty years of diving in oceans around the world, watching a school of scalloped hammerhead sharks swim overhead has been one of the most magnificent ocean experiences I've ever had. And I'm pleased and proud to know I've had such an encounter not only in the Galápagos Islands and Cocos Islands but also at my "home" reefs in the northern Gulf.

Scalloped hammerhead sharks tend to congregate at the East and West Flower Garden Banks in the late winter and early spring months.

6

On and Off the Shelf

A broad rim or continental shelf encircles nearly the entire basin of the Gulf of Mexico, extending more than 100 miles off the Texas coast, as much as 200 miles off the west coast of Florida, and an equal distance north of the Yucatán Peninsula. Combined with the intertidal areas close to shore, the continental shelf and the slope running down to the "deep sea" constitute upwards of 60 percent of the area of the Gulf of Mexico. Areas deeper than 660 feet (200 meters) make up the remainder of the Gulf. The deepest region of the Gulf, deeper than 10,000 feet (3,000 meters) is larger than most expect. It includes 20 percent of the area of the Gulf (see map 3, Gulf of Mexico basin and Loop Current). The oil and gas industry continues to probe deeper parts of the Gulf in search of hydrocarbons, and the scientific exploration of the deeper Gulf continues as well, but so much is left to explore. If there's a silver lining in the blowout of the Macondo Prospect well in 2010, it's the renewed interest and funding for further scientific research in the Gulf of Mexico, especially the deeper Gulf.

For marine scientists, the "deep sea" begins at 660 feet (200 meters) below the surface or roughly six times deeper than the limit for recreational scuba diving and approximately twice the depth limit for the majority of technical divers. No "deep sea" images are presented in this book, but it's worth noting that a significant portion of the Gulf is considered "deep sea," where depth and pressure increase significantly while temperature and light drop to constant lows. Nutrient levels also drop, yet a complex food web living without sunlight includes such weird-looking creatures as vampire squid, goblin sharks, and hatchetfish.

Whales and Dolphins in the Gulf of Mexico

Scientists report twenty-eight species of whales and dolphins inhabit the Gulf of Mexico. Whales include minke, blue, fin, Bryde's, and sperm, to name a few; some of the dolphin family members living in the Gulf are spinner, spotted, and bottlenose dolphins. Killer whales, *Orcinus orca*, also inhabit the Gulf. As mentioned earlier, a population of fifteen hundred sperm whales, *Physeter macrocephalus*, resides year round in the northern Gulf from Florida to South Texas at the three-thousand-meter depth contour (nearly ten thousand feet). The sperm whales that live in this area just beyond the continental slope hunt in total darkness in the deep, cold canyons, where they feed on squid. More than thirty Bryde's whales have been identified in an area south of the eastern panhandle of Florida. An estimated forty thousand bottlenose dolphins live in the Gulf of Mexico. That number constitutes 30 percent of the population in US waters.

Ancient Nomads of the Gulf

The Gulf of Mexico is home to five of the seven species of sea turtles in the world: hawksbill, green, Kemp's ridley, loggerhead, and leatherback. (The only two not found in the Gulf are the olive ridley and the flatback). Hawksbills can be identified by their raptor-like jaws. Green turtles get their name from the color of their body fat (not from their shells, which are olive-brown with dark spots). Kemp's ridleys are the smallest and most endangered Gulf turtle. They feed mainly on crabs and tunicates. Loggerheads are easily recognized by their size and enormous heads. Leatherbacks, however, are by far the largest sea turtle, weighing in at fourteen hundred pounds. They are the only sea turtle without a hard shell.

The humpback whale, like this one photographed at Silver Bank off the Dominican Republic, is one of several species of whales known to visit the Gulf of Mexico.

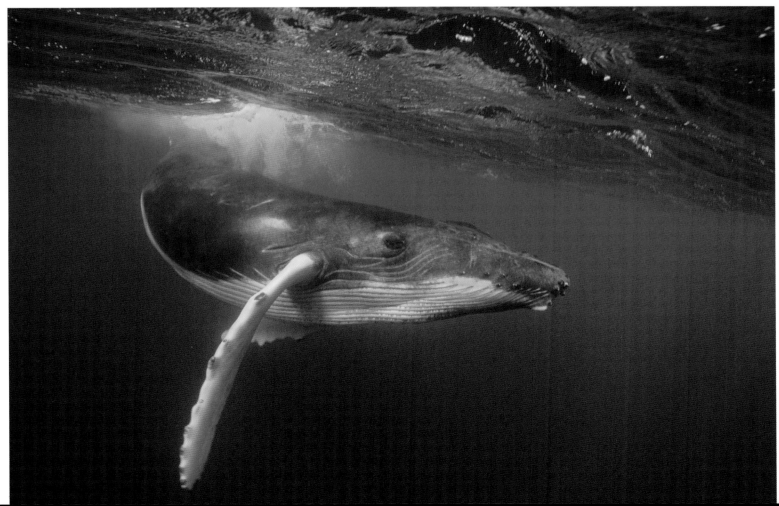

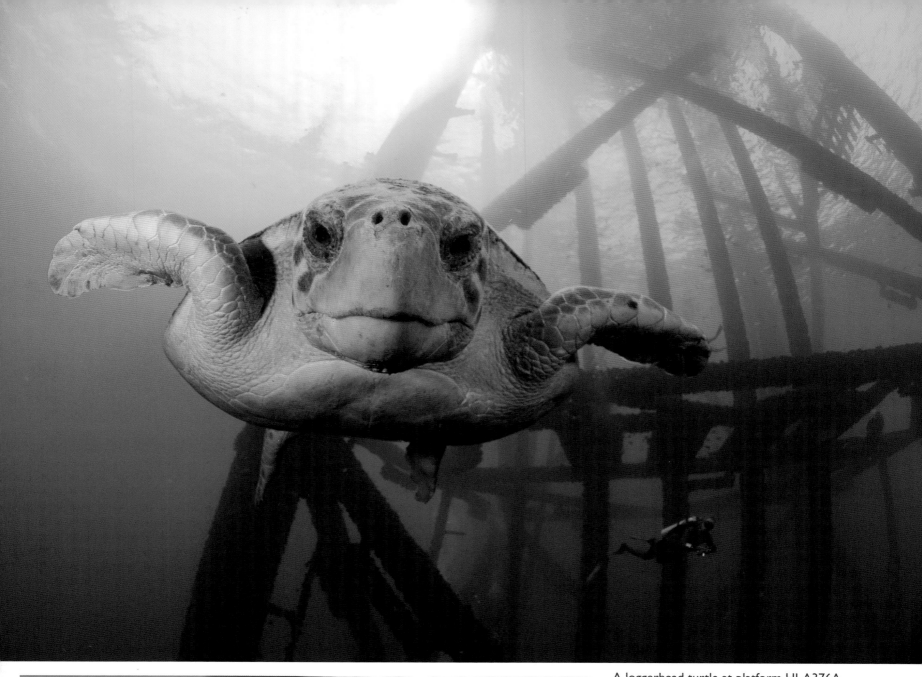

A loggerhead turtle at platform HI-A376A swims directly into the camera port.

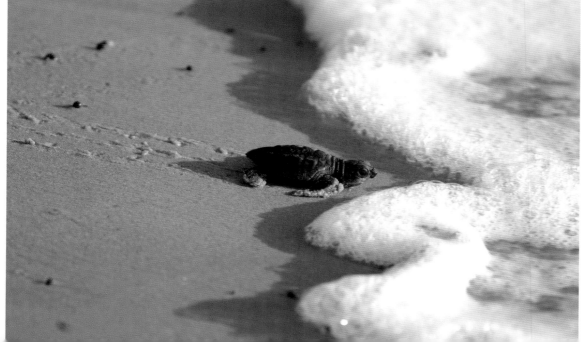

Baby Kemp's ridley sea turtles return to the ocean at South Padre Island.

Sea turtles nest all along the Gulf of Mexico coastline, on beaches from Dry Tortugas to South Padre Island, Texas, and Tamaulipas, Mexico. The two species commonly encountered at the offshore banks of the northwestern Gulf are the loggerhead and the hawksbill.

Sometimes called "ancient nomads of the deep," these air-breathing ocean reptiles have been around for more than one hundred million years and still roam the ocean in a mostly solitary fashion. They have the ability to travel long distances using their powerful front flippers and are able to dive to great depths and come up for air just a few times each hour. They have powerful and effective jaws but no teeth. Loggerheads can easily crush shells to feed, and hawksbills eat by using their beaklike jaws to tear apart sponges and corals.

Humans are by far the greatest threat to marine turtles in the Gulf of Mexico, and their impact began shortly after the Spaniards arrived in the early sixteenth century. Turtles were hunted primarily for their meat and later for their shells. All marine turtles in US waters are now protected by the federal Endangered Species Act, but protecting nesting areas remains a concern. Besides coastal development of nesting beaches, threats today include ingestion of discarded plastic, fishing line, aluminum foil, and many other types of floating and bottom debris. Trawlers without the turtle-friendly "turtle excluding device," or TED, are also a threat.

The Floating Nurseries of the Gulf

Sargassum seaweed, found throughout the Gulf of Mexico, is especially plentiful in the northwestern Gulf. Marine scientists report this part of the Gulf is a "nursery" for the massive clusters of free-floating plants. As much as a million tons of sargassum seaweed is produced annually in this region alone. Off Texas and Louisiana I've snorkeled in giant swaths of the floating brown algae that extended for miles and were, in some spots, more than five feet deep. These drifting, nearly self-contained ecosystems serve numerous functions. Besides behaving as the plants they are in converting carbon dioxide to oxygen by way of photosynthesis, sargassum mats serve as food webs for an astonishing number of species from both the ocean and the air overhead. More than 150 species of biota are associated with

A drifting sargassum seaweed mat floats on the surface at Ewing Bank off Louisiana.

sargassum mats. The young of at least four species of sea turtles hide from predators in sargassum weed. Some of the fish species most commonly found in these "floating rainforests" include triggerfish, various flying fishes, filefish, and blue runners. Some of the most impressive animals include seahorses, dolphinfish, larval forms of various billfishes, and of course sargassum fish. From the air, masked boobies, terns, and shearwaters feed on the live bait hiding under the mats, which are kept buoyant by the many closely spaced, air-filled floats. So, the "nursery" description is twofold: the northwestern Gulf is a nursery for sargassum seaweed, and the sargassum seaweed is an open-water floating nursery for a host of incredible ocean life.

This huge mat of vegetation provides crucial habitats for a wide variety of marine animals in the open ocean, including pelagic species such as tuna, dolphinfish, wahoo, and billfish.

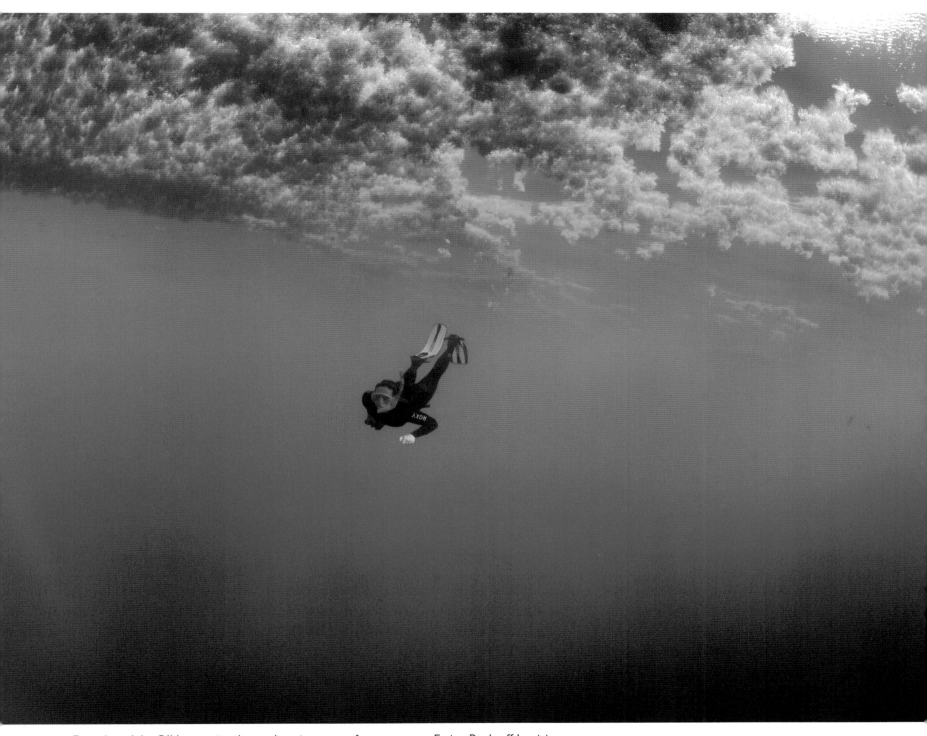

Free diver Julia O'Hern swims beneath a giant mat of sargassum at Ewing Bank off Louisiana.

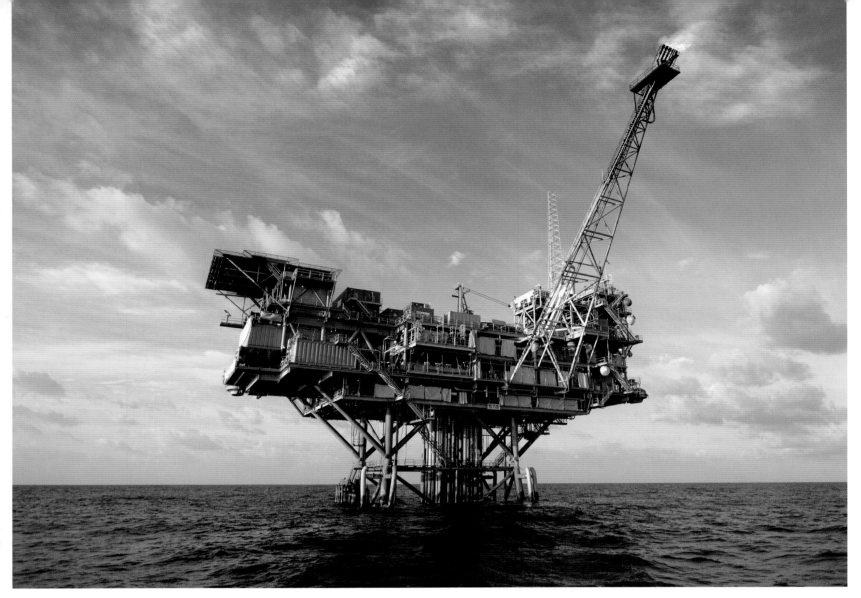

There are more than thirty-five hundred oil and gas platforms in the northern Gulf of Mexico alone.

Oil and Gas Platforms in the Gulf

Today there are a whopping thirty-five hundred gas and oil platforms operating in the northern Gulf: roughly twenty-six hundred off the Louisiana-Mississippi coasts and nine hundred off Texas.

Besides being important energy producers (roughly 25 percent of gas and 10 percent of oil produced in the United States), these platforms are significant habitats for marine life and major destinations for scuba divers. The warm, plankton-rich currents that swirl their way around the Gulf transport the seeds of life that attach to the platform steel as if it were a natural hard-bottom

area. Marine scientists indicate that the platforms closest to the natural reefs are the most heavily endowed with algae, sponges, hydroids, anemones, and corals, along with an aquariumlike tank of tropical fishes within their structural members. On a macro scale, colorful tessellated and seaweed blennies put on a show as they poke their comical heads out of barnacle shells attached

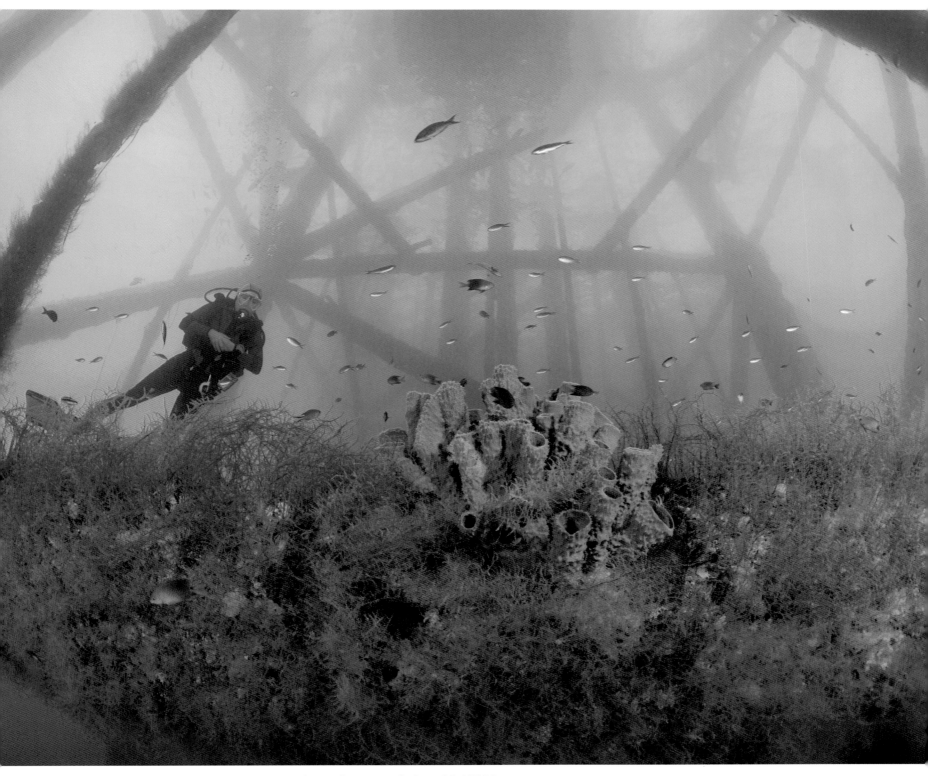

Diver Vivian Dunlop views sponges and reef juveniles at gas platform HI-A389A.

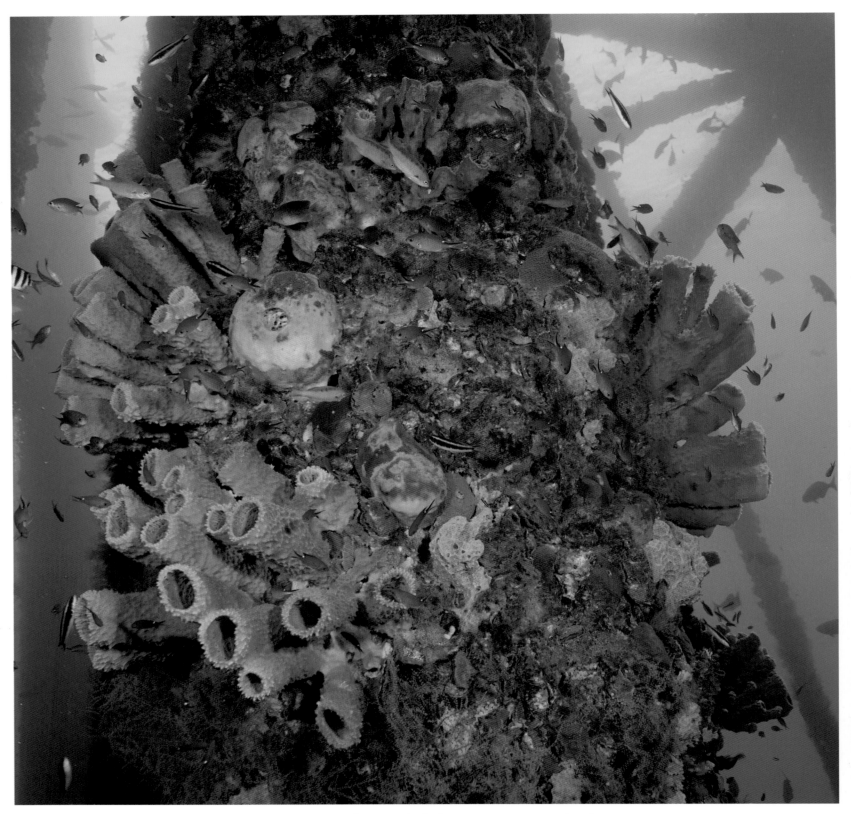

Colorful sponges and algae use the platform structure as a substrate, which also supports a community of small tropical fishes.

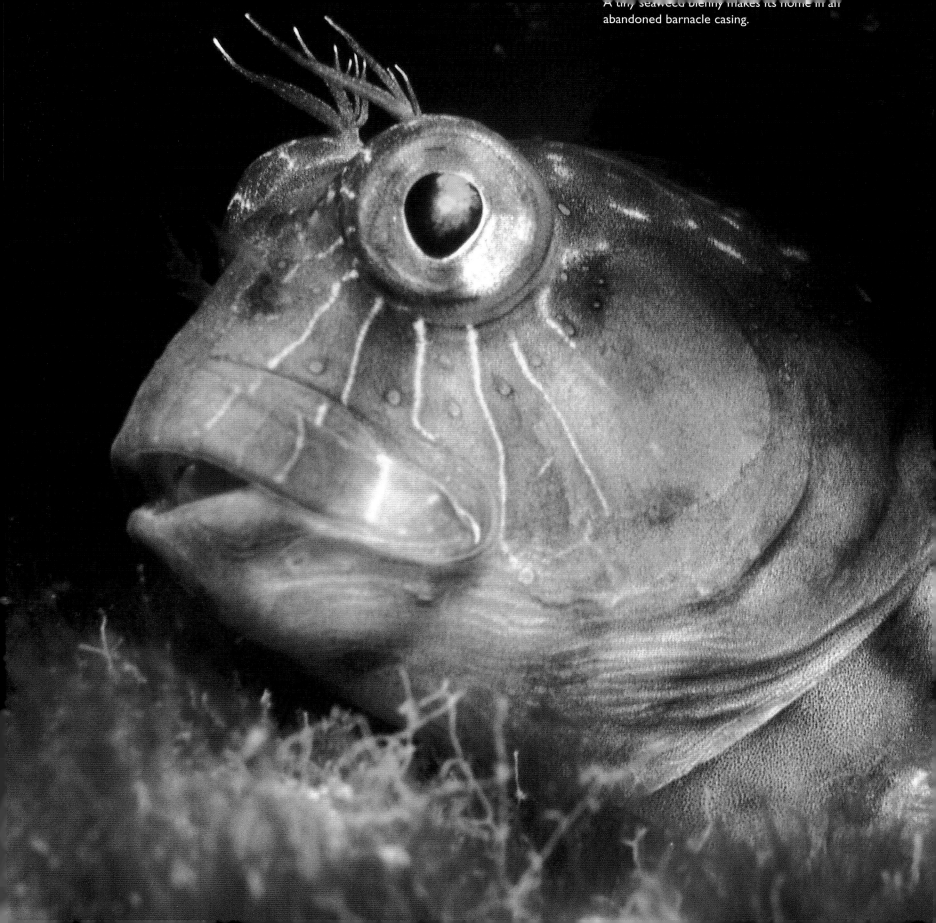

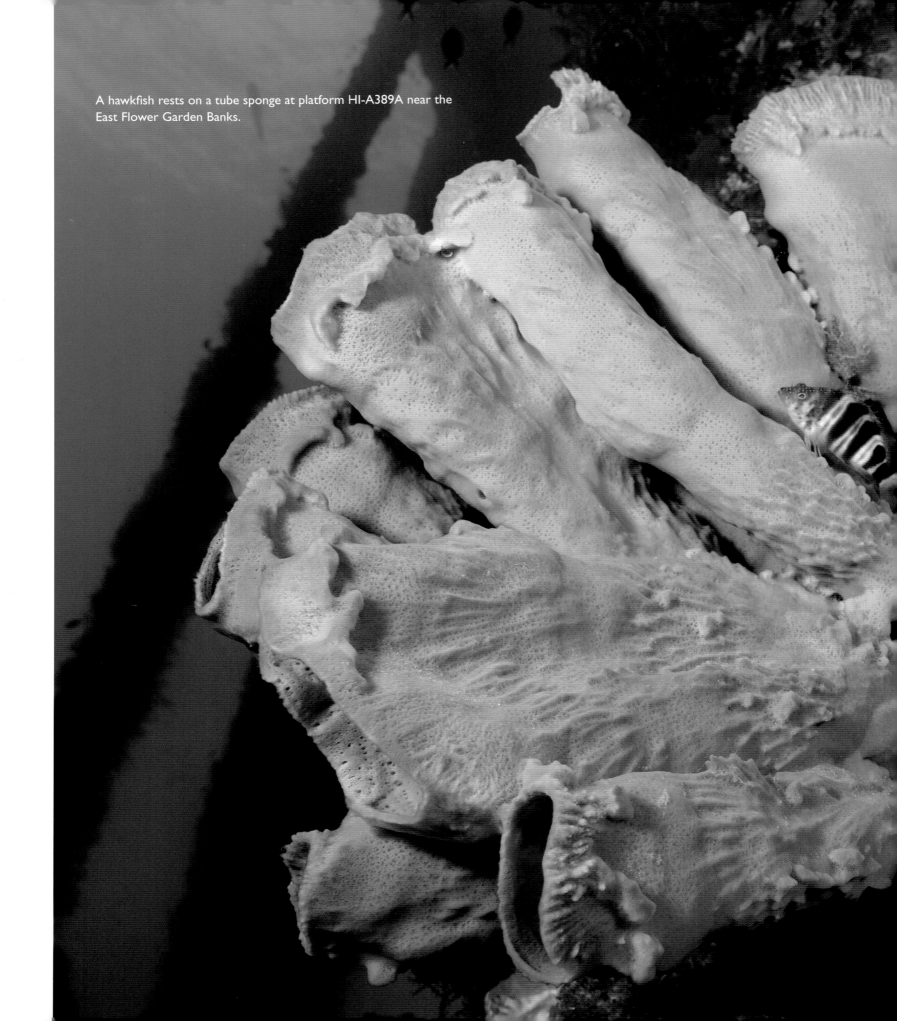

A hawkfish rests on a tube sponge at platform HI-A389A near the East Flower Garden Banks.

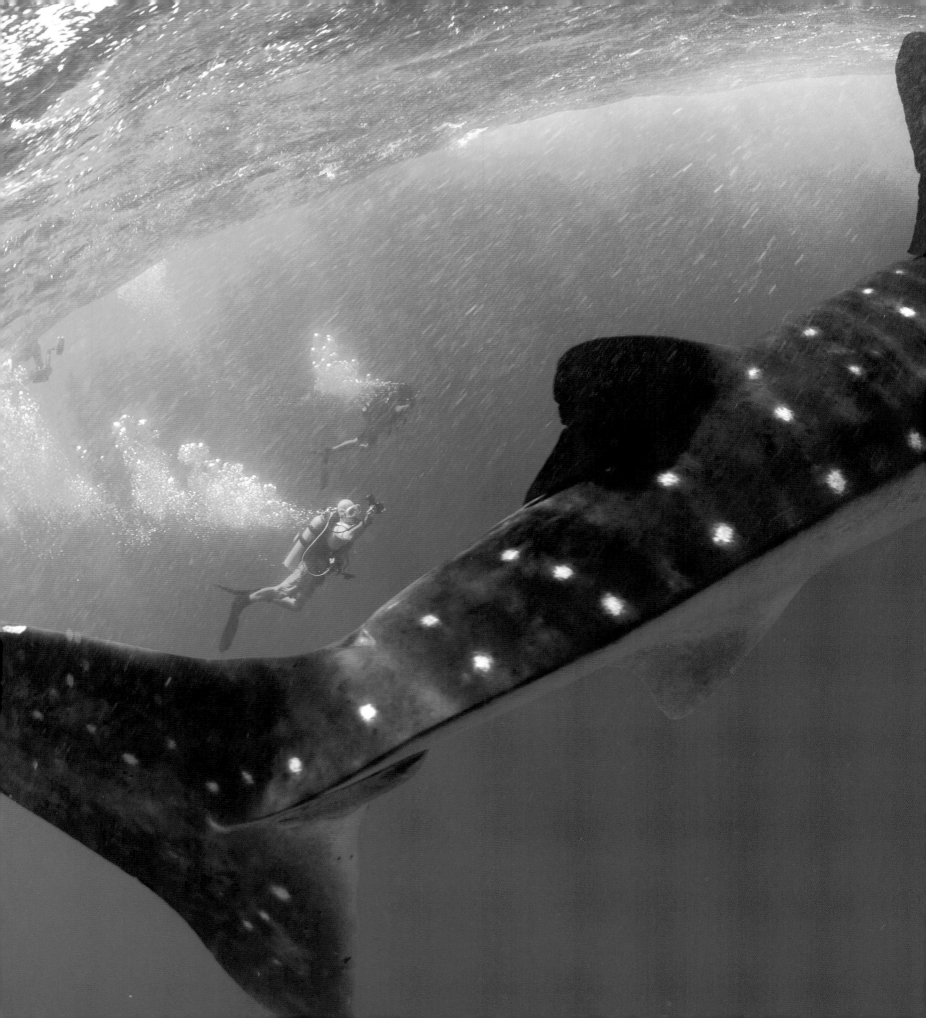

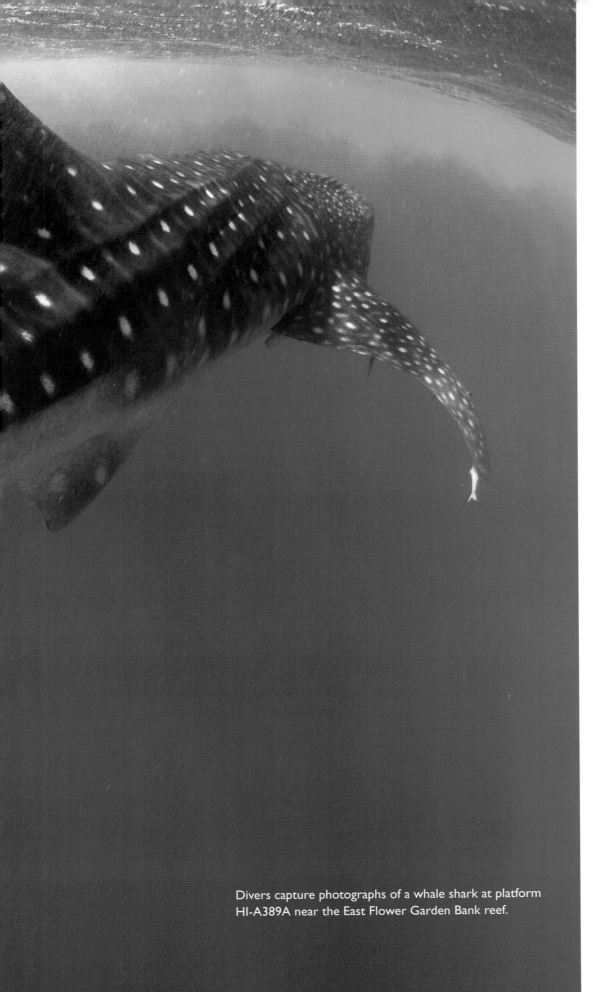

to the platform steel. At the other end of the size spectrum, loggerhead turtles make platform structures their home and silky sharks circle platforms like other sharks do a seamount. In 2011, while swimming just outside the High Island A389A platform near the East Flower Garden Bank, I photographed a whale shark. In the northern Gulf of Mexico, the "iron islands" on the outer continental shelf also offer something special that none of the nearby natural reefs can—a portion of shallow substrate for life. The outer continental shelf of the northern Gulf has no natural islands and the shallowest reeftop is fifty-five feet below the surface, so the platform structures are the only substrates for flora and fauna in the zone from the surface to nearly sixty feet deep.

Maritime Heritage in the Gulf of Mexico

When assessing the various assets in the magnificent Gulf of Mexico, historical shipwrecks may be the most underappreciated component. They represent not just a physical record of where we came from but also, in part, why we are who we are. To damage or destroy a sample of our heritage is to lose a piece of our identity. I've always

Divers capture photographs of a whale shark at platform HI-A389A near the East Flower Garden Bank reef.

been fascinated with shipwrecks, but not until recent years have I gained such a profound appreciation for what they really mean for us.

In 2003 three fellow adventurers and I dived on the Civil War wreck of the USS *Hatteras*, a Union warship that sank twenty-eight miles off Galveston after thirteen minutes of exchanging raging gunfire with a Confederate ship, the CSS *Alabama*. Nearly 150 years later, we found most of the *Hatteras* hull buried beneath the muddy bottom, which is fifty-seven feet below the surface. Only the upper parts of the paddlewheels and some toppled machinery protruded from the bottom. I returned in 2012 as a participant in a mission led by Dr. James Delgado of NOAA to map the wreck using a special high-definition sonar device. The project was a huge success, and I was able to get new photographs that showed much more of the wreck, which has since been exposed as a result of turbulent wave action from Hurricane Ike in 2008.

Another historical wreck I dived during research for this book is the USS *Somers* off the port of Veracruz, Mexico. This American officer training vessel capsized and sank in a squall while chasing a blockade runner in December 1846, just prior to the US-Mexico War. The details of the sinking remain unclear and somewhat mysterious. The USS *Somers* is the only US Navy ship to undergo a mutiny and conduct executions at sea. The Gulf of Mexico has many other significant historical wrecks at locations in bays or just off the beach, while some have been discovered off the continental shelf in thousands of feet of water. There are an estimated 750 known shipwrecks in the Gulf of Mexico.

An Atlantic spadefish school at the USS *Hatteras*, a historic wreck off Galveston that also functions as an artificial reef.

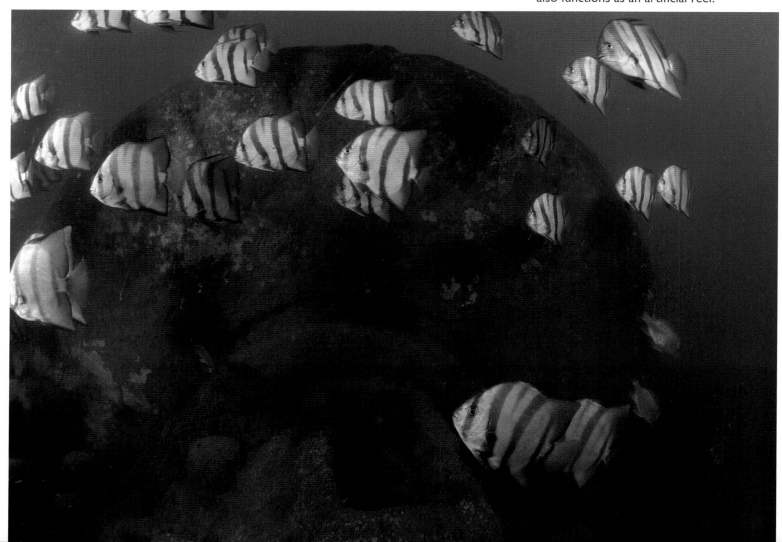

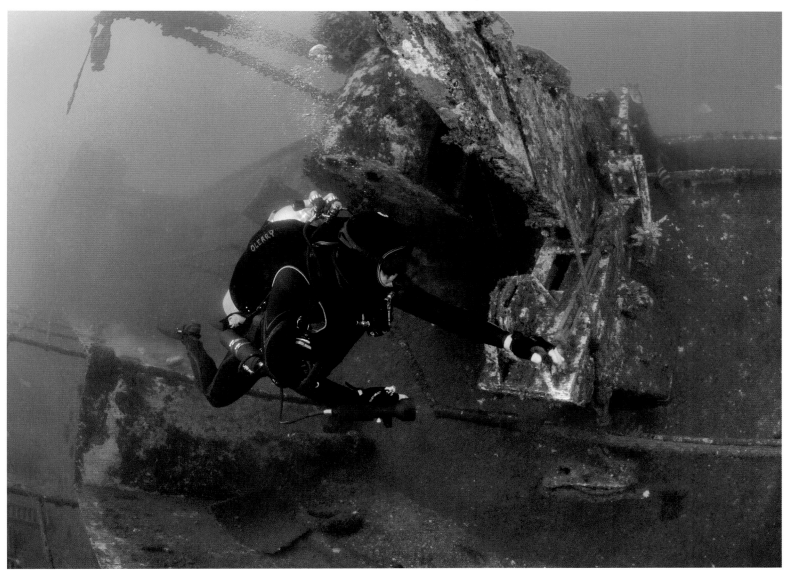

A diver explores the *Texas Clipper* artificial reef.

Intentionally Placed Artificial Reefs

As noted earlier, the Gulf of Mexico also has hundreds of intentionally sunk ships and obsolete gas and oil platforms that have been relocated and reefed. They serve well as marine habitats in areas devoid of natural reefs. The two most prominent in the northern Gulf are the *Oriskany* and the *Texas Clipper*. The USS *Oriskany*, an aircraft carrier that served during the era of the Korean and Vietnam Wars, was sunk twenty-four miles southeast of Pensacola in 215 feet of water. At 888 feet long, it's the largest intentionally reefed ship in the world.

The 473-foot-long *Texas Clipper* served as a merchant marine training vessel for Texas A&M University at Galveston. It was sunk seventeen miles off South Padre Island in November 2007.

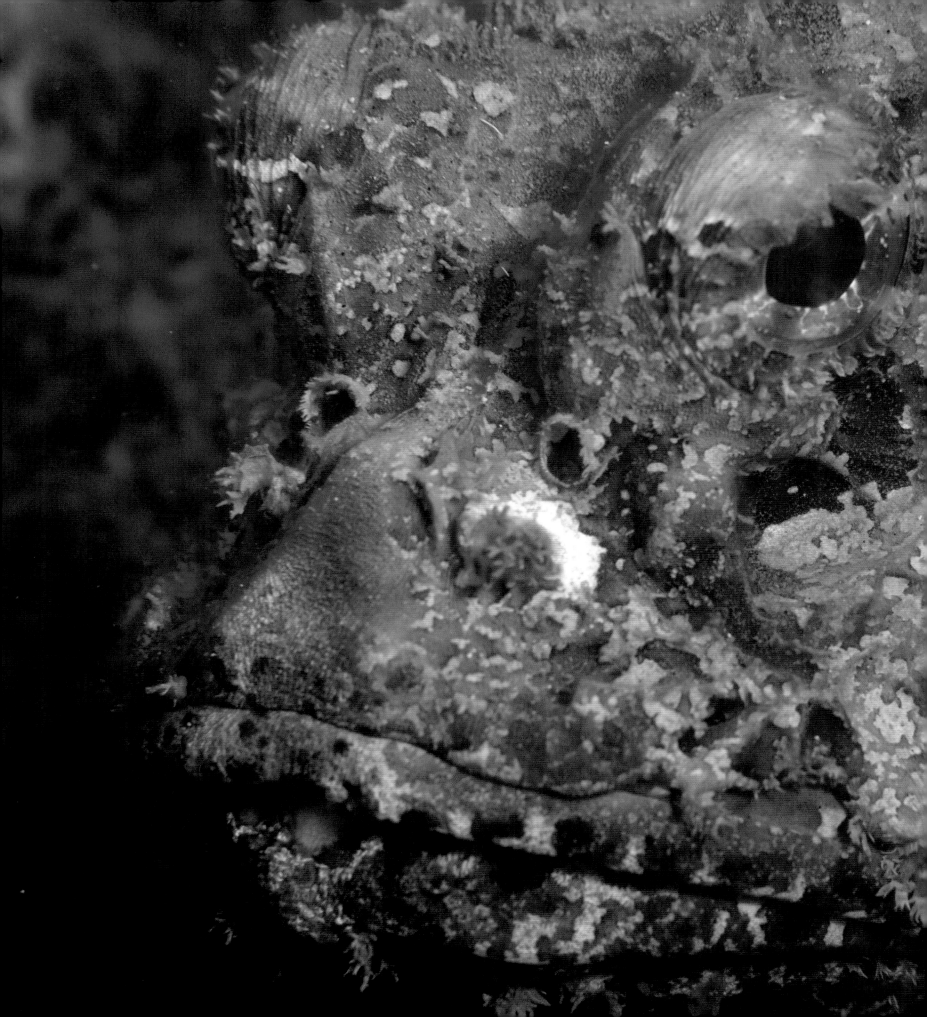

Call to Action

In my forty years of scuba diving and exploring ocean habitats around the globe, I have become increasingly passionate about the preservation of our wondrous aquatic world. As the ocean advocate I am today, I believe every one of us has the ability to contribute to making a better world for our future. I cannot think of a better place to begin than close to home with our glorious Gulf of Mexico.

A spotted scorpionfish portrait taken at Anegada de Adentro.

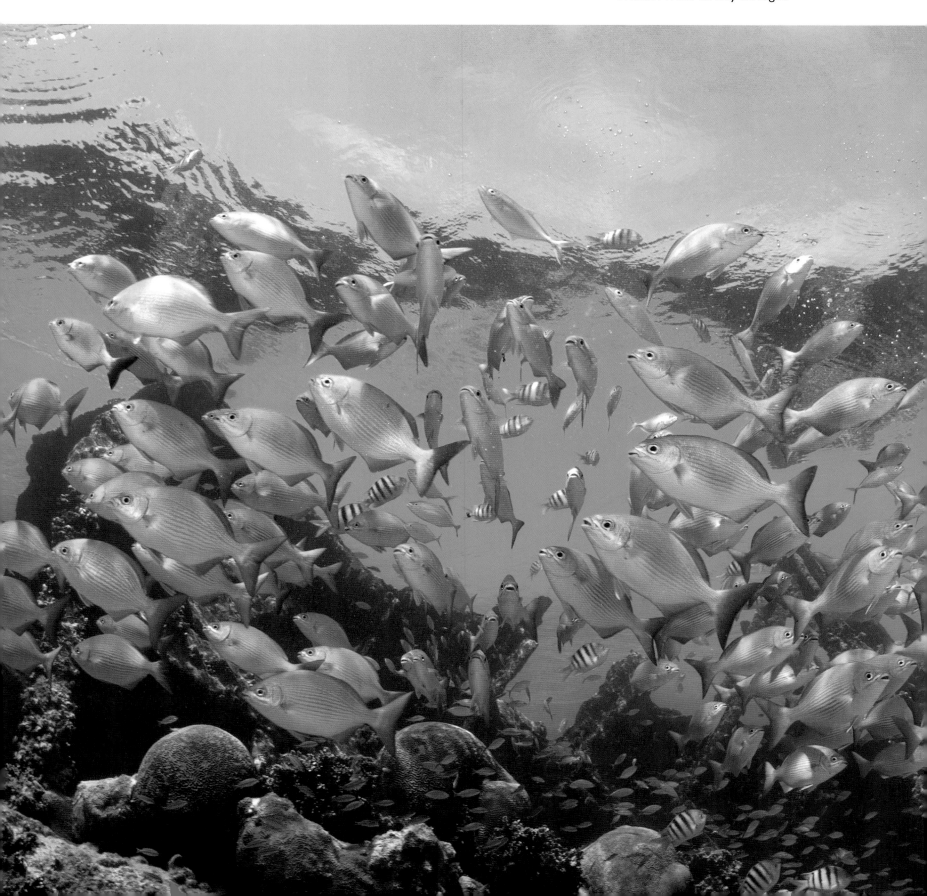

Schooling Bermuda chub find refuge on the French Wreck off Dry Tortugas.

Suggested Reading

Bright, Thomas J., and Linda H. Pequegnat, eds. *Biota of the West Flower Garden Bank*. Houston: Gulf Publishing, 1974.

Cancelmo, J. *Texas Coral Reefs*. College Station: Texas A&M University Press, 2008.

Hoese, H. Dickson, and Richard H. Moore. *Fishes of the Gulf of Mexico: Texas, Louisiana, and Adjacent Waters*. 2nd ed. College Station: Texas A&M University Press, 1998.

Moretzsohn, Fabio, Julio A. Sánchez Chávez, and John W. Tunnell Jr., eds. "Reefs, Banks and Islands." In GulfBase: Resource Database for Gulf of Mexico Research. http://www.gulfbase.org.

National Oceanic and Atmospheric Administration (NOAA). "Snapshot of Gulf of Mexico's MPAs." In NOAA's National Marine Protected Areas Center, March 2011. http://marineprotectedareas.noaa.gov/pdf/helpful-resources/gom_mpas_snapshot.pdf.

Rezak, Richard, Thomas J. Bright, and David W. McGrail. *Reefs and Banks of the Northwestern Gulf of Mexico: Their Geological, Biological, and Physical Dynamics*. New York: Wiley, 1985.

Ritchie, K. B., and B. D. Keller, eds. *A Scientific Forum on the Gulf of Mexico: The Islands in the Stream Concept*. Marine Sanctuaries Conservation Series NMSP-08–04. Silver Spring, Md.: US Department of Commerce, National Oceanic and Atmospheric Administration, National Marine Sanctuary Program, 2008.

Ritchie, K. B., and W. E. Kiene, eds. "Beyond the Horizon: A Forum to Discuss a Potential Network of Special Ocean Places to Strengthen the Ecology, Economy and Culture of the Gulf of Mexico." Proceedings of the Forum, May 11–13, 2011, Mote Marine Laboratory, Sarasota, Fla.

Tunnell, John W., Jr., Ernesto A. Chávez, and Kim Withers. *Coral Reefs of the Southern Gulf of Mexico*. College Station: Texas A&M University Press, 2007.

Map Data Sources

Map 1: 5, 7, 1
Map 2: 5, 7, 1, 3
Map 3: 5, 7, 6
Map 4: 4, 2
Map 5: 5, 7, 1

1. Institute for Marine Remote Sensing, University of South Florida (IMaRS/USF), Institut de Recherche pour le Développement (IRD), United Nations Environment Programme–World Conservation Monitoring Centre (UNEP-WCMC), the WorldFish Center, and World Resources Institute (WRI). Global coral reefs composite data set compiled from multiple sources, incorporating products from the Millennium Coral Reef Mapping Project prepared by IMaRS/USF and IRD, 2011.

2. Mullins, Troy. Boundary of Dry Tortugas National Park, 2006. Accessed August 12, 2014, pubs.usgs.gov/.

3. National Marine Fisheries Service. GIS data for the Gulf of Mexico Fisheries, Subpart D:

Coral and Coral Reefs, 2013. Accessed July 2, 2014, sero.nmfs.noaa.gov/.

4. National Park Service. Dry Tortugas National Park Maps, 2007. Accessed October 20, 2014, http://www.nps.gov/.

5. NOAA National Geophysical Data Center. Computerized digital image of the Gulf of Mexico, 2014. Accessed June 21, 2014, http://www.ngdc.noaa.gov/.

6. NOAA National Geophysical Data Center. Loop Current, 2014. Accessed August 10, 2014, http://www.ngdc.noaa.gov/.

7. Ocean Conservancy. Enhanced computerized digital image of the Gulf of Mexico, 2011. Raster dataset based on NOAA National Geophysical Data Center, 2010.

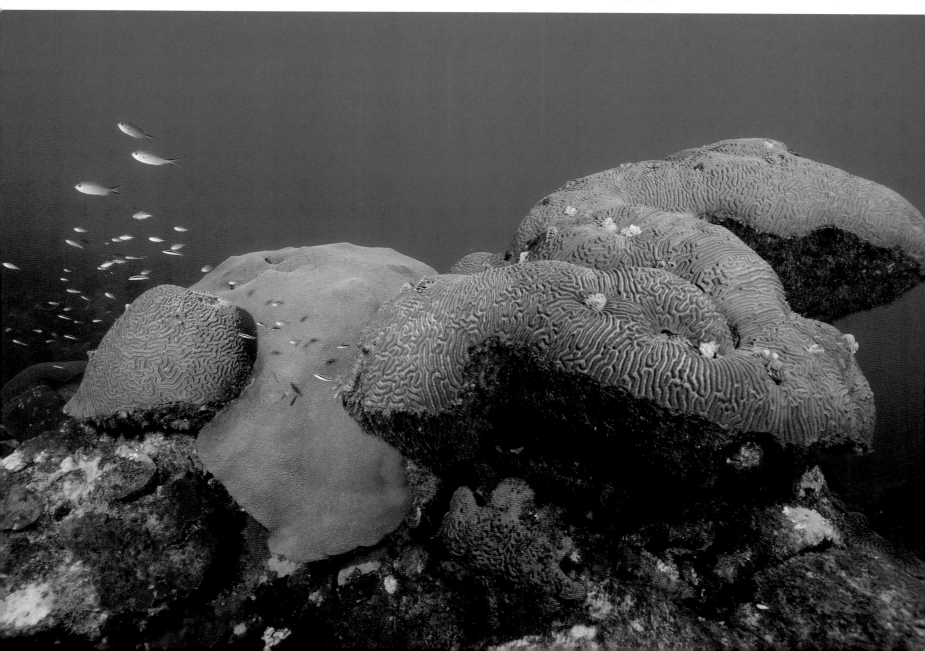

A magnificent formation of brain and star corrals at the East Flower Garden Bank Reef.

Index

The letter *m* following a page number denotes a map, the letter *n* denotes a note.

The letter *p* following page numbers associated with locations indicates photographs of selected species.

Other titles in the Gulf Coast Books series: